The Beginner's
FASHION DESIGN
STUDIO

DRAWING WITH Christopher Hart

The Beginner's
FASHION DESIGN
STUDIO
Easy Templates for Drawing Fashion Favorites

Get Creative 6

New York

DRAWING WITH Christopher Hart

An imprint of **Get Creative 6**
19 West 21st Street
Suite 601,
New York, NY 10010
sixthandspringbooks.com

Managing Editor/Senior Editor
LAURA COOKE

Art Director
IRENE LEDWITH

Assistant Editor
JACOB SEIFERT

Chief Executive Officer
CAROLINE KILMER

President
ART JOINNIDES

Chairman
JAY STEIN

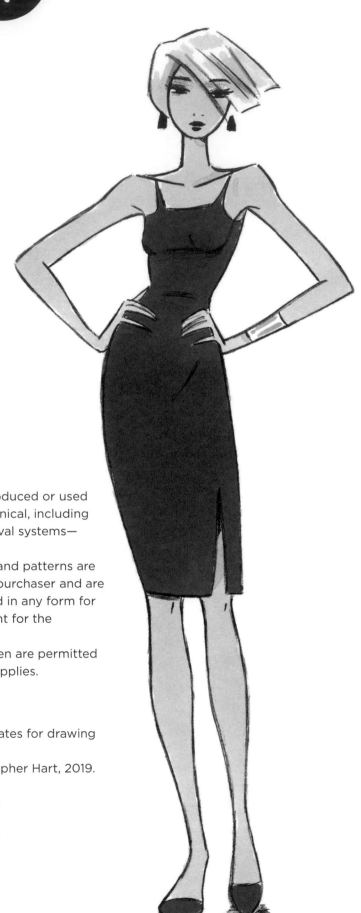

Library of Congress Cataloging-in-Publication Data
Names: Hart, Christopher, 1957- author.
Title: The beginner's fashion design studio : 100 easy templates for drawing
 fashion favorites / Christopher Hart.
Description: First edition. | New York : Drawing with Christopher Hart, 2019.
 | Includes index.
Identifiers: LCCN 2018057384 | ISBN 9781640210325 (pbk.)
Subjects: LCSH: Fashion drawing--Juvenile literature.
Classification: LCC TT509 .H368 2019 | DDC 741.6/72--dc23
LC record available at https://lccn.loc.gov/2018057384

Manufactured in China

5 7 9 10 8 6

First Edition

*I'd like to thank everyone
at Soho Publishing
for contributing their
support and enthusiasm
to this project.*
—Christopher Hart

CONTENTS

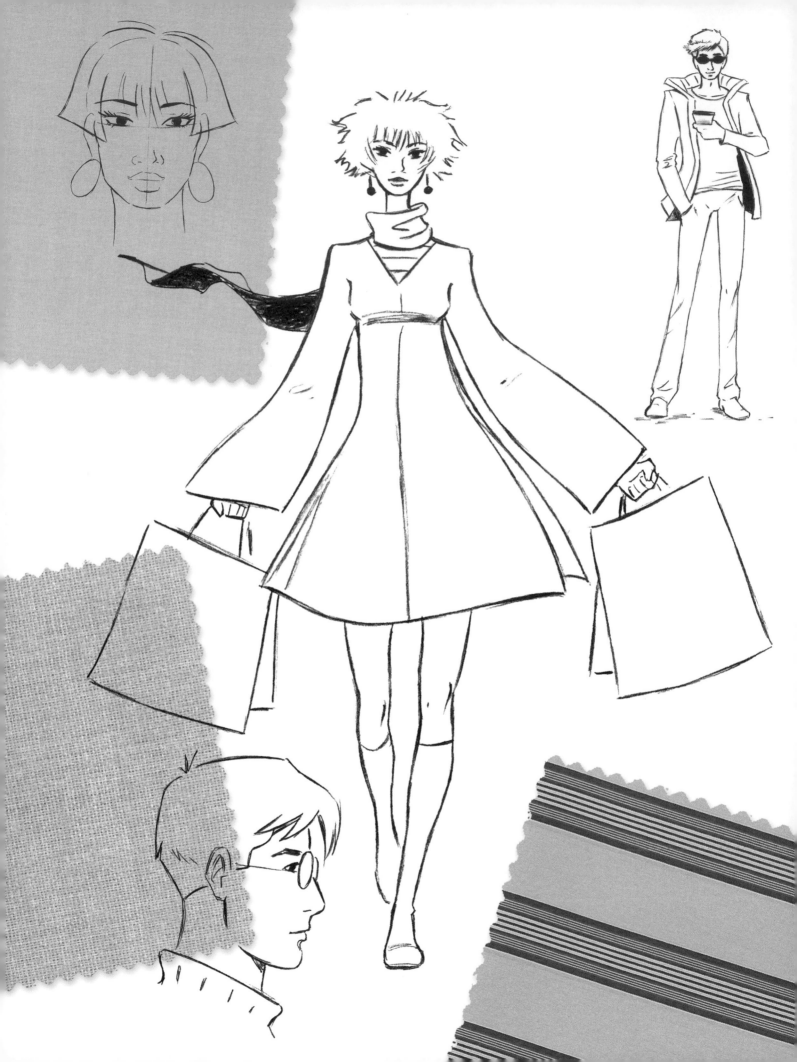

INTRODUCTION

YES, YOU REALLY CAN LEARN TO DRAW FASHIONS and figures. And have fun doing it too! Your creativity will sparkle as your ability grows and your drawings improve.

All artists at every level can benefit from this book. Whether you're a beginner interested in basic drawing, an aspiring manga artist, or someone who just enjoys sketching and coloring, the techniques in this book will help you. Learning how to enhance the overall style of your subjects is an invaluable skill, and something you'll find rewarding creatively. In this book, I'll show you exactly how to do that with simplified and finished examples.

You'll learn how to draw idealized versions of the head and body, how to draw poses with attitude, how to create a great variety of fashionable outfits and accessories, when to indicate textures, and the smart application of color.

Easy-to-use templates appear throughout the book. The templates are simple shapes, springboards from which the drawings are created. These will get you started in the right direction. I will also point out key concepts along the way. Are you ready to get started?

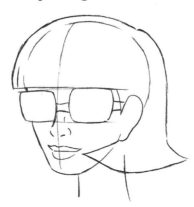

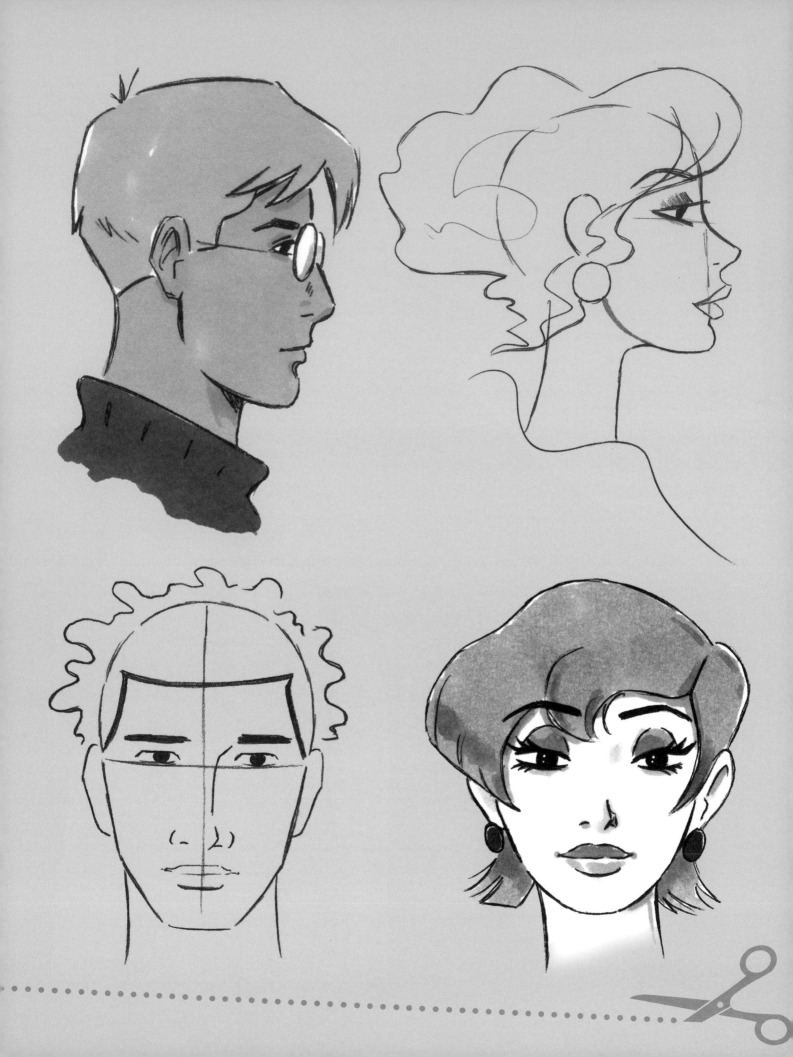

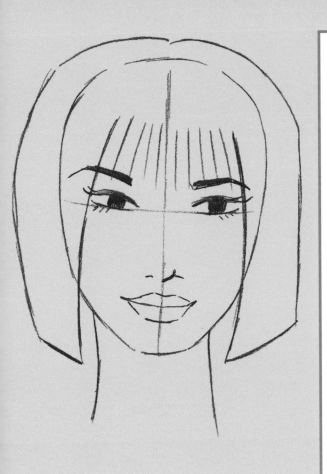

DRAWING THE HEAD

The attractive look of fashion models is primarily established in the outline of the face. This includes the raised cheekbones, sleek angle of the jaw, and pronounced chin. We'll draw these features by varying their emphasis—heavy on the eyes, light on the nose, and medium on the lips. I'll give you tips and suggestions to help you build on these basic concepts along the way.

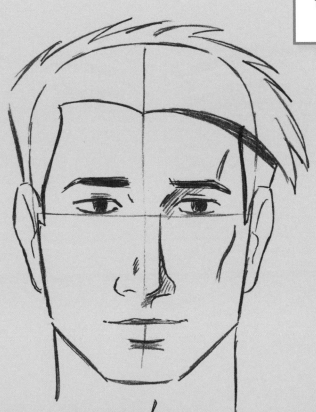

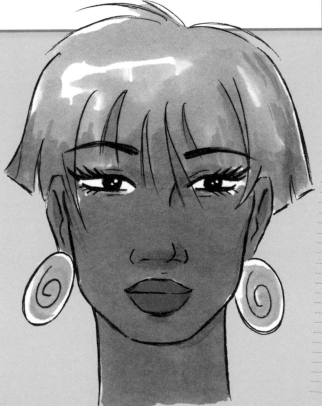

THE **BASICS**

The head starts with a basic outline. As you draw, keep in mind that facial expressions in fashion illustrations should reflect the overall vibe of the clothing on display. Whether it is confident, happy, slinky, carefree, defiant, or wistful, the expression works together with the outfit.

Simple Head Shape

The foundation starts simple. You can make changes later, such as drawing higher cheekbones or developing a specific expression.

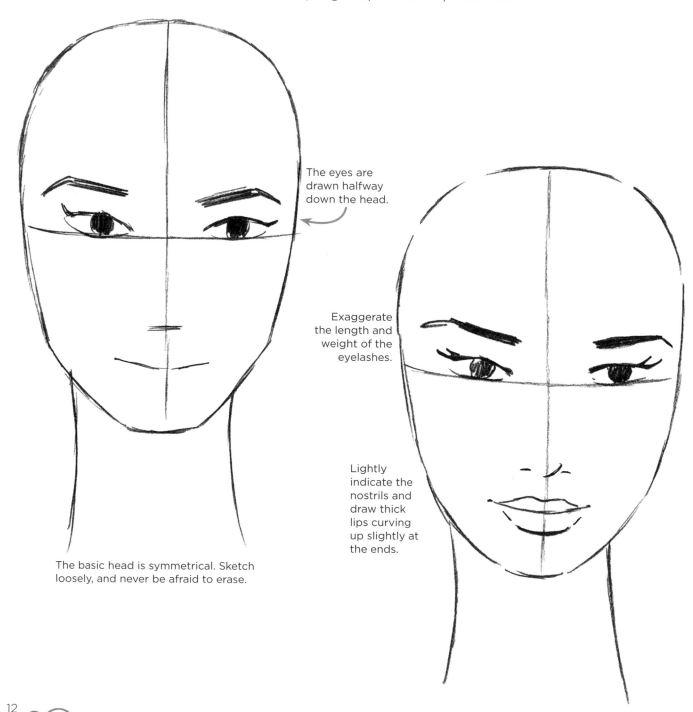

The eyes are drawn halfway down the head.

Exaggerate the length and weight of the eyelashes.

Lightly indicate the nostrils and draw thick lips curving up slightly at the ends.

The basic head is symmetrical. Sketch loosely, and never be afraid to erase.

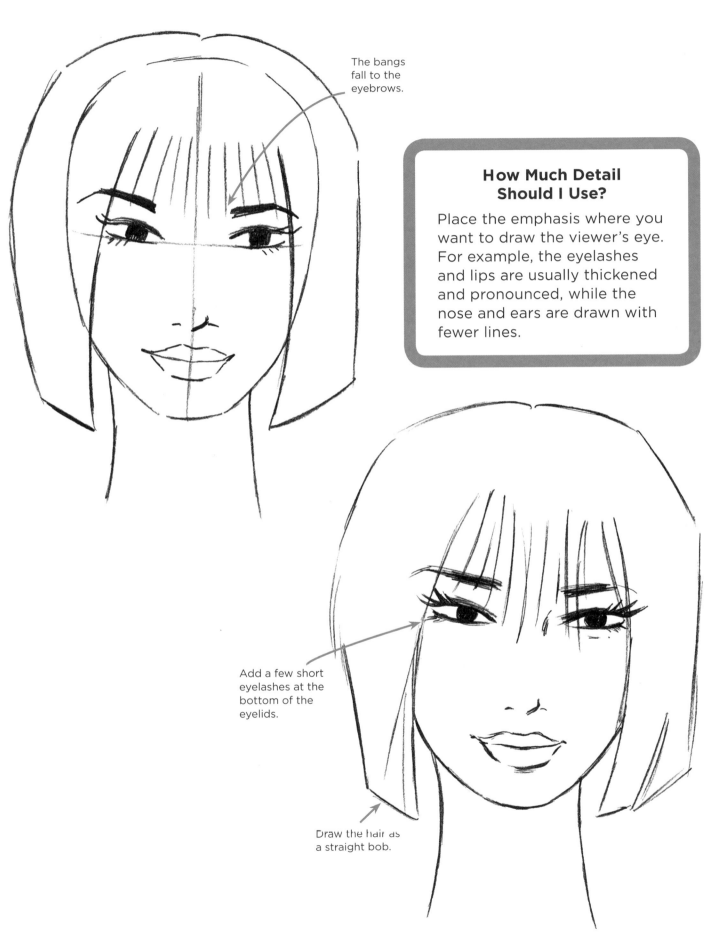

The bangs fall to the eyebrows.

How Much Detail Should I Use?

Place the emphasis where you want to draw the viewer's eye. For example, the eyelashes and lips are usually thickened and pronounced, while the nose and ears are drawn with fewer lines.

Add a few short eyelashes at the bottom of the eyelids.

Draw the hair as a straight bob.

ACCENT ON THE **CHEEKBONES**

High cheekbones can be used to modify the head shape. They create a dramatic look. You can round the cheekbones or make them angular; it's a stylistic choice. Be sure to draw both sides so they line up symmetrically.

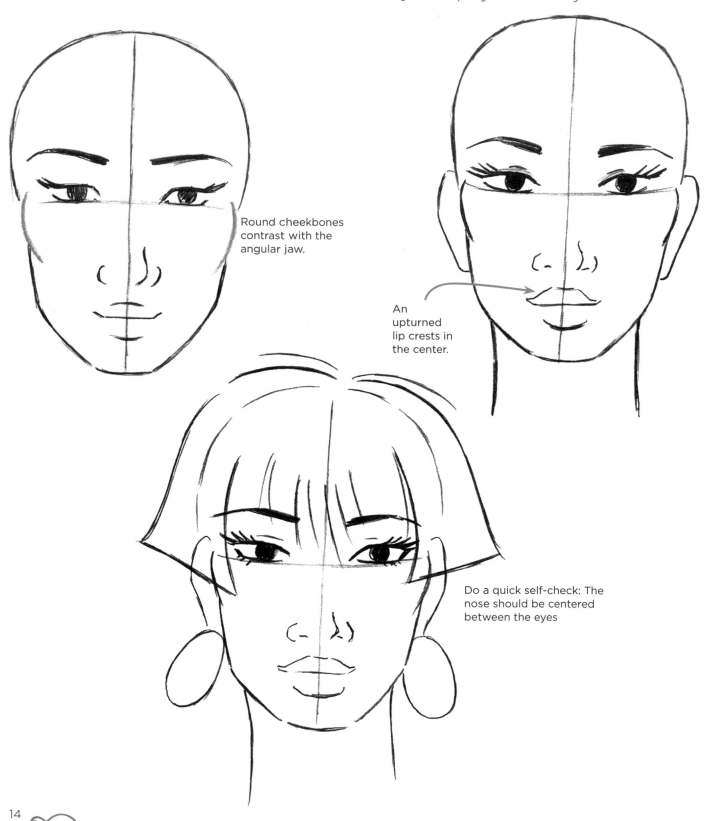

Round cheekbones contrast with the angular jaw.

An upturned lip crests in the center.

Do a quick self-check: The nose should be centered between the eyes

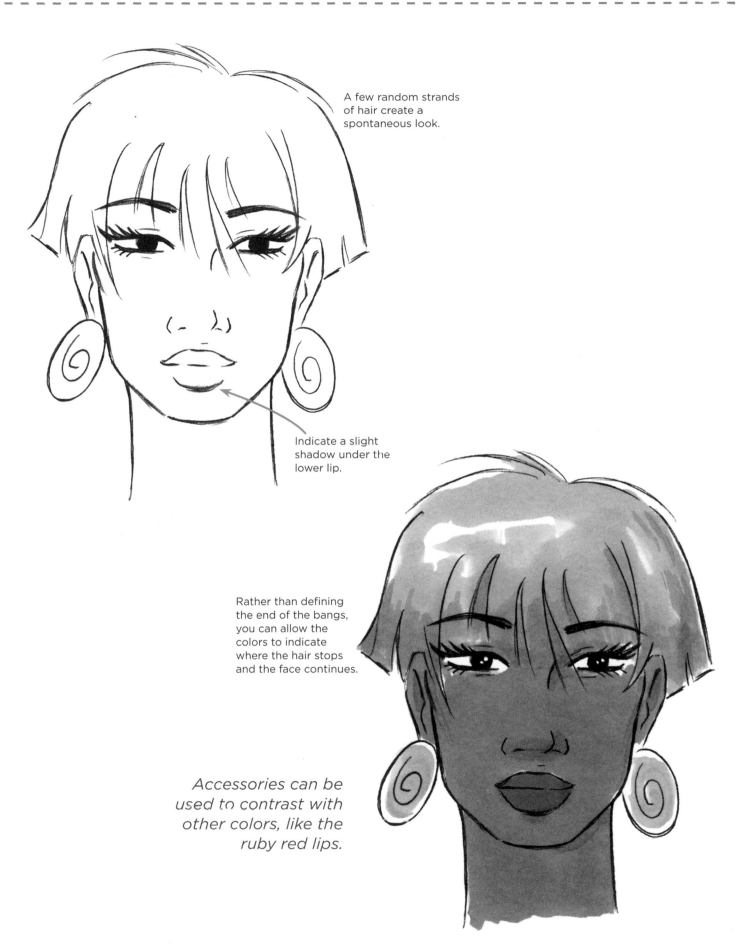

A few random strands of hair create a spontaneous look.

Indicate a slight shadow under the lower lip.

Rather than defining the end of the bangs, you can allow the colors to indicate where the hair stops and the face continues.

Accessories can be used to contrast with other colors, like the ruby red lips.

DRAWING THE **PROFILE**

In the profile, the lips take on added emphasis. This can present a common problem for beginners. Therefore, if your side view doesn't look quite right, I suggest that you double check to see if you have extended the lips enough. You may discover that all you needed was a little tweak in that area.

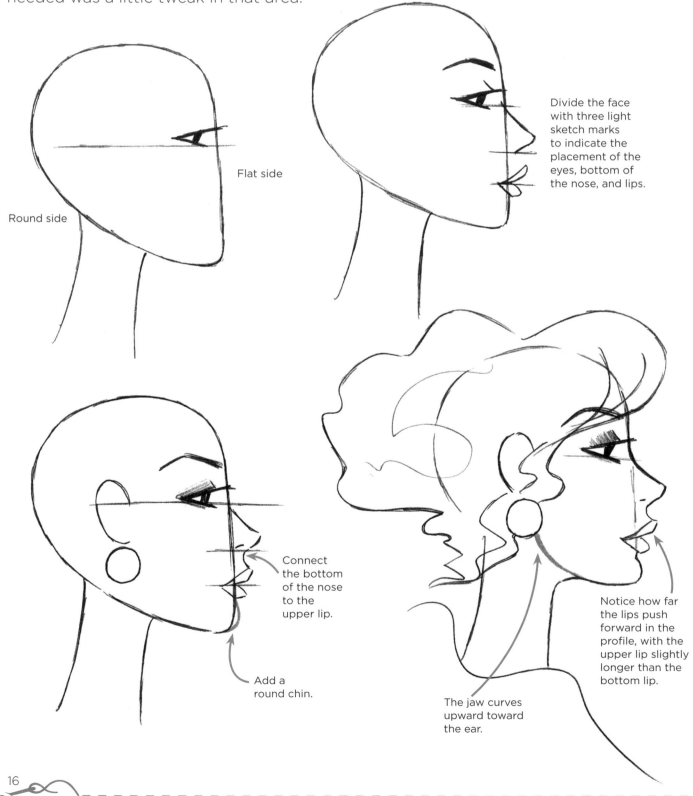

Round side

Flat side

Divide the face with three light sketch marks to indicate the placement of the eyes, bottom of the nose, and lips.

Connect the bottom of the nose to the upper lip.

Add a round chin.

The jaw curves upward toward the ear.

Notice how far the lips push forward in the profile, with the upper lip slightly longer than the bottom lip.

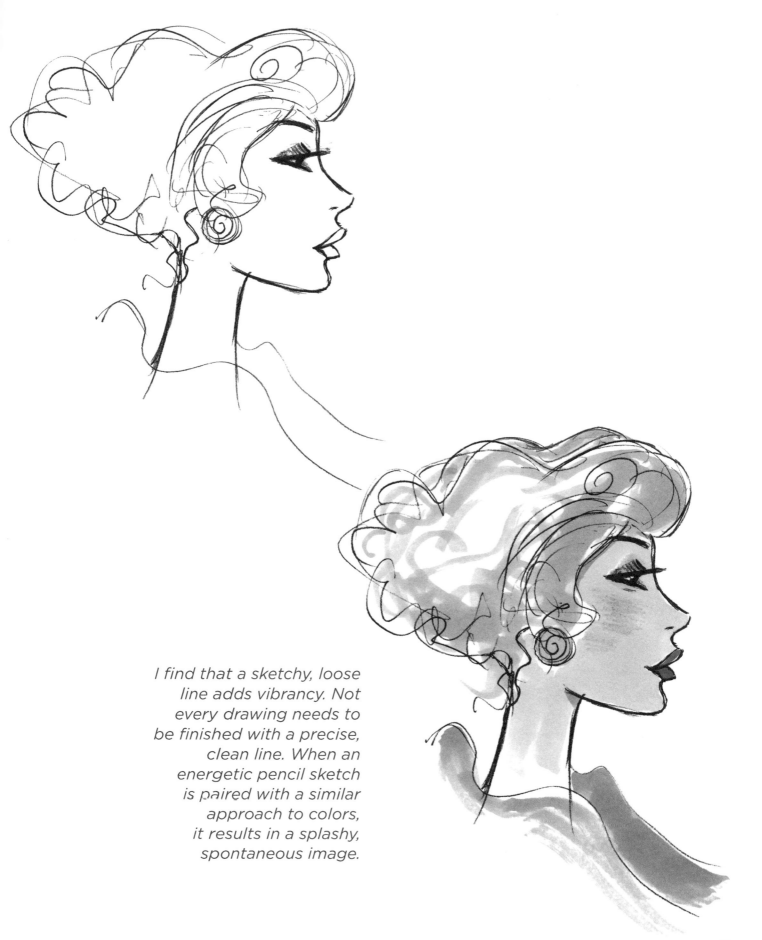

I find that a sketchy, loose line adds vibrancy. Not every drawing needs to be finished with a precise, clean line. When an energetic pencil sketch is paired with a similar approach to colors, it results in a splashy, spontaneous image.

ACCENT ON THE **EYES**

The eyelids can be an effective way to create different expressions. By lowering them, you create a self-assured expression, which works well with fashionable types.

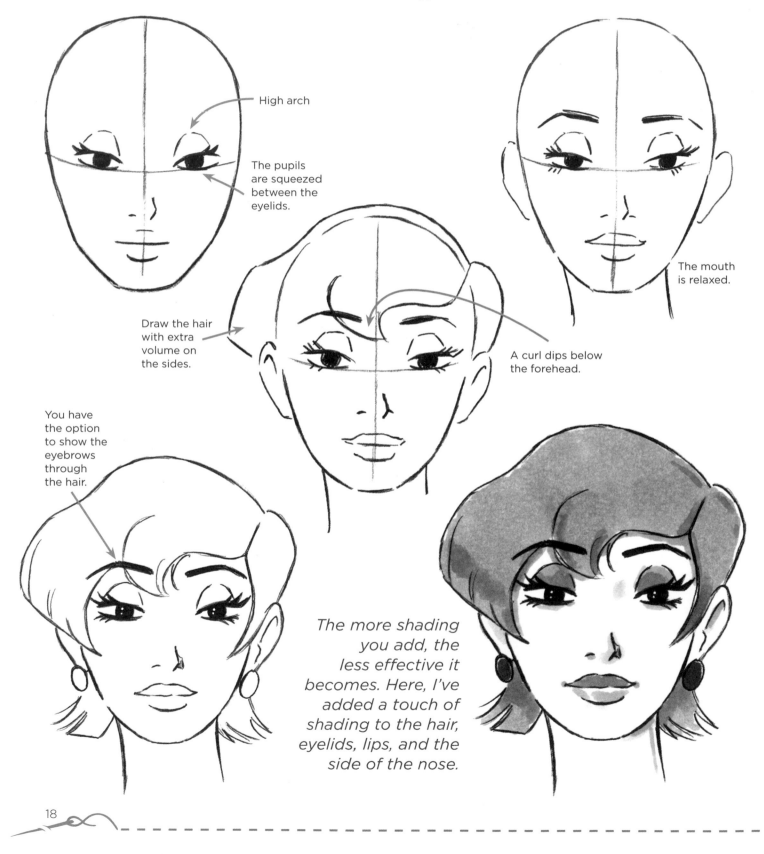

High arch

The pupils are squeezed between the eyelids.

The mouth is relaxed.

Draw the hair with extra volume on the sides.

A curl dips below the forehead.

You have the option to show the eyebrows through the hair.

The more shading you add, the less effective it becomes. Here, I've added a touch of shading to the hair, eyelids, lips, and the side of the nose.

PROPORTION TIPS

Here are a few key proportions for drawing the head. They come in handy when your character is at an angle, such as the ¾ view, which falls between the front and side views.

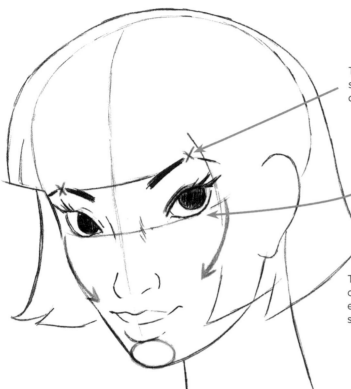

The eyebrows peak at the same place on both sides of the forehead.

The eyes are drawn halfway up the head, as measured from top to bottom.

The cheekbones create two contour lines that travel to either side of the chin for a sleek look.

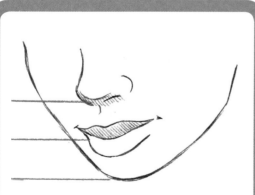

Proportion Detail

There's slightly less room from the nose to the lips than from the lips to the chin.

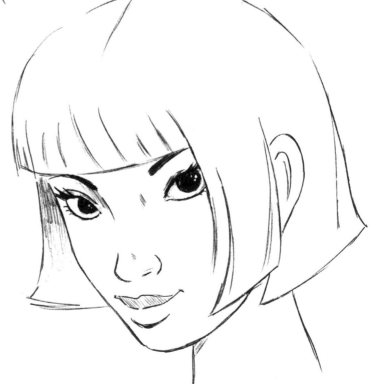

ADJUSTING THE SHAPE OF THE **HEAD**

In the same way that you can change the features of the face, you can also change the outline of the head. This is a powerful tool for creating individuals and is sometimes underutilized. To demonstrate, I'll begin with the basic head shape. Then we'll widen it out—all but the chin.

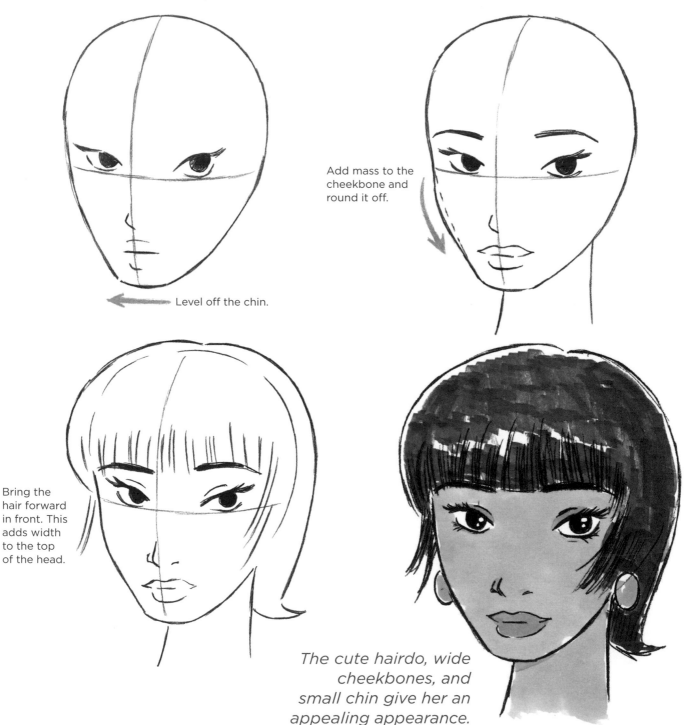

Level off the chin.

Add mass to the cheekbone and round it off.

Bring the hair forward in front. This adds width to the top of the head.

The cute hairdo, wide cheekbones, and small chin give her an appealing appearance.

DRAWING DRAMATIC **HAIR**

Hair has waves, curls, flips, and, well, a mind of its own. It's an essential part of any look. Throughout the book, I'll point out interesting hints about various hairstyles you'll see on some of the characters.

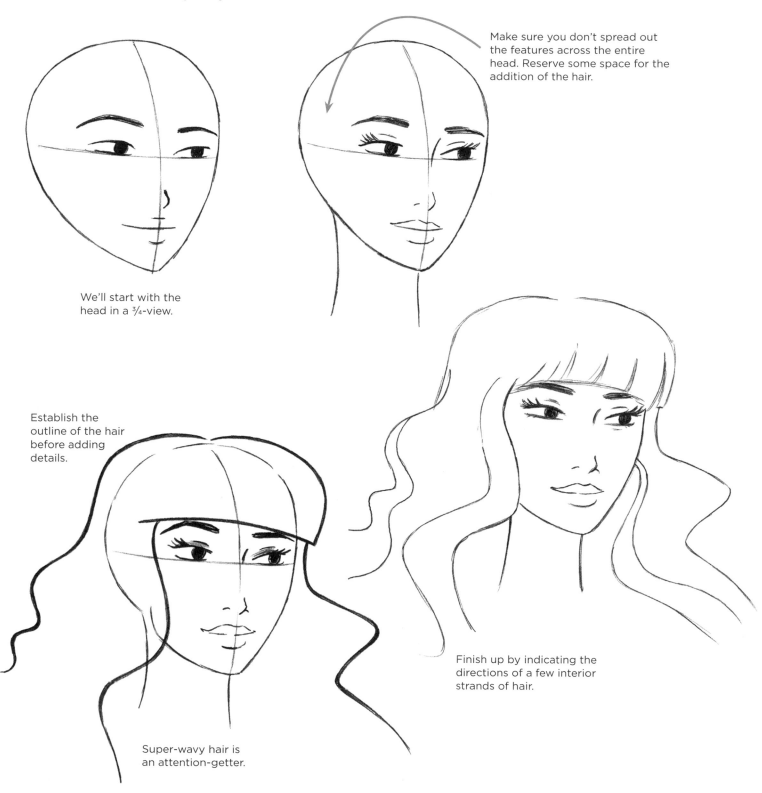

Make sure you don't spread out the features across the entire head. Reserve some space for the addition of the hair.

We'll start with the head in a ¾-view.

Establish the outline of the hair before adding details.

Finish up by indicating the directions of a few interior strands of hair.

Super-wavy hair is an attention-getter.

MALE FACE—**FRONT**

The head shape for men usually displays clearly formed angles at the jaw. The brow is also more defined, but that only shows up in the ¾ and side views. Read on for more effective tools for drawing your male fashion model.

Draw a well defined hairline.

The eyebrows are horizontal, rather than drawn with the high arch of female eyebrows.

The eyes are horizontal, almost rectangular.

The bottom half of the head is drawn with hard angles.

The nose can be effectively drawn without a lot of detail.

Thicken the line under the bottom lip.

The spontaneous look of the hairstyle is balanced by the controlled look of the hairline.

Add contour lines to the side of the forehead and around the cheekbone.

I've added some pencil shading to this black and white drawing to soften the image.

A touch of shadow above the chin.

Front Variation

In this popular hairstyle, the hair is brushed dramatically to the side. Once again, a well-defined hairline (where the hair meets the forehead) gives the face and head structure.

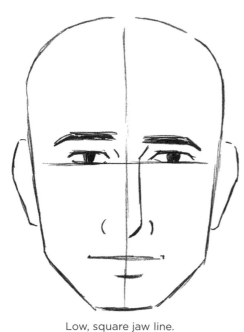

The eyebrows are drawn at the same level as the top of the ears.

Plot out the nose before you draw it in detail. Don't be afraid to erase.

Low, square jaw line.

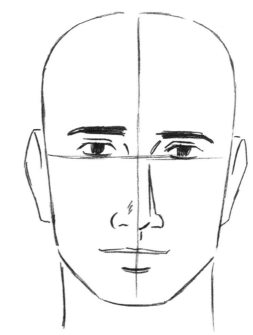

The nose protrudes from the face, and therefore, one side is often hit by shadow. Keep it minimal.

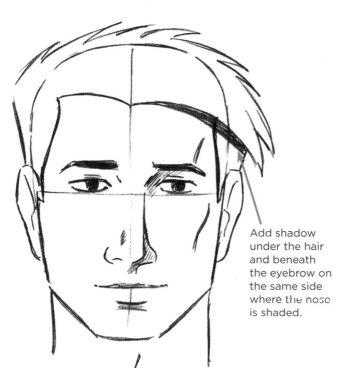

Add shadow under the hair and beneath the eyebrow on the same side where the nose is shaded.

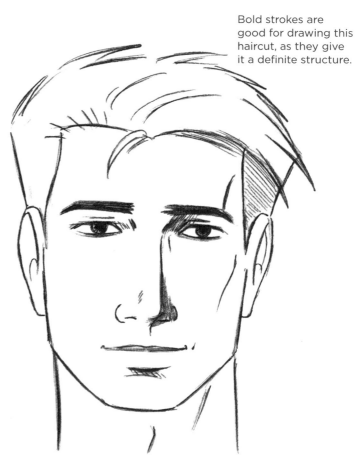

Bold strokes are good for drawing this haircut, as they give it a definite structure.

MALE FACE—**PROFILE**

A common mistake beginners make when drawing guys is that the lips are sometimes flat against the surface of the face, instead of protruding. While they don't protrude to the same extent as female lips, they still push forward to accommodate the teeth.

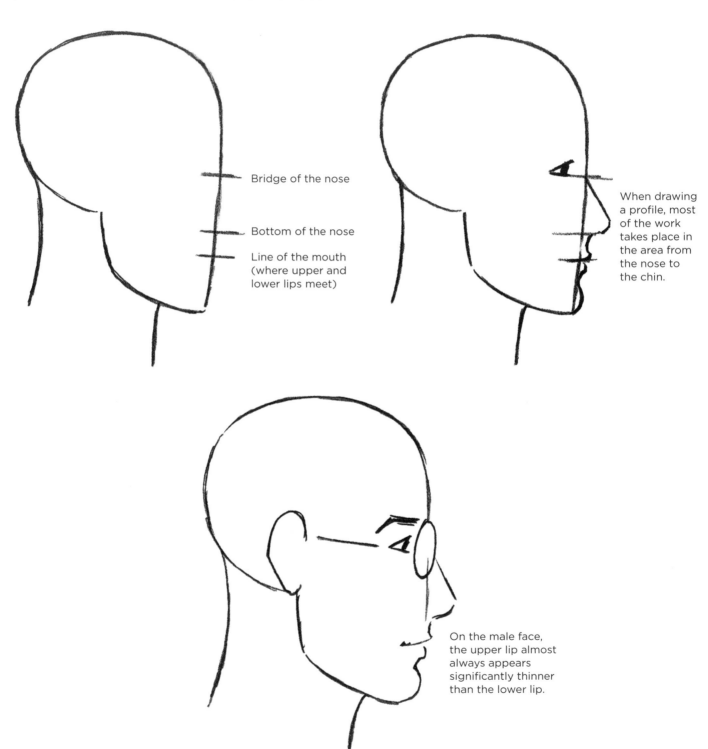

Bridge of the nose

Bottom of the nose

Line of the mouth (where upper and lower lips meet)

When drawing a profile, most of the work takes place in the area from the nose to the chin.

On the male face, the upper lip almost always appears significantly thinner than the lower lip.

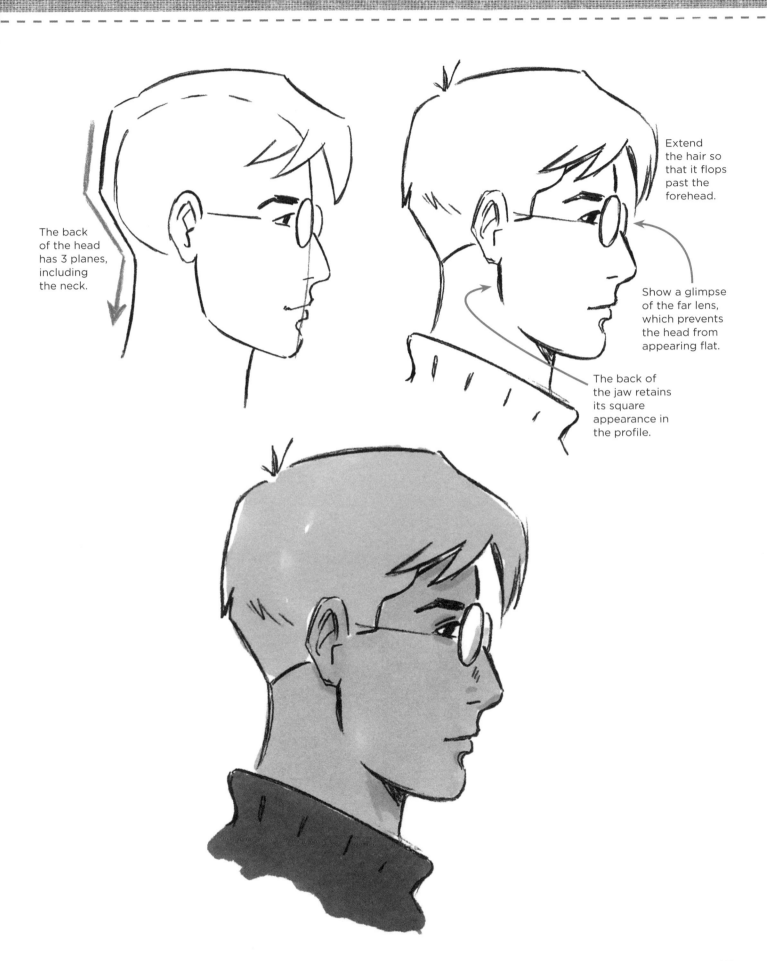

The back of the head has 3 planes, including the neck.

Extend the hair so that it flops past the forehead.

Show a glimpse of the far lens, which prevents the head from appearing flat.

The back of the jaw retains its square appearance in the profile.

DRAWING **GLASSES**

Sunglasses are a fashion statement. Paired with a stylish hairdo, it's a very cool look. A placid expression is a good choice for a character with sunglasses. It suggests confidence with a touch of intrigue.

Style Note
Oversized sunglasses have more style.

Start by sketching two guidelines for the sunglasses. These act as brackets to keep the frames and lenses aligned.

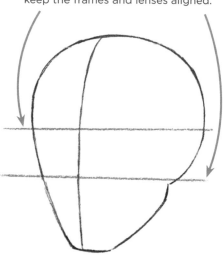

The far lens extends past the head in the ¾ view.

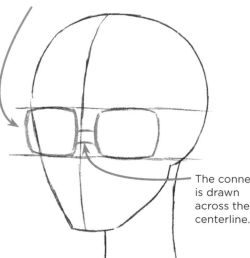

The connector is drawn across the centerline.

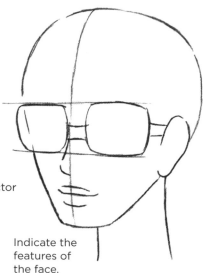

Indicate the features of the face.

The bangs falls just over the top of the lenses. This allows you to omit the eyebrows.

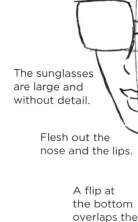

The sunglasses are large and without detail.

Flesh out the nose and the lips.

A flip at the bottom overlaps the face.

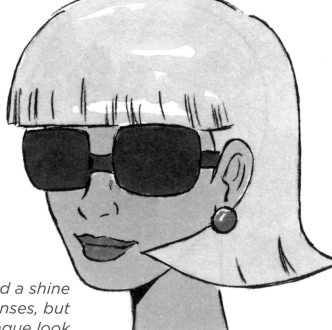

You can add a shine to the lenses, but an opaque look also works nicely.

What is the Difference Between Drawing Glasses and Sunglasses?

When you draw glasses, you emphasize the shape of the lenses. But when you draw sunglasses you emphasize the shape of the frames. Sunglasses are usually oversized in fashion illustrations.

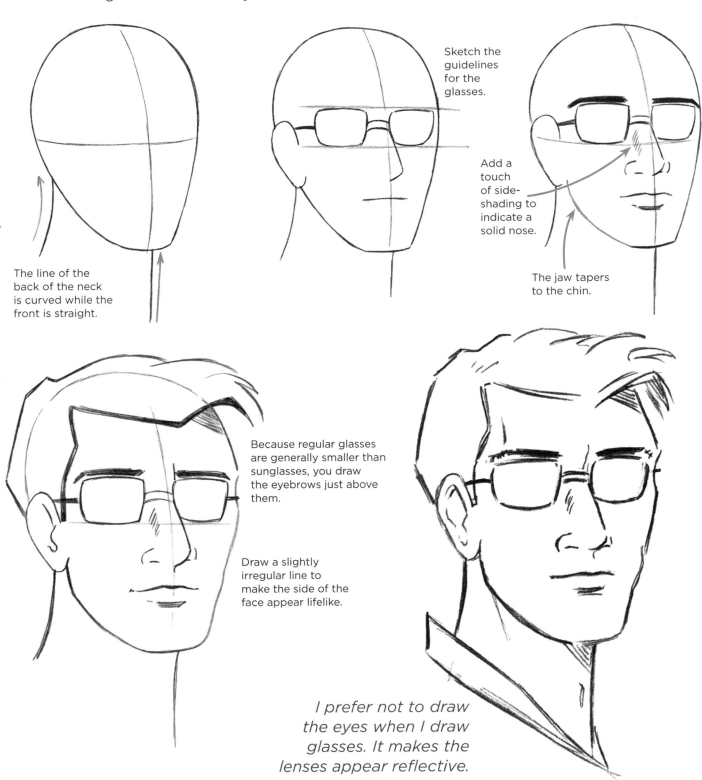

Sketch the guidelines for the glasses.

Add a touch of side-shading to indicate a solid nose.

The jaw tapers to the chin.

The line of the back of the neck is curved while the front is straight.

Because regular glasses are generally smaller than sunglasses, you draw the eyebrows just above them.

Draw a slightly irregular line to make the side of the face appear lifelike.

I prefer not to draw the eyes when I draw glasses. It makes the lenses appear reflective.

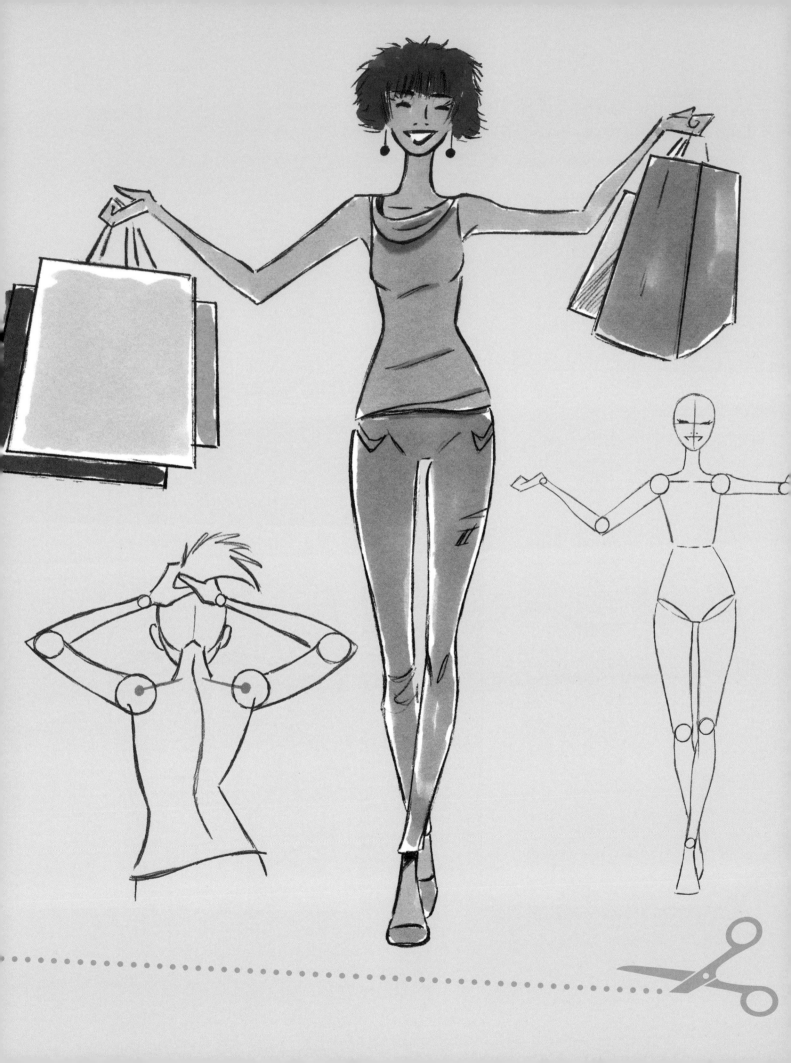

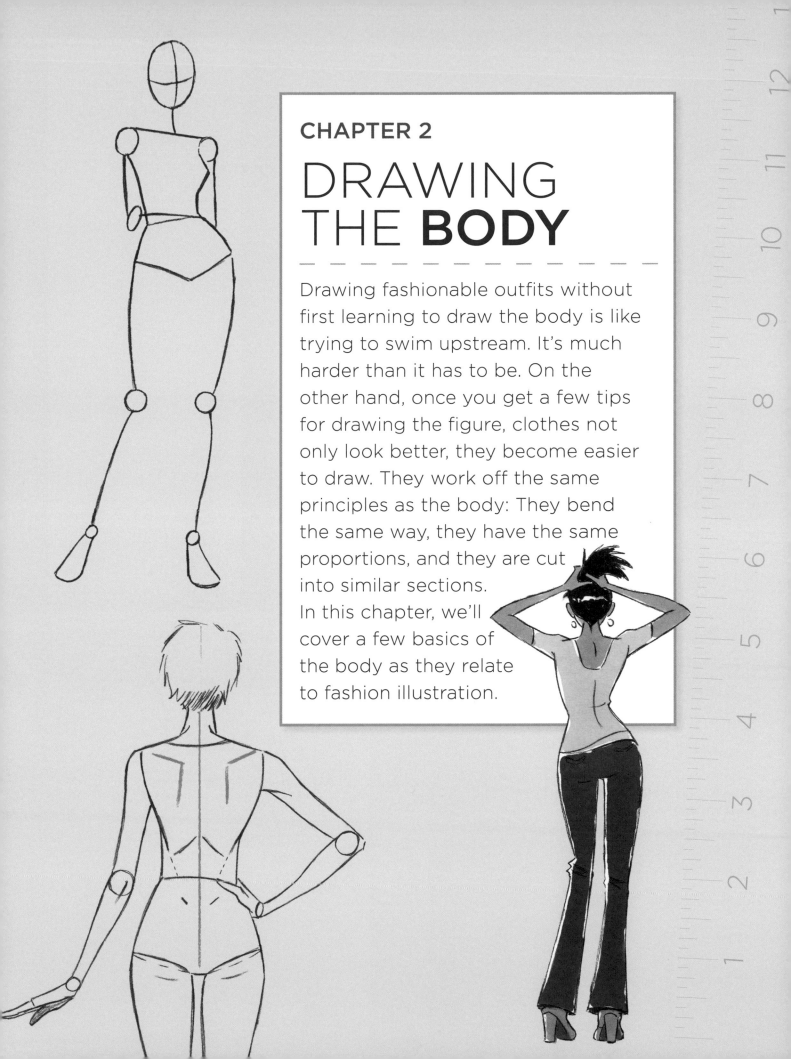

CHAPTER 2

DRAWING THE **BODY**

Drawing fashionable outfits without first learning to draw the body is like trying to swim upstream. It's much harder than it has to be. On the other hand, once you get a few tips for drawing the figure, clothes not only look better, they become easier to draw. They work off the same principles as the body: They bend the same way, they have the same proportions, and they are cut into similar sections. In this chapter, we'll cover a few basics of the body as they relate to fashion illustration.

THE **TORSO**

Here's the classic fashion torso. It's long and lanky with wide shoulders and hips. Let's go over a few more of the classic torso elements.

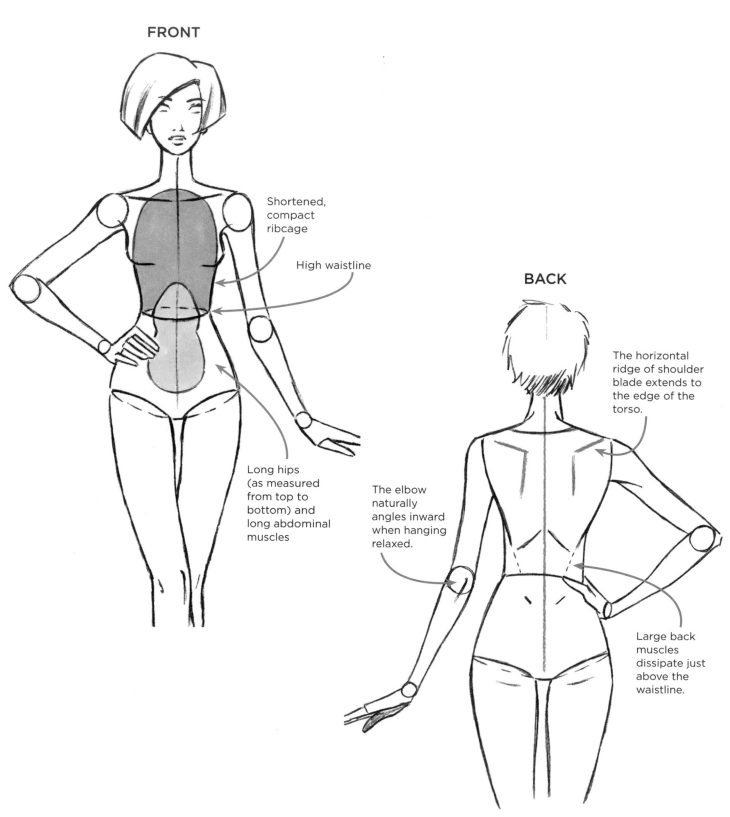

FRONT

Shortened, compact ribcage

High waistline

Long hips (as measured from top to bottom) and long abdominal muscles

BACK

The horizontal ridge of shoulder blade extends to the edge of the torso.

The elbow naturally angles inward when hanging relaxed.

Large back muscles dissipate just above the waistline.

NECK AND SHOULDERS

On tall figures, which are often associated with fashion models, the neck and shoulders carry great importance. Tops and dresses hang attractively from wide shoulders, and the neck gives the figure an elongated look, creating a slinky, flowing posture.

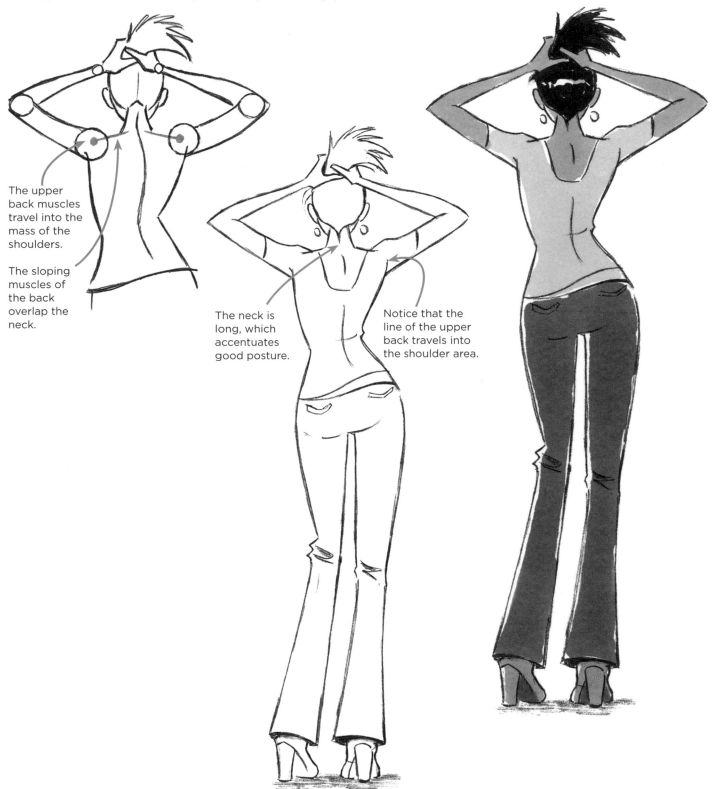

The upper back muscles travel into the mass of the shoulders.

The sloping muscles of the back overlap the neck.

The neck is long, which accentuates good posture.

Notice that the line of the upper back travels into the shoulder area.

LET'S TALK ABOUT **POISE**

Did you ever wonder how fashion models stand with their hips pushed far forward without ever looking off balance? It comes naturally to models, but artists have to draw this pose consciously. Draw the model with her shoulders pulled back to the same degree that the hips are pushed forward. This positions the head directly over the hips, and that keeps the figure balanced.

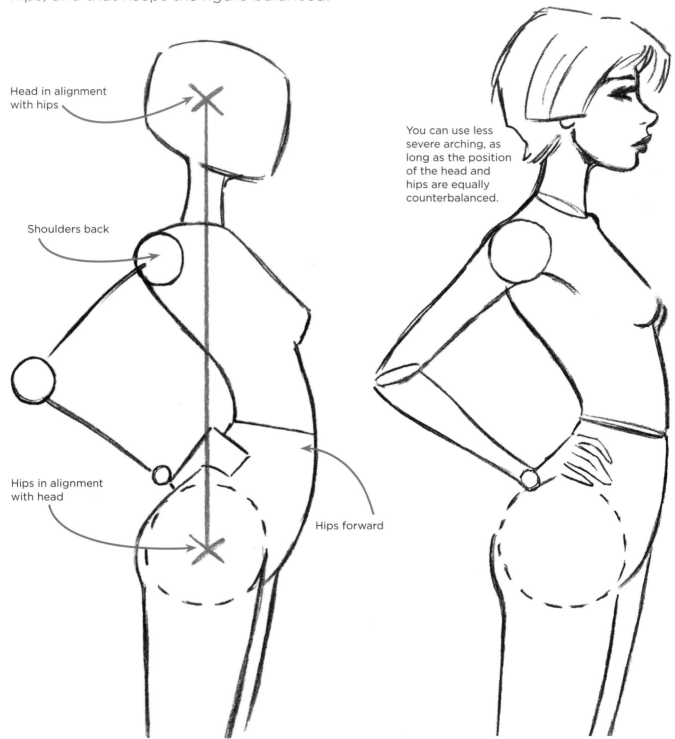

Head in alignment with hips

Shoulders back

Hips in alignment with head

Hips forward

You can use less severe arching, as long as the position of the head and hips are equally counterbalanced.

THE TRICK TO **FASHION PROPORTIONS**

The figures in fashion drawings appear taller than the average person, but their extra height derives almost exclusively from the length of the legs. On a normally proportioned person, the legs are half the length of the body. But the fashion figure has legs that take up more than half of the overall height. If you can remember this one trick, your drawings will immediately look more fashionable.

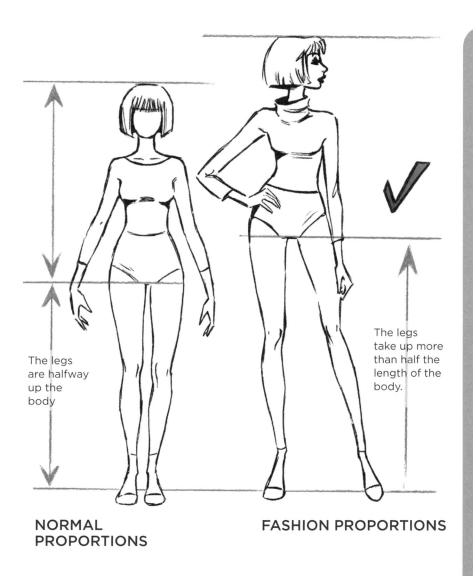

The legs are halfway up the body

The legs take up more than half the length of the body.

NORMAL PROPORTIONS

FASHION PROPORTIONS

Proportion Detail

The proportions for fashion figures are different from those of real people. You may have noticed that the mannequins in stylish clothing stores are taller than real people, have smaller heads, and longer limbs. You can apply the same proportions to your fashion drawings.

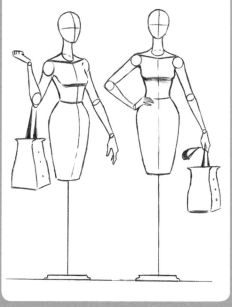

THE **LEGS** IN ACTION

This concept is simple and works with any pose: The contours of the upper and lower legs curve toward the knee. That just makes sense. The knee is a complex piece of machinery where the bones, muscles, tendons, and ligaments converge. Naturally, we should be able to see the effect of this in our drawings.

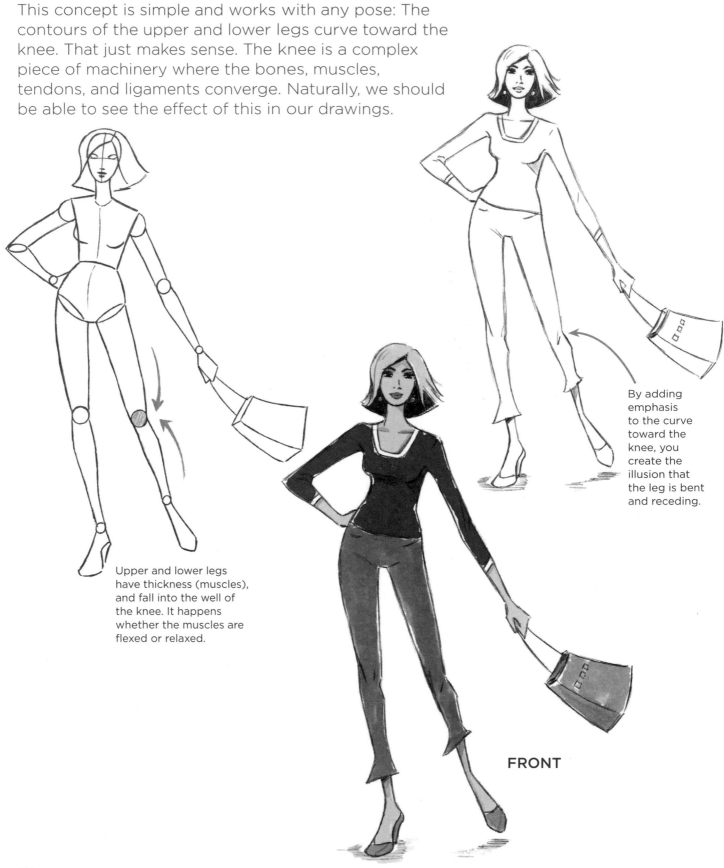

Upper and lower legs have thickness (muscles), and fall into the well of the knee. It happens whether the muscles are flexed or relaxed.

By adding emphasis to the curve toward the knee, you create the illusion that the leg is bent and receding.

FRONT

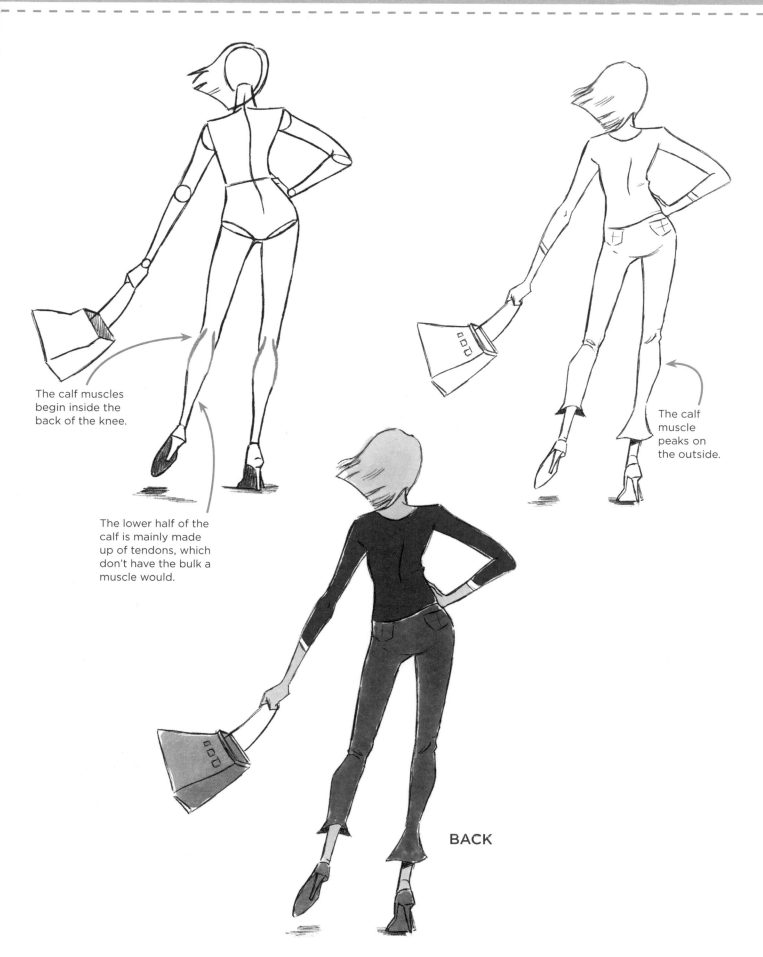

The calf muscles begin inside the back of the knee.

The lower half of the calf is mainly made up of tendons, which don't have the bulk a muscle would.

The calf muscle peaks on the outside.

BACK

POSING

There are only two basic concepts you need to draw appealing fashion poses. The first addresses the shoulders, and the second addresses the hips. Unless the pose is neutral, you will most likely exaggerate one of these areas.

Shoulders

The more uneven the shoulders, the more attitude and style the pose will have. Think of the shoulders as a locked system. When one side goes up, the other goes down. This isn't always the case, but to create dramatic poses, it's an effective technique.

Down

Up

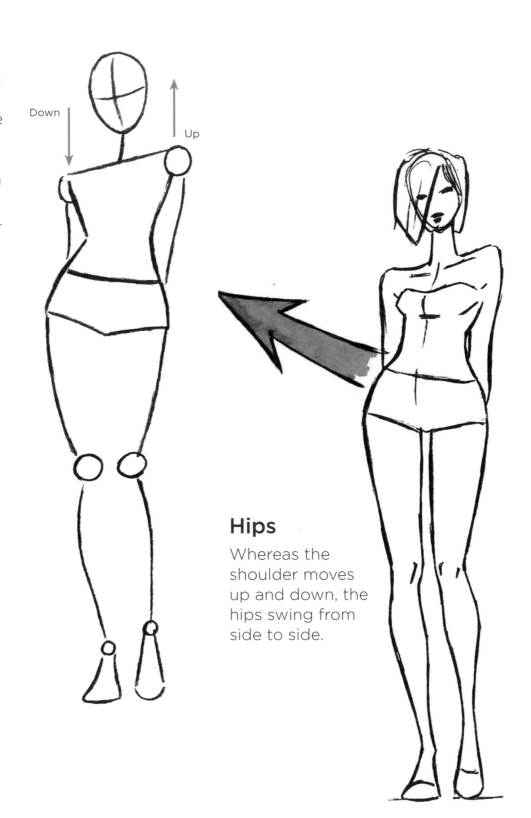

Hips

Whereas the shoulder moves up and down, the hips swing from side to side.

SHOULDERS

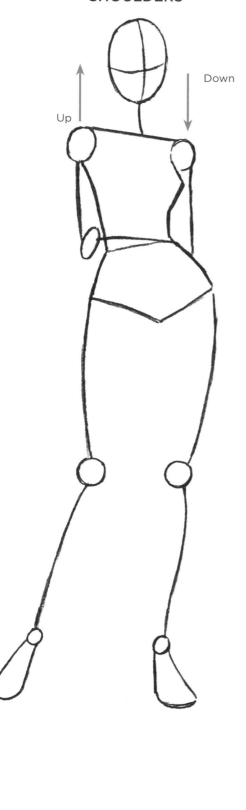

Up

Down

HIPS

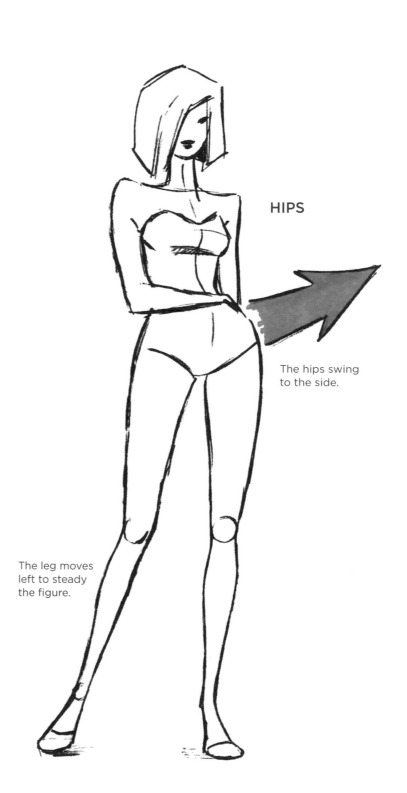

The hips swing
to the side.

The leg moves
left to steady
the figure.

NEUTRAL POSES

Some poses focus on the arms and legs, in which case the shoulders and hips don't make any dramatic shifts.

Shopping Pose

This is the classic "shopping" pose: symmetrical, both hands down, carrying bags while walking in a front view, toward the viewer.

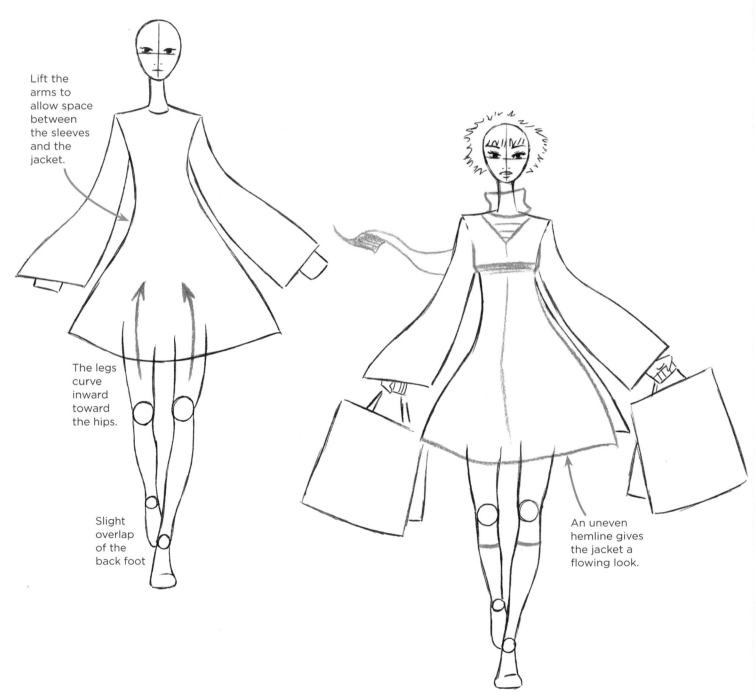

Lift the arms to allow space between the sleeves and the jacket.

The legs curve inward toward the hips.

Slight overlap of the back foot

An uneven hemline gives the jacket a flowing look.

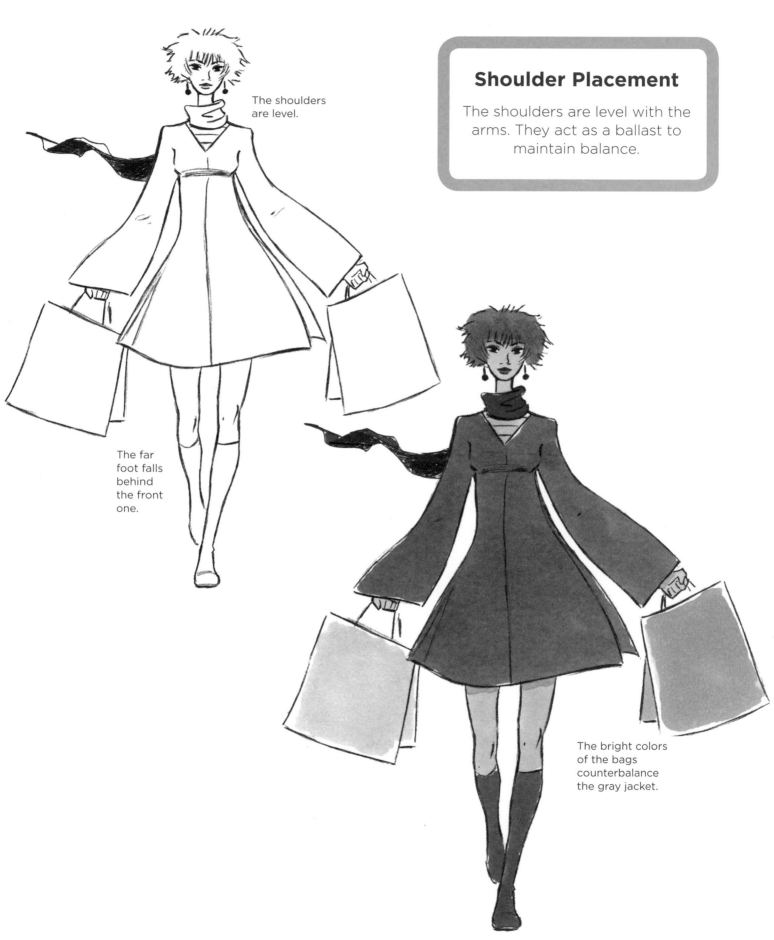

The shoulders are level.

The far foot falls behind the front one.

Shoulder Placement

The shoulders are level with the arms. They act as a ballast to maintain balance.

The bright colors of the bags counterbalance the gray jacket.

Shopping Pose Variation

The pose is still symmetrical and forward facing, but the change in arm position creates a new exuberance. She's almost triumphant.

The point isn't to instantly judge which pose is better. The point is to give yourself choices. Sketch out a few variations before deciding on a pose.

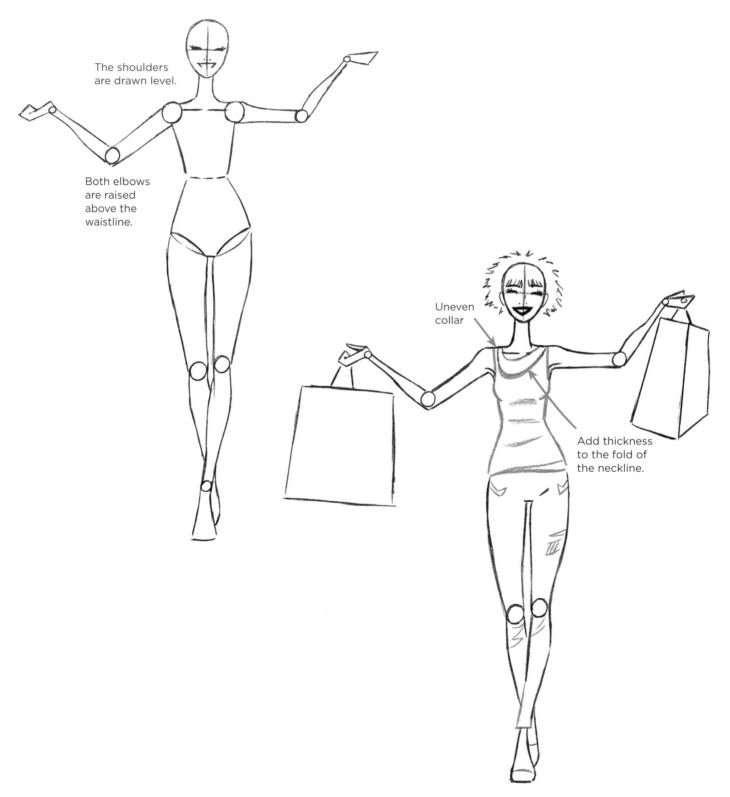

The shoulders are drawn level.

Both elbows are raised above the waistline.

Uneven collar

Add thickness to the fold of the neckline.

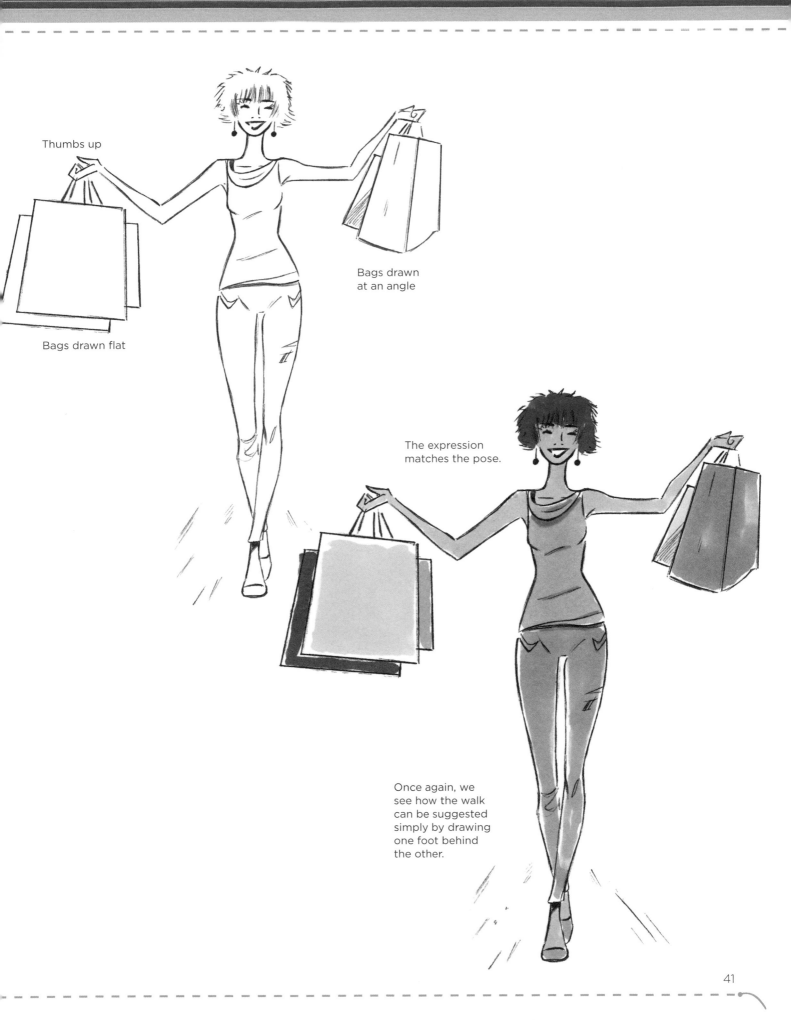

Thumbs up

Bags drawn flat

Bags drawn at an angle

The expression matches the pose.

Once again, we see how the walk can be suggested simply by drawing one foot behind the other.

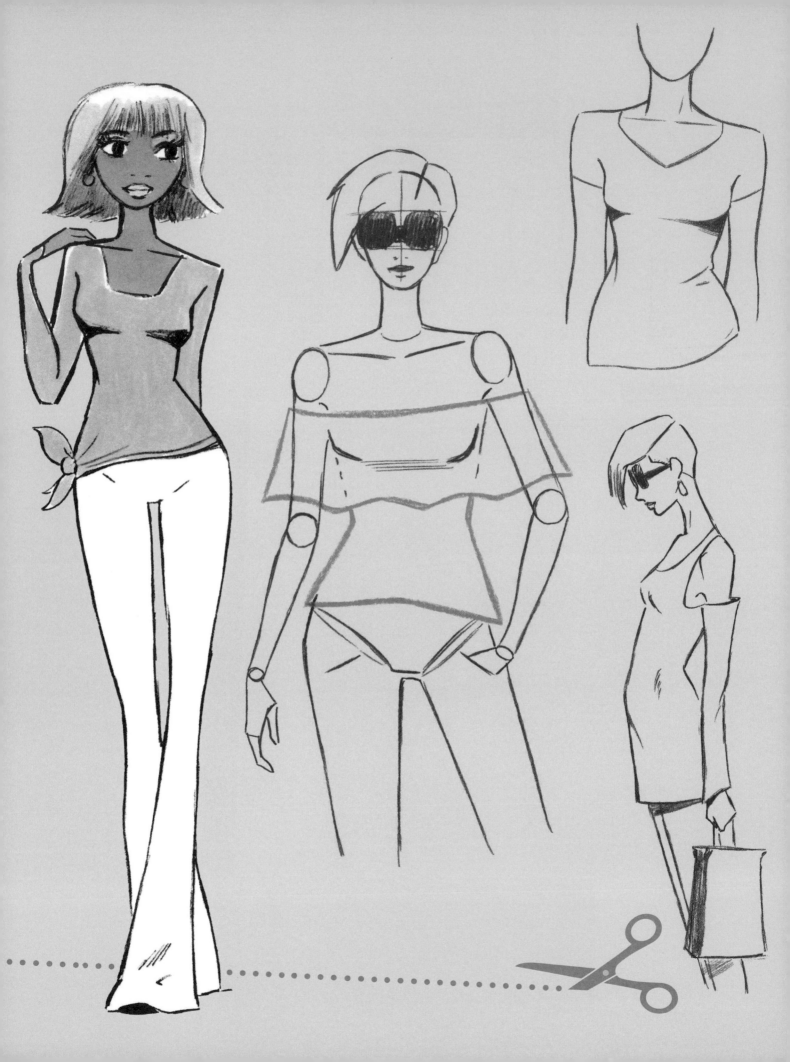

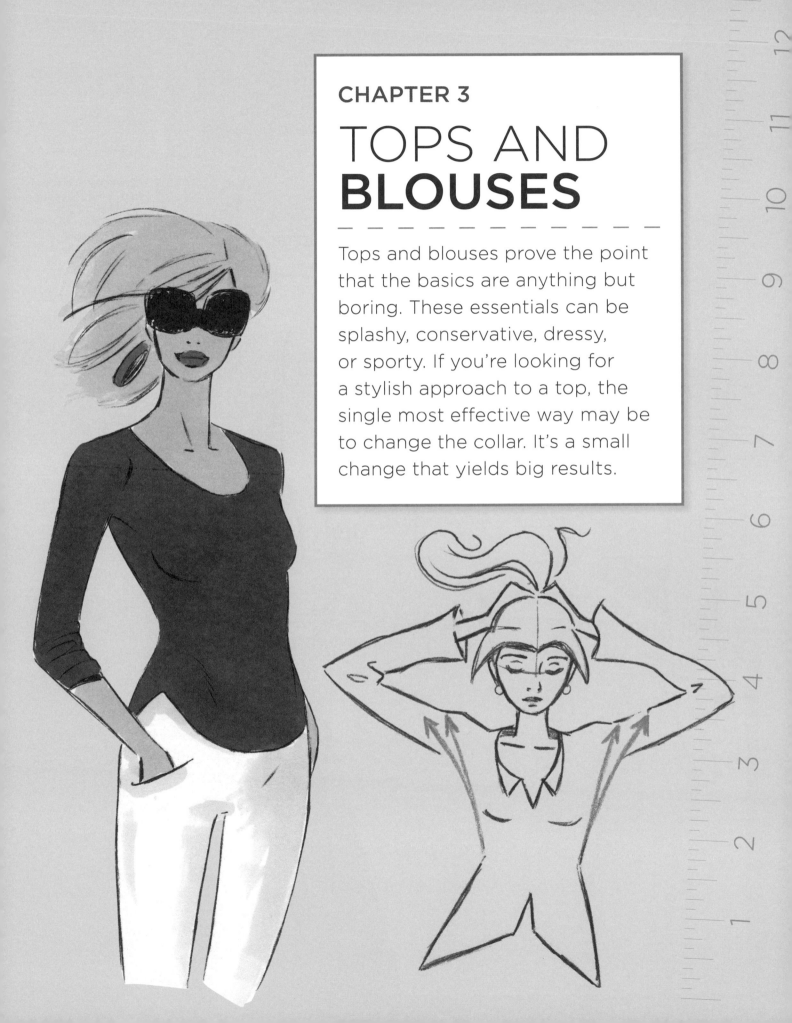

CHAPTER 3
TOPS AND BLOUSES

Tops and blouses prove the point that the basics are anything but boring. These essentials can be splashy, conservative, dressy, or sporty. If you're looking for a stylish approach to a top, the single most effective way may be to change the collar. It's a small change that yields big results.

NECKLINES

Let's begin by looking at several popular necklines that can be used again and again. You can recreate the basic drawing below to practice the different neckline variations.

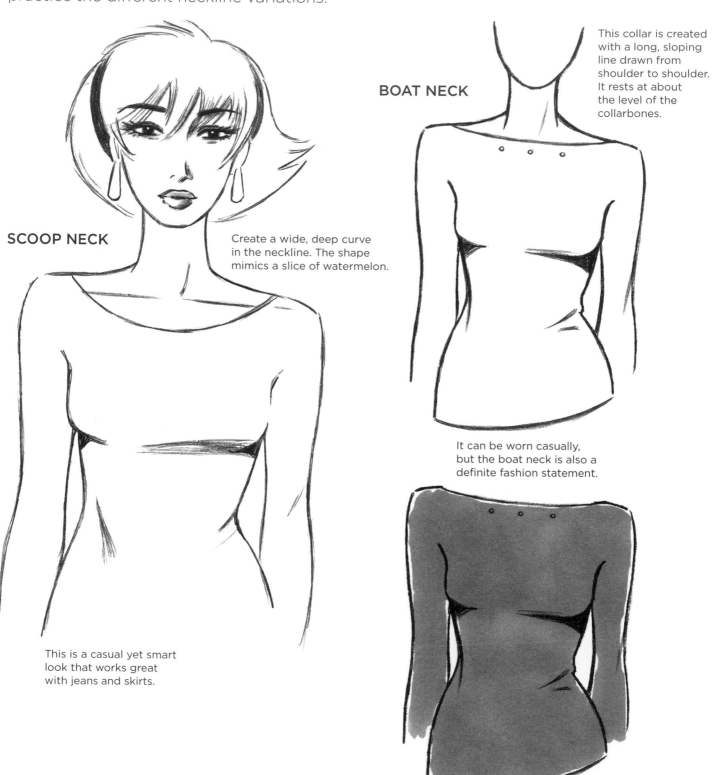

BOAT NECK

This collar is created with a long, sloping line drawn from shoulder to shoulder. It rests at about the level of the collarbones.

SCOOP NECK

Create a wide, deep curve in the neckline. The shape mimics a slice of watermelon.

It can be worn casually, but the boat neck is also a definite fashion statement.

This is a casual yet smart look that works great with jeans and skirts.

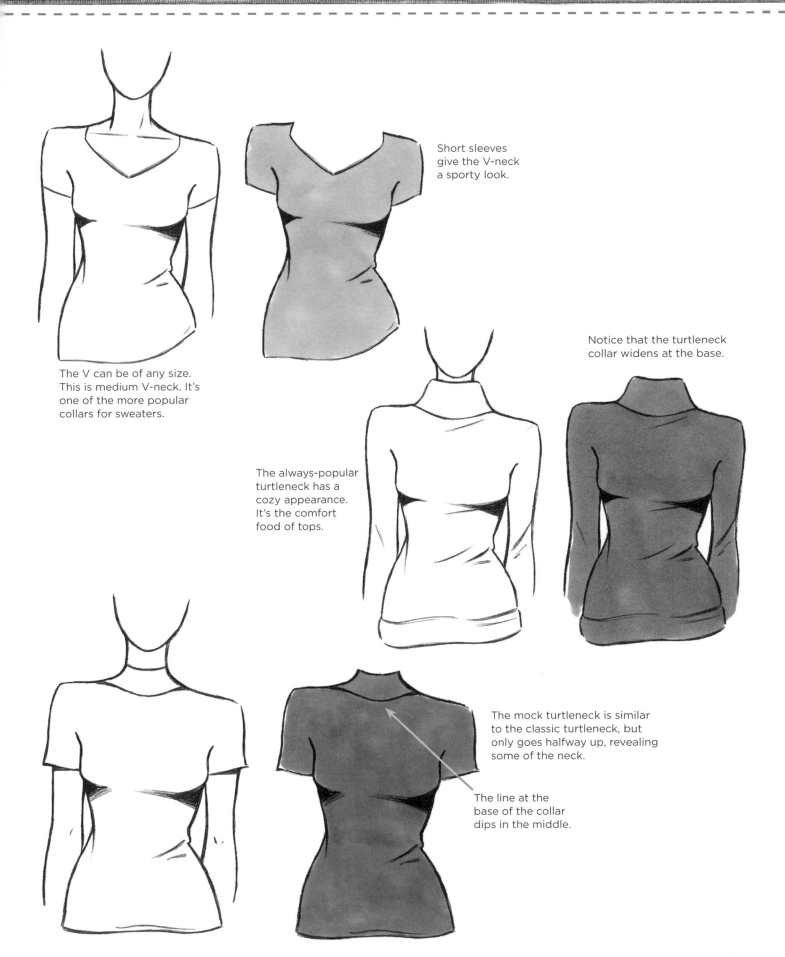

Short sleeves give the V-neck a sporty look.

The V can be of any size. This is medium V-neck. It's one of the more popular collars for sweaters.

Notice that the turtleneck collar widens at the base.

The always-popular turtleneck has a cozy appearance. It's the comfort food of tops.

The mock turtleneck is similar to the classic turtleneck, but only goes halfway up, revealing some of the neck.

The line at the base of the collar dips in the middle.

DRAWING TOPS STEP-BY-STEP

Let's use the first few steps to sketch the figure in a pose that will best show off the clothing. Once that's in place, we'll draw the top so that it fits naturally on the body. Then we'll add details such as creases, folds, belled sleeves, accessories and more.

Sleeveless

This is a versatile style that can be dressed down or up, for when you want to show off more than the average fashion sense.

The cut of the top angles in toward the neck.

The line shifts as it arches over the shoulder.

Higher on one side

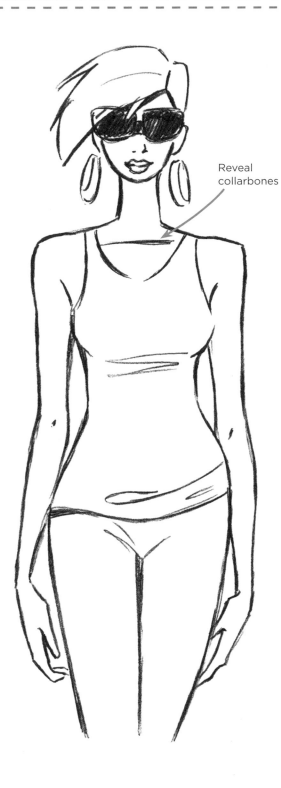

Reveal
collarbones

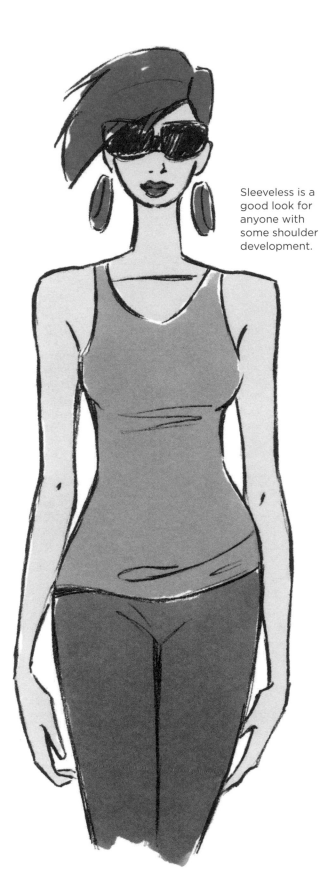

Sleeveless is a
good look for
anyone with
some shoulder
development.

Rolled-Up Sleeves

This look goes well with summer days. Think of her near the beach. This top both protects her from the wind while allowing her to feel the breeze. It has a casual, sporty appearance.

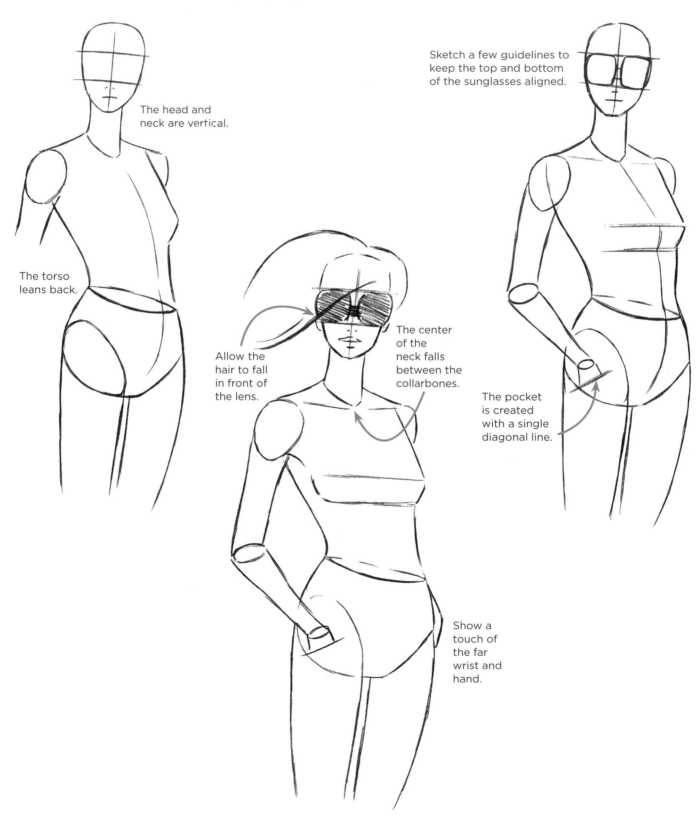

The head and neck are vertical.

The torso leans back.

Sketch a few guidelines to keep the top and bottom of the sunglasses aligned.

Allow the hair to fall in front of the lens.

The center of the neck falls between the collarbones.

The pocket is created with a single diagonal line.

Show a touch of the far wrist and hand.

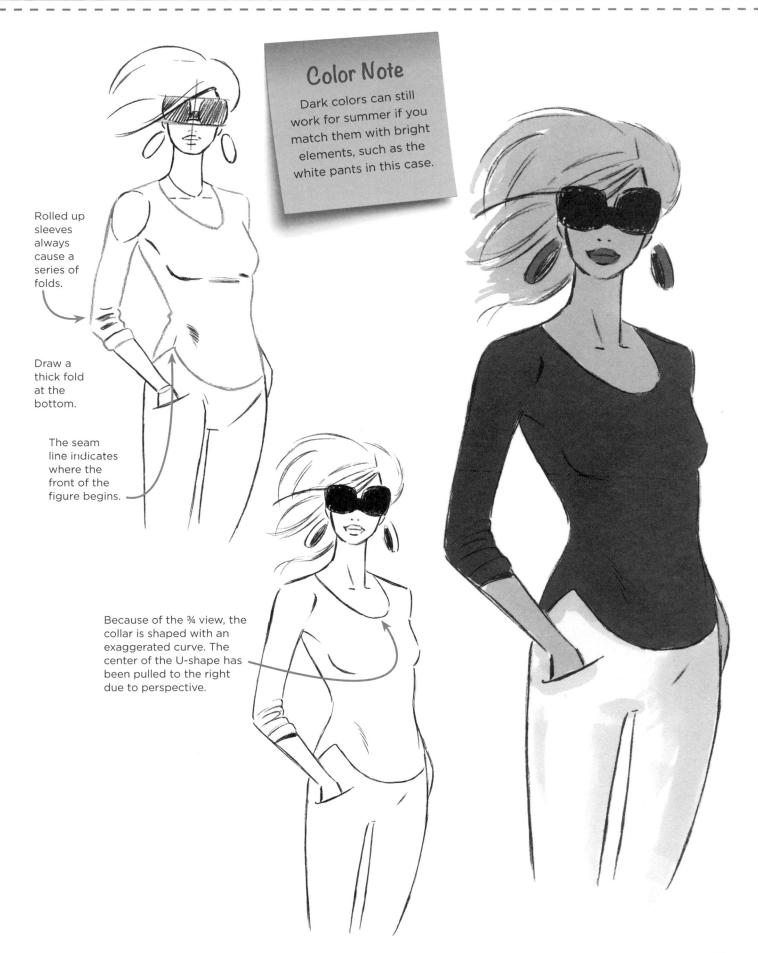

Color Note

Dark colors can still work for summer if you match them with bright elements, such as the white pants in this case.

Rolled up sleeves always cause a series of folds.

Draw a thick fold at the bottom.

The seam line indicates where the front of the figure begins.

Because of the ¾ view, the collar is shaped with an exaggerated curve. The center of the U-shape has been pulled to the right due to perspective.

Off the Shoulder

This top is both dramatic and carefree. The ruffle across the arms is fun and casual, but the bare shoulders are the standout feature. It's an interesting choice for fashion illustrations.

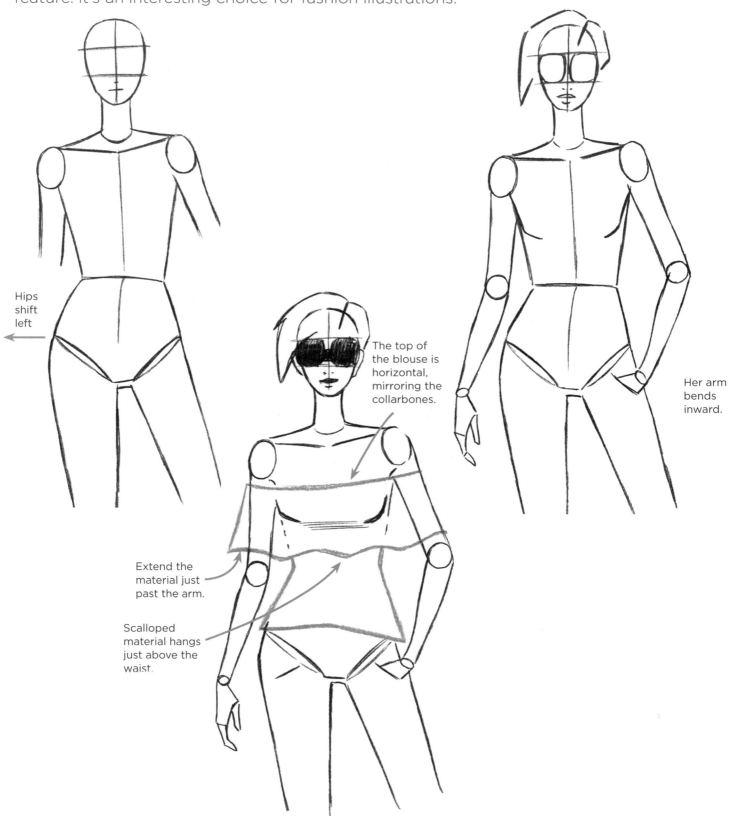

Hips shift left

The top of the blouse is horizontal, mirroring the collarbones.

Her arm bends inward.

Extend the material just past the arm.

Scalloped material hangs just above the waist.

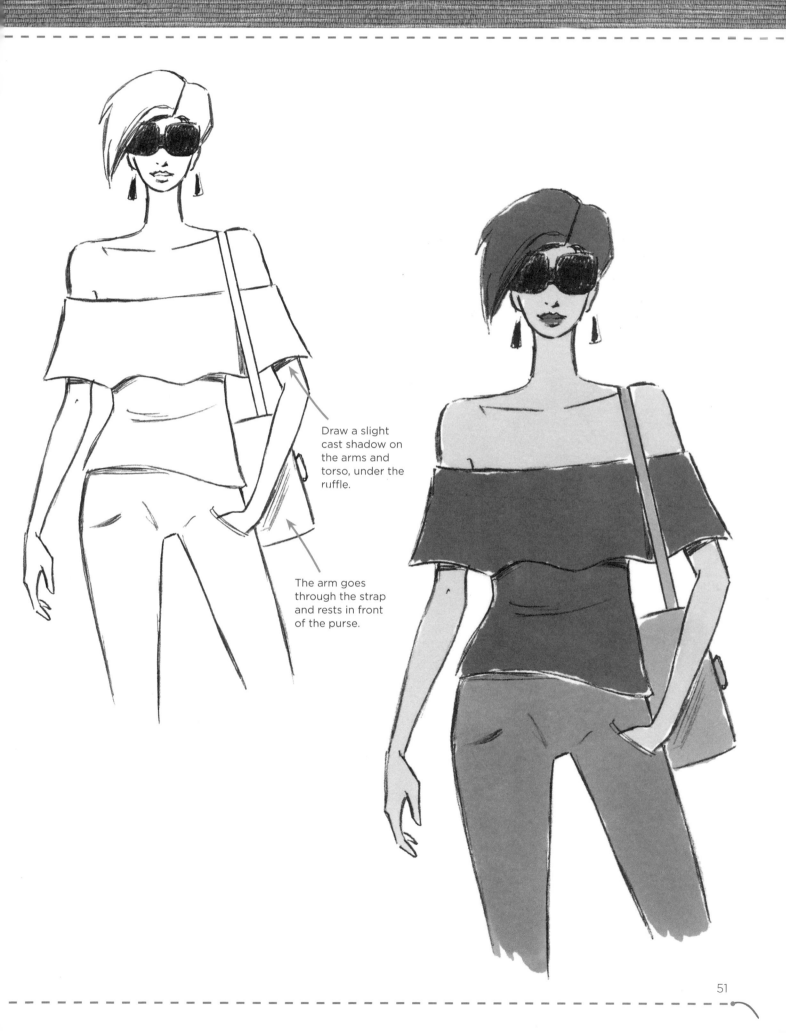

Draw a slight cast shadow on the arms and torso, under the ruffle.

The arm goes through the strap and rests in front of the purse.

Cold-Shoulder Tunic

This is a creative and trendy look. It pushes the boundaries between a blouse and a short dress. Boundary pushing is a good thing in fashion.

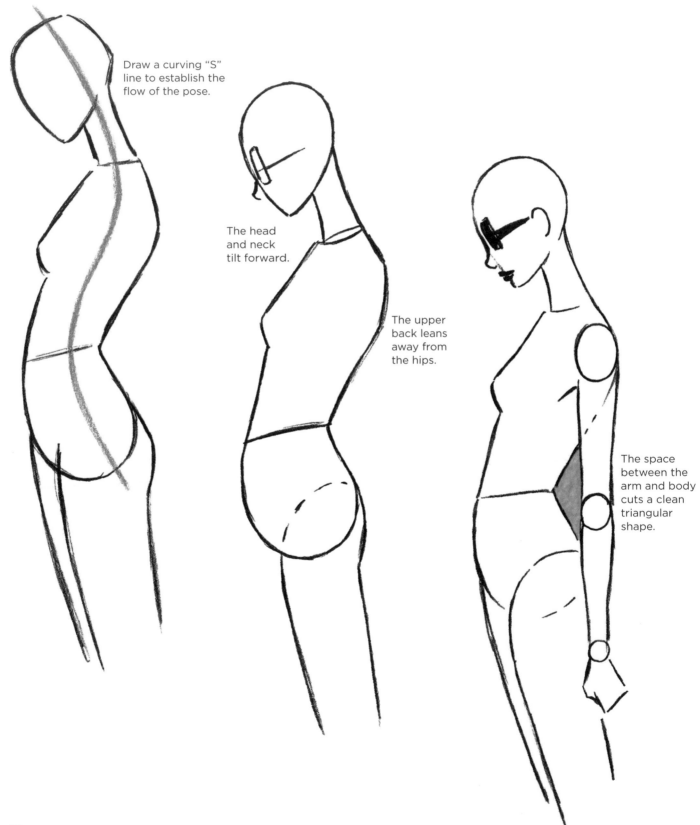

Draw a curving "S" line to establish the flow of the pose.

The head and neck tilt forward.

The upper back leans away from the hips.

The space between the arm and body cuts a clean triangular shape.

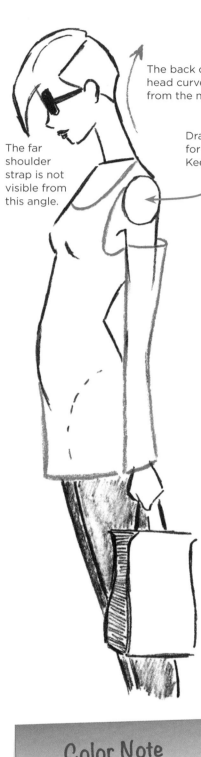

The back of the
head curves away
from the neck.

The far
shoulder
strap is not
visible from
this angle.

Draw an oval
for the opening.
Keep it loose.

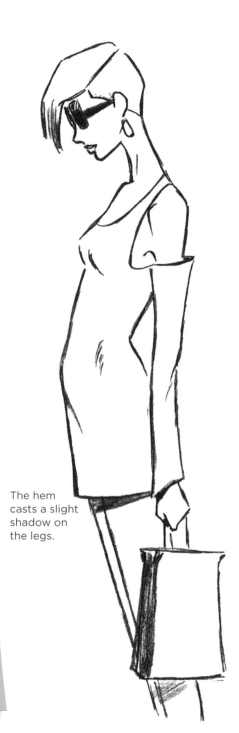

The hem
casts a slight
shadow on
the legs.

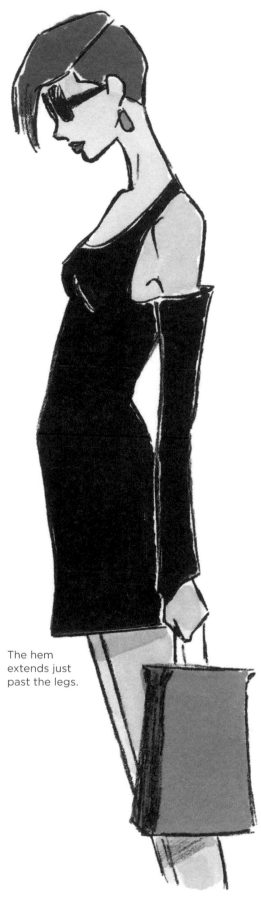

The hem
extends just
past the legs.

Color Note

When black is on black,
such as the sleeve against
the tunic, it can be hard
to see what's going on. To
make it clearer, use a thin,
white line to articulate the
interior shapes.

Button Down with Collar

It's an unwritten axiom (though I'm about to change that) that the more casual the outfit, the more confident you have to appear to pull it off. That doesn't mean drawing the model with swagger. Just draw her so she appears self assured during casual moments, such as when tying her hair.

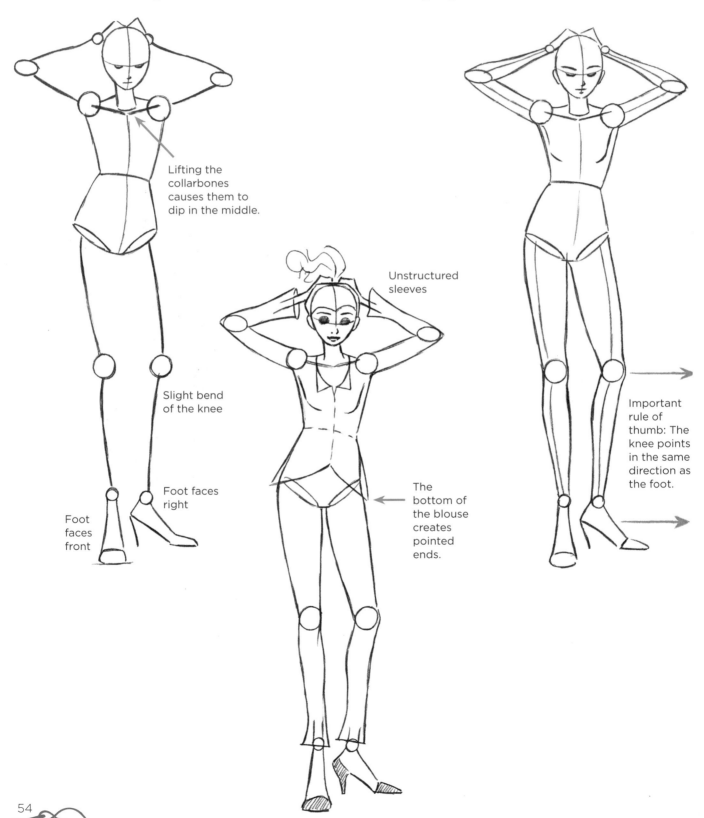

Lifting the collarbones causes them to dip in the middle.

Slight bend of the knee

Foot faces front

Foot faces right

Unstructured sleeves

The bottom of the blouse creates pointed ends.

Important rule of thumb: The knee points in the same direction as the foot.

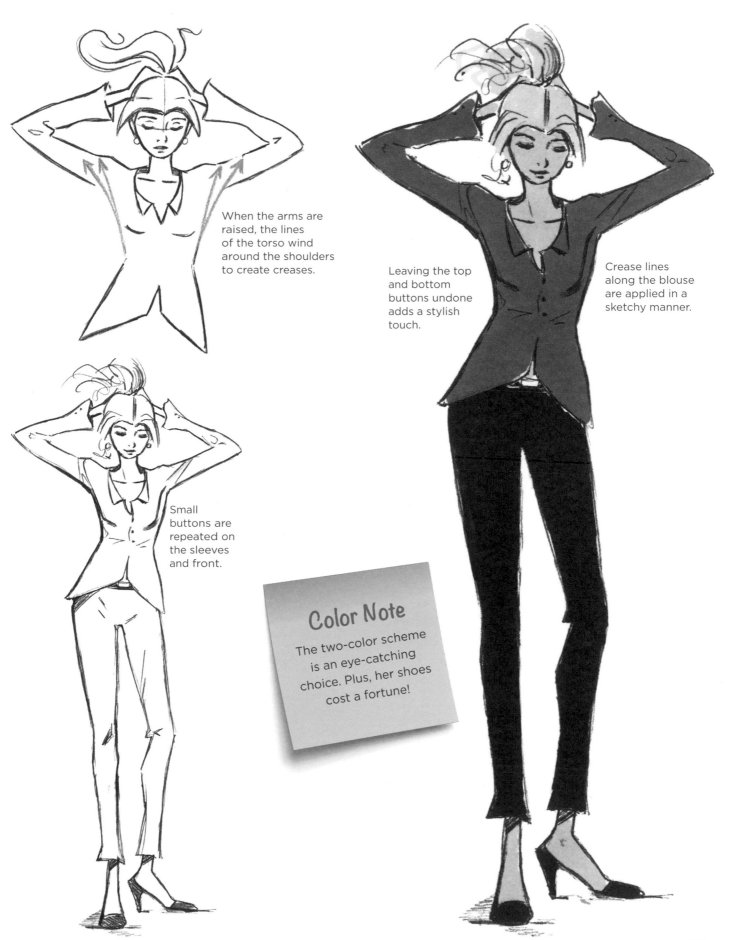

When the arms are raised, the lines of the torso wind around the shoulders to create creases.

Leaving the top and bottom buttons undone adds a stylish touch.

Crease lines along the blouse are applied in a sketchy manner.

Small buttons are repeated on the sleeves and front.

Color Note

The two-color scheme is an eye-catching choice. Plus, her shoes cost a fortune!

Tied Shirt

Here's a good example of how you can use a pose to emphasize an article of clothing. All you have to do is draw her so she is resting more of her weight on her right leg (page-right) than on her left. This unevenness is found in the clothing as well: The tie at the bottom of the top is as asymmetrical as the pose.

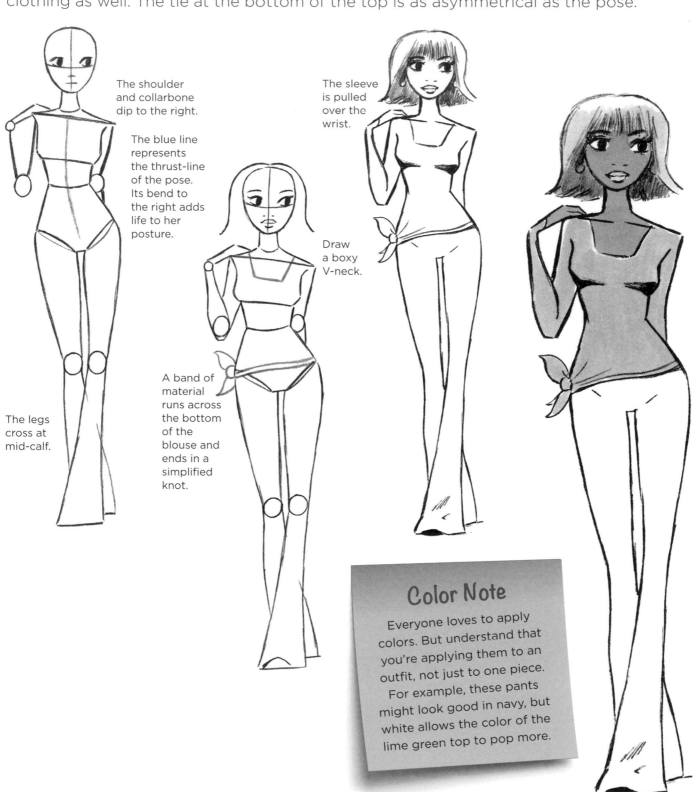

The shoulder and collarbone dip to the right.

The blue line represents the thrust-line of the pose. Its bend to the right adds life to her posture.

The legs cross at mid-calf.

A band of material runs across the bottom of the blouse and ends in a simplified knot.

Draw a boxy V-neck.

The sleeve is pulled over the wrist.

Color Note

Everyone loves to apply colors. But understand that you're applying them to an outfit, not just to one piece. For example, these pants might look good in navy, but white allows the color of the lime green top to pop more.

Scoop Neck with Bell Sleeves

Another way to create a look is by repeating a theme. For example, repeat the theme of the scooped neck and use it for the bell sleeves. Add thick, nautical stripes to create eye-catching contrast.

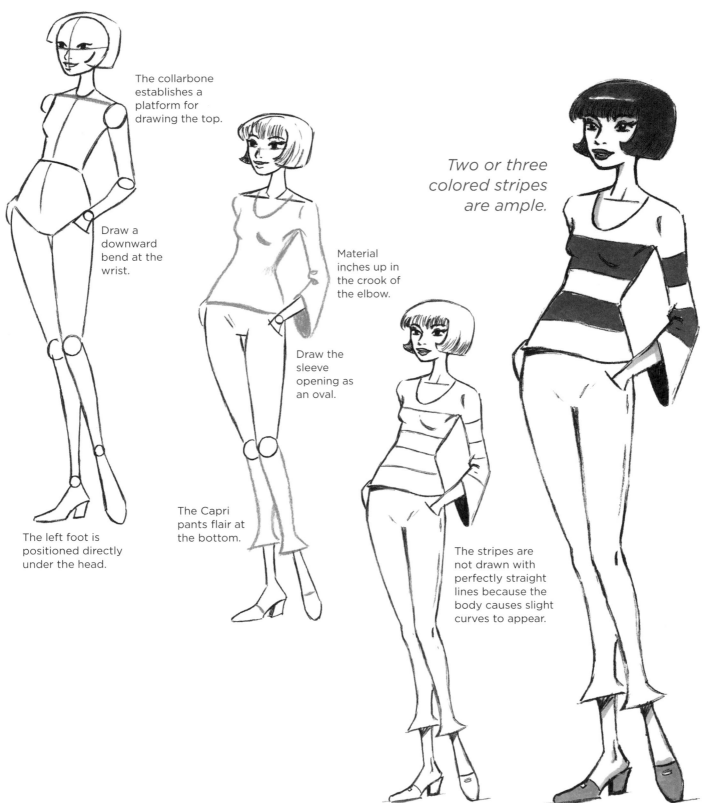

The collarbone establishes a platform for drawing the top.

Draw a downward bend at the wrist.

The left foot is positioned directly under the head.

Material inches up in the crook of the elbow.

Draw the sleeve opening as an oval.

The Capri pants flair at the bottom.

Two or three colored stripes are ample.

The stripes are not drawn with perfectly straight lines because the body causes slight curves to appear.

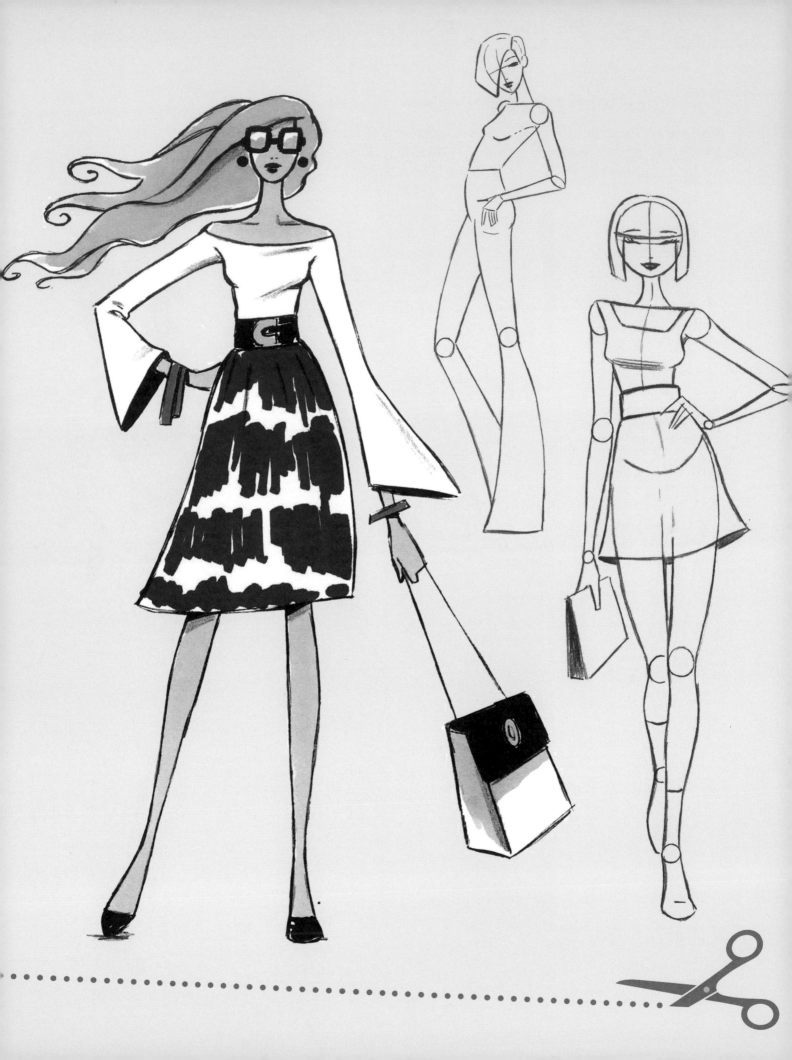

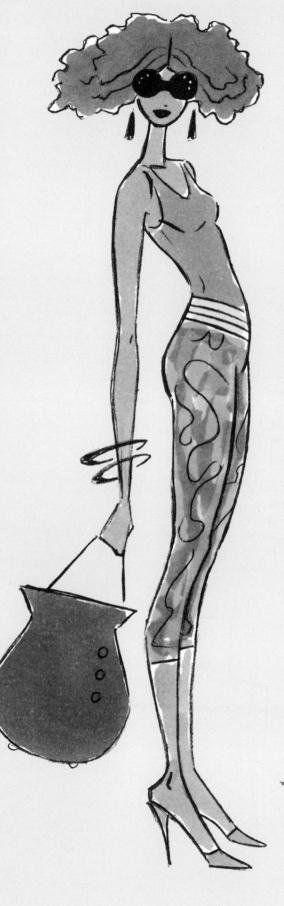

CHAPTER 4
DRAWING **SKIRTS** AND **PANTS**

A top needs to be paired with a bottom to create a complete look, so now we will learn how to draw some popular styles for skirts and pants. These can be designed to fit any personality, from smart and trendy to super-chic—and everything in between.

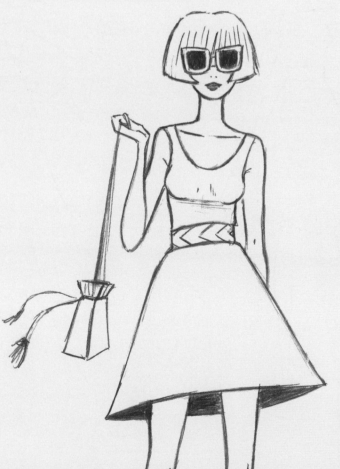

SKIRTS

Skirts bring a lot of versatility to a wardrobe. They can dress up a casual shirt or pull together a more polished outfit. Let's take a look at how to draw some go-to skirt styles.

Bell Skirt

The outline of the bell-shaped skirt serves as a good canvass for a splashy pattern.

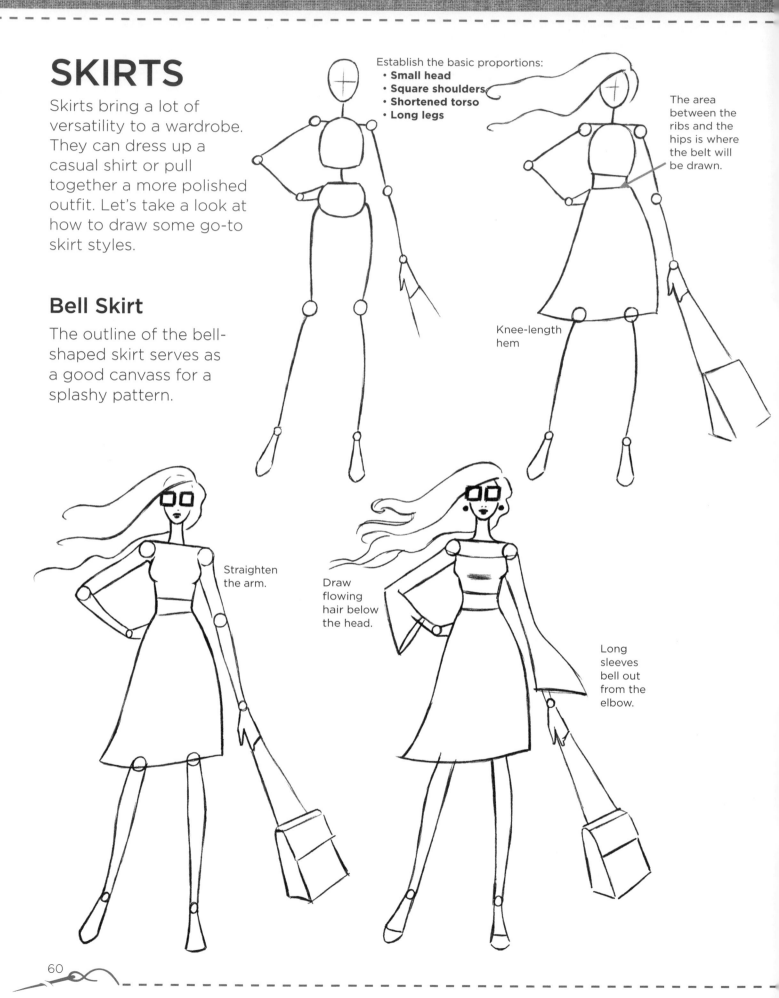

Establish the basic proportions:
- **Small head**
- **Square shoulders**
- **Shortened torso**
- **Long legs**

The area between the ribs and the hips is where the belt will be drawn.

Knee-length hem

Straighten the arm.

Draw flowing hair below the head.

Long sleeves bell out from the elbow.

Hints and Hems

Here are a few pointers to keep in mind:

- The top of the blouse is curved, not straight.
- The hips jut out from the beltline.
- Draw the sleeves as ovals.
- The hem is a wavy line.

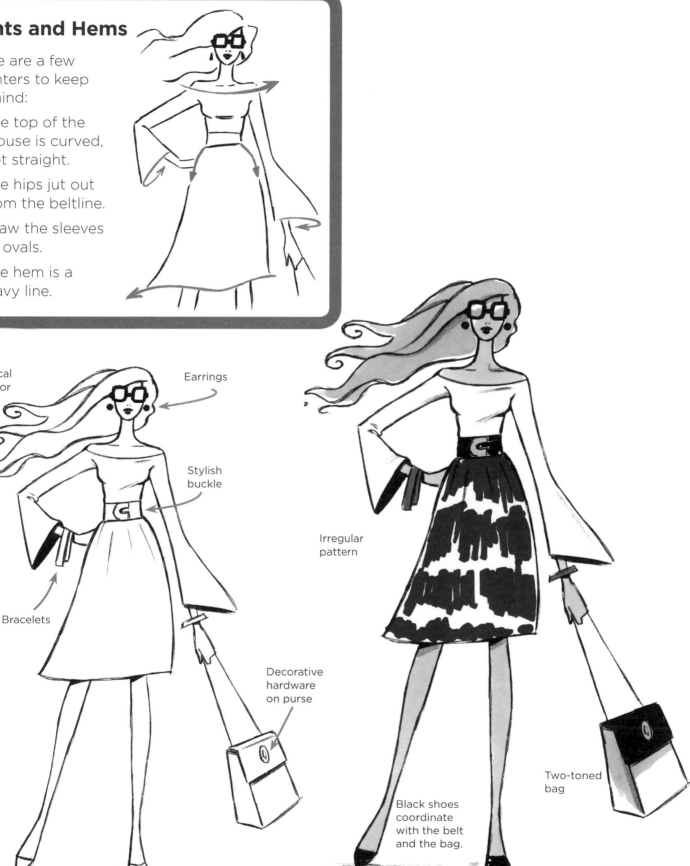

Whimsical styling for the hair

Earrings

Stylish buckle

Bracelets

Decorative hardware on purse

Irregular pattern

Black shoes coordinate with the belt and the bag.

Two-toned bag

Mini Skirt

Life has to have its fun, carefree moments, and this blouse and mini skirt combo is made for them. This hip look would work for a fun photo shoot in Williamsburg, Brooklyn, or any artsy section of town.

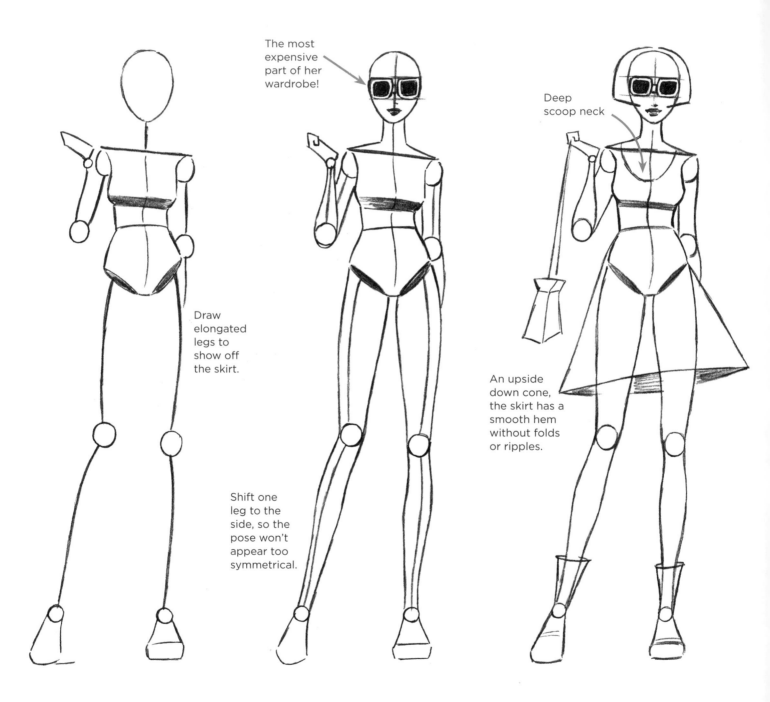

The most expensive part of her wardrobe!

Deep scoop neck

Draw elongated legs to show off the skirt.

Shift one leg to the side, so the pose won't appear too symmetrical.

An upside down cone, the skirt has a smooth hem without folds or ripples.

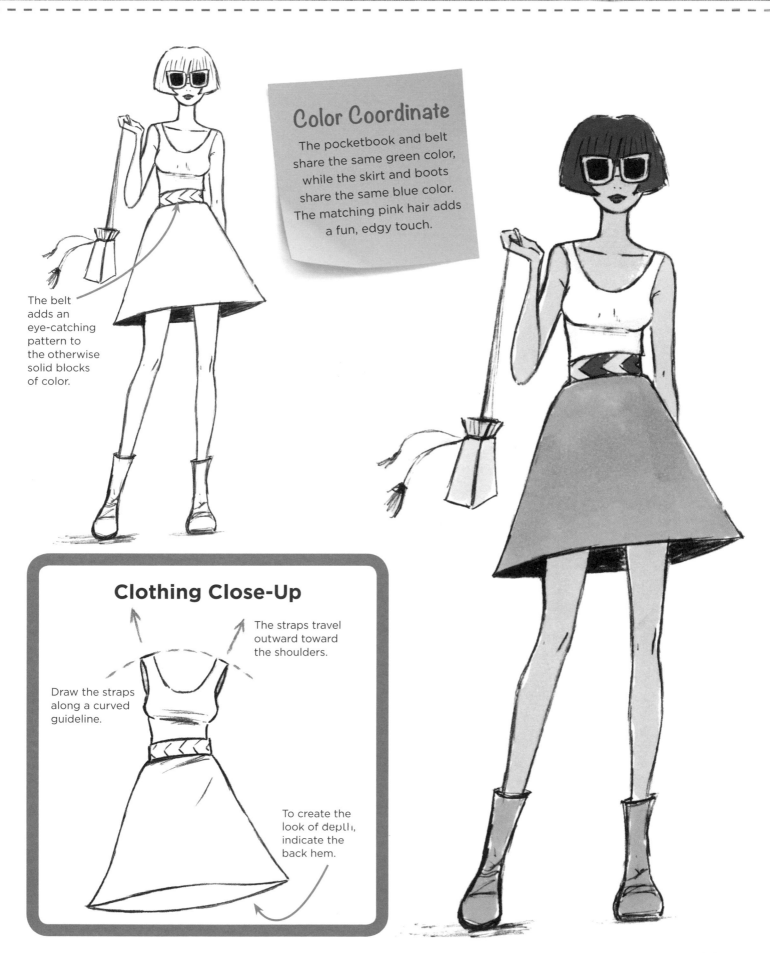

Color Coordinate

The pocketbook and belt share the same green color, while the skirt and boots share the same blue color. The matching pink hair adds a fun, edgy touch.

The belt adds an eye-catching pattern to the otherwise solid blocks of color.

Clothing Close-Up

The straps travel outward toward the shoulders.

Draw the straps along a curved guideline.

To create the look of depth, indicate the back hem.

Pencil Skirt

A pencil skirt is part of a suit worn in the corporate world. But does that mean it's simply too conservative or frumpy to be a stylish choice? Fight the frump by making the pencil skirt part of a smartly cut suit that's so tasteful it almost hurts.

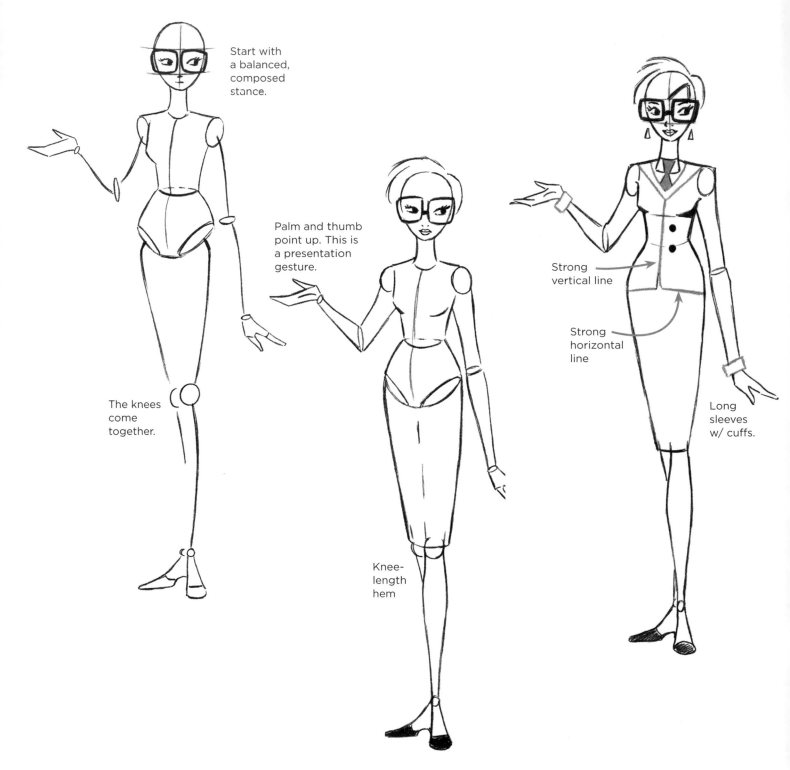

Start with a balanced, composed stance.

Palm and thumb point up. This is a presentation gesture.

The knees come together.

Knee-length hem

Strong vertical line

Strong horizontal line

Long sleeves w/ cuffs.

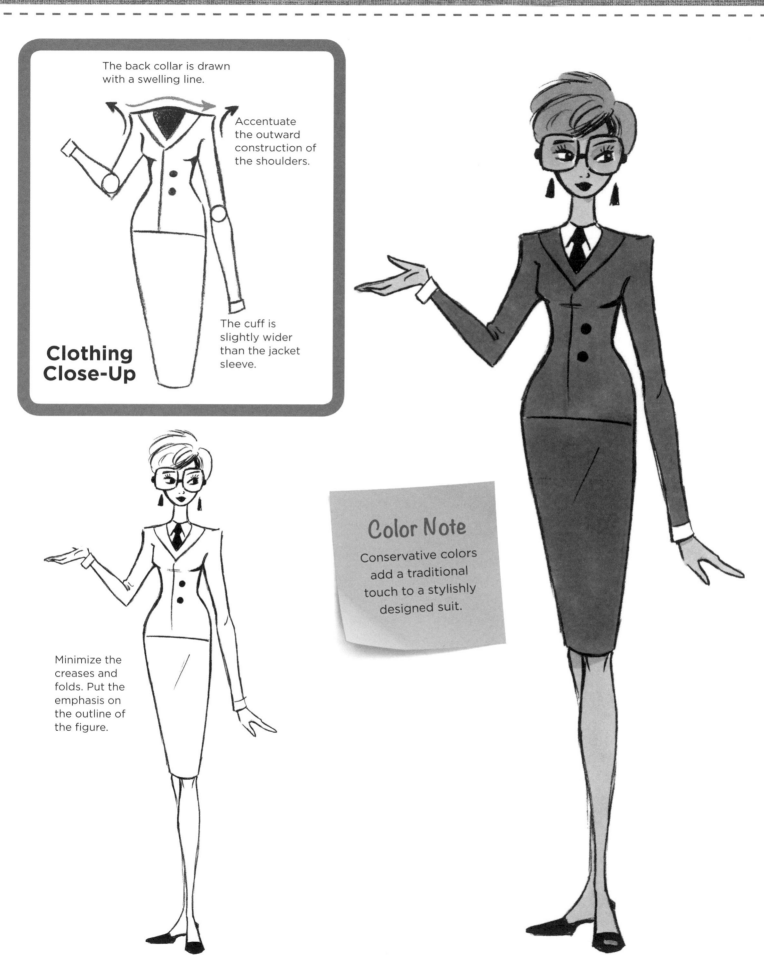

The back collar is drawn with a swelling line.

Accentuate the outward construction of the shoulders.

Clothing Close-Up

The cuff is slightly wider than the jacket sleeve.

Minimize the creases and folds. Put the emphasis on the outline of the figure.

Color Note

Conservative colors add a traditional touch to a stylishly designed suit.

ON THE **CATWALK**

The model on the catwalk wears a top and a skirt that looks completely strategic. It almost weaponizes glamour. The accessories are contributing a lot to the look: an oversized belt, stacked bracelets, hanging earrings, and mock go-go boots.

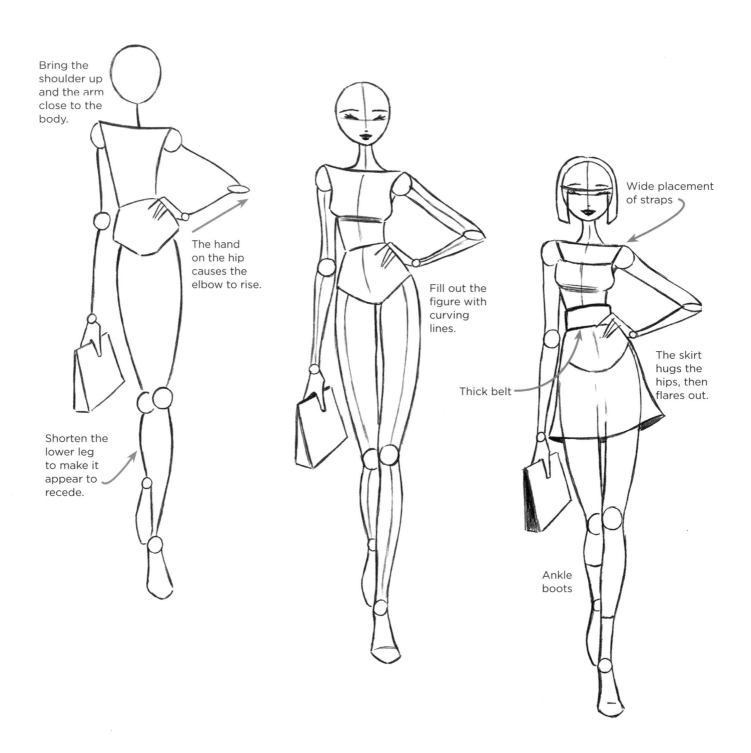

Bring the shoulder up and the arm close to the body.

The hand on the hip causes the elbow to rise.

Shorten the lower leg to make it appear to recede.

Fill out the figure with curving lines.

Wide placement of straps

Thick belt

The skirt hugs the hips, then flares out.

Ankle boots

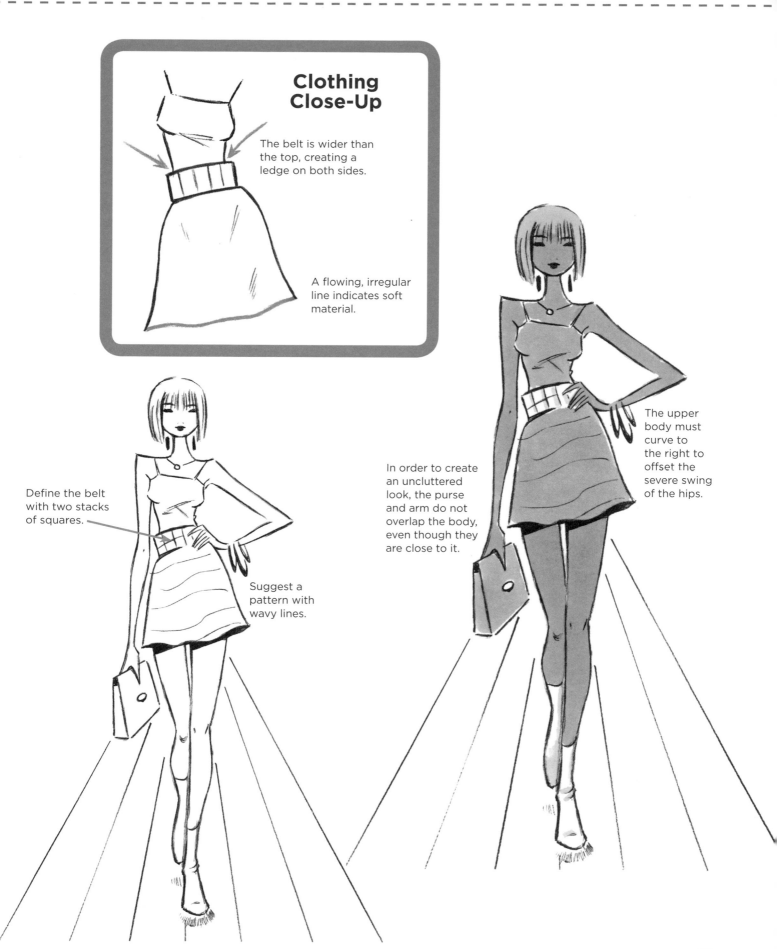

Clothing Close-Up

The belt is wider than the top, creating a ledge on both sides.

A flowing, irregular line indicates soft material.

Define the belt with two stacks of squares.

Suggest a pattern with wavy lines.

In order to create an uncluttered look, the purse and arm do not overlap the body, even though they are close to it.

The upper body must curve to the right to offset the severe swing of the hips.

PANTS AND JEANS

Although pants and jeans cover the legs, they reveal their shape more than skirts do, so we'll give special focus to drawing the figure at the initial stage of the step-by-step images below.

Capri Pants

Color and pattern gives these Capri pants a hippie-chic vibe. It's a splashy outfit that refuses to back down. The same goes for her attitude.

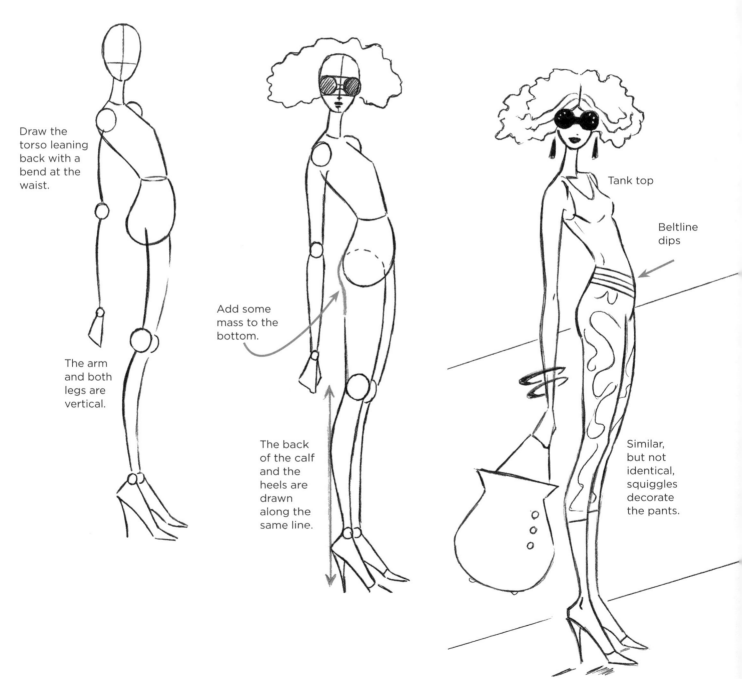

Draw the torso leaning back with a bend at the waist.

The arm and both legs are vertical.

Add some mass to the bottom.

The back of the calf and the heels are drawn along the same line.

Tank top

Beltline dips

Similar, but not identical, squiggles decorate the pants.

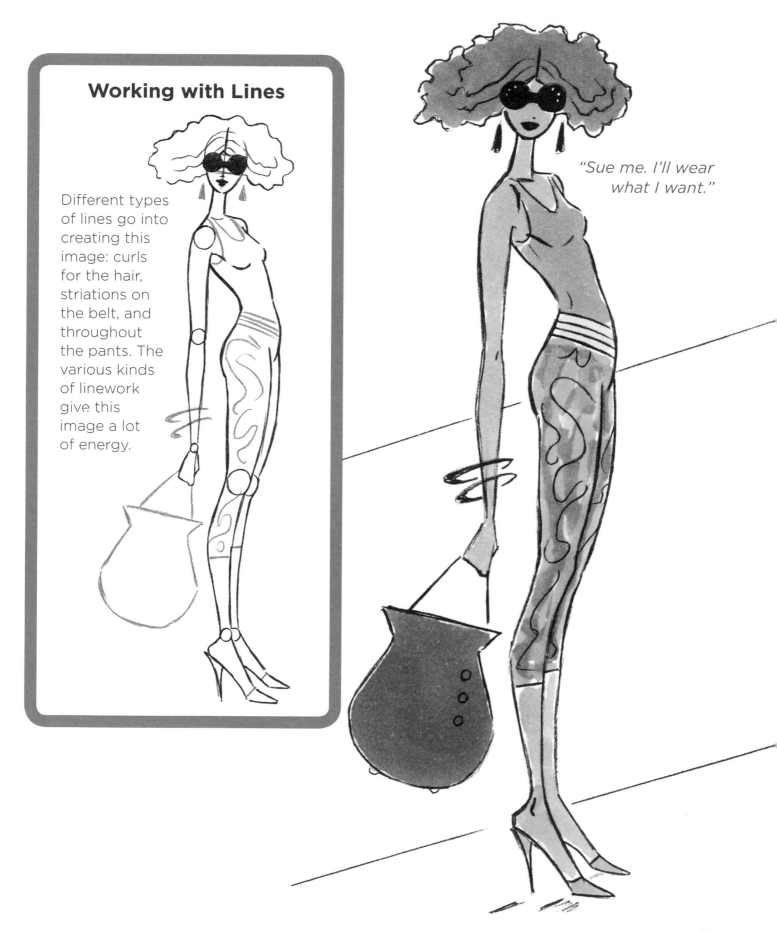

Working with Lines

Different types of lines go into creating this image: curls for the hair, striations on the belt, and throughout the pants. The various kinds of linework give this image a lot of energy.

"Sue me. I'll wear what I want."

Torn Bell-Bottom Jeans

Bell-bottoms hug the body down to the knees. The stylistic tearing and shredding can occur at any point down legs of the pants.

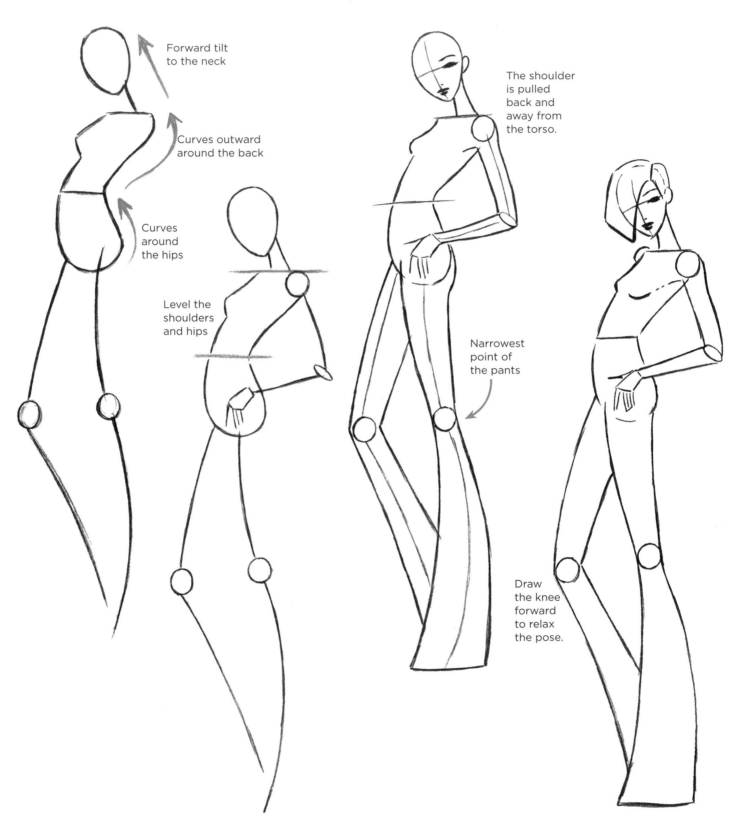

Forward tilt to the neck

Curves outward around the back

Curves around the hips

Level the shoulders and hips

The shoulder is pulled back and away from the torso.

Narrowest point of the pants

Draw the knee forward to relax the pose.

Constructing the Hip

The hip area is built with three curved lines:

Tummy

Bottom

Upper thigh

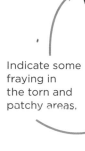

Side-View Tip

On side poses, it can be helpful to lightly indicate the seam line in the pants. This helps define the pant leg.

Indicate some fraying in the torn and patchy areas.

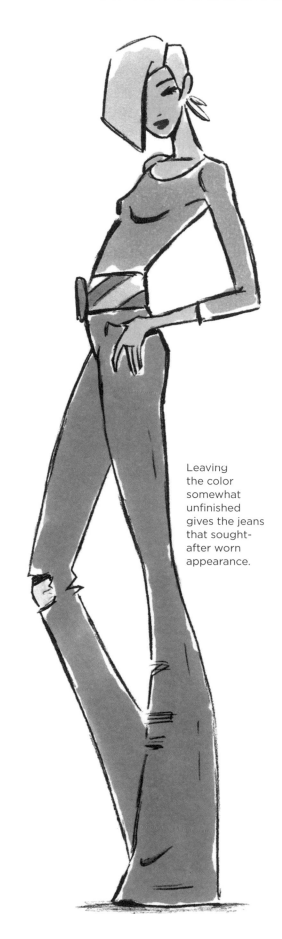

Leaving the color somewhat unfinished gives the jeans that sought-after worn appearance.

Sporty and Chic

As a fashion illustrator, you'll never know what you may be asked to draw. Let's say that you've just gotten an assignment to create a campaign for a chic sportswear company targeted at the serious weekend athlete. You might design a quasi-baseball uniform that can double as an inventive outfit.

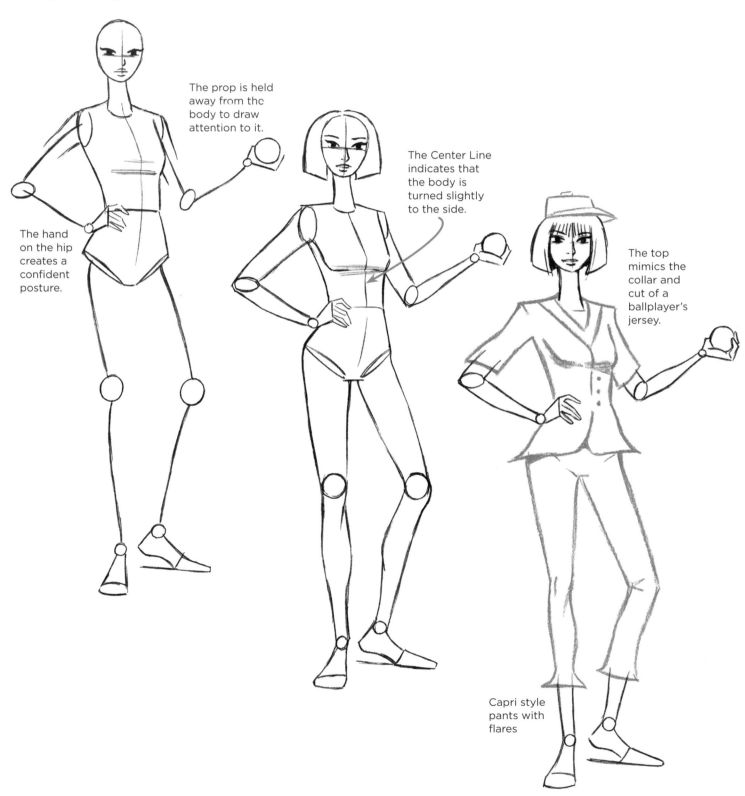

The prop is held away from the body to draw attention to it.

The Center Line indicates that the body is turned slightly to the side.

The hand on the hip creates a confident posture.

The top mimics the collar and cut of a ballplayer's jersey.

Capri style pants with flares

Just one bracelet and cap are sufficient for accessories. Too many accessories would be at odds with a sporty outfit.

Pose Detail

Both elbows produce similar, 45-degree angles.

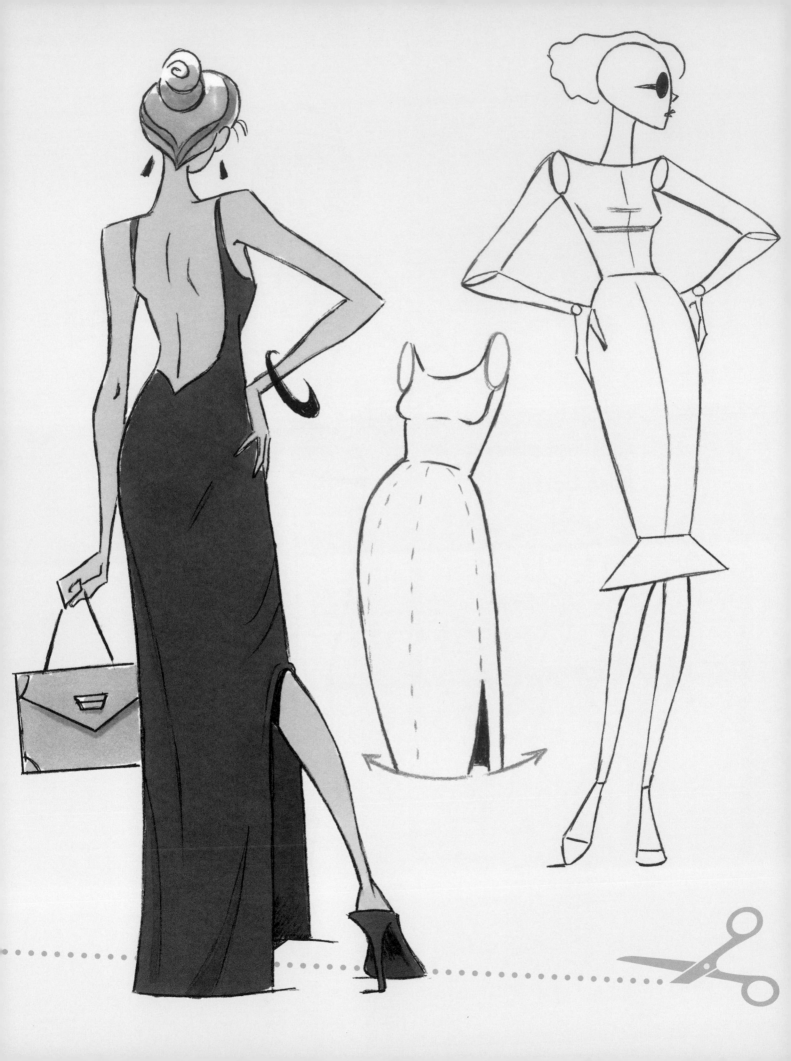

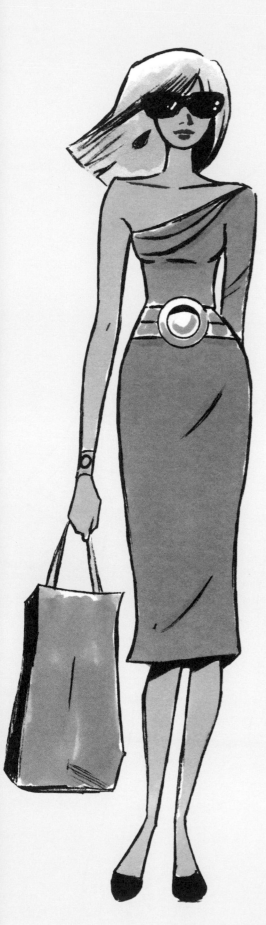

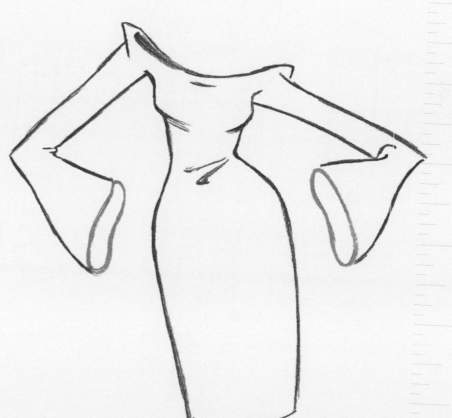

CHAPTER 5

DRESSING
IT UP!

A well-designed dress worn in a stylish pose can be striking. But a pose isn't drawn in isolation. It is meant to highlight the best qualities of an outfit. In this chapter, we'll go for a little more style with the outfits and combine them with some popular fashion poses.

SLEEVELESS WITH A SLIT

If you want to jazz up your drawing in a way that doesn't change the nature of the dress, but provides additional impact, drawing a mid-thigh slit up the side is an economical way to do it. It gives a traditional dress a bit of attitude.

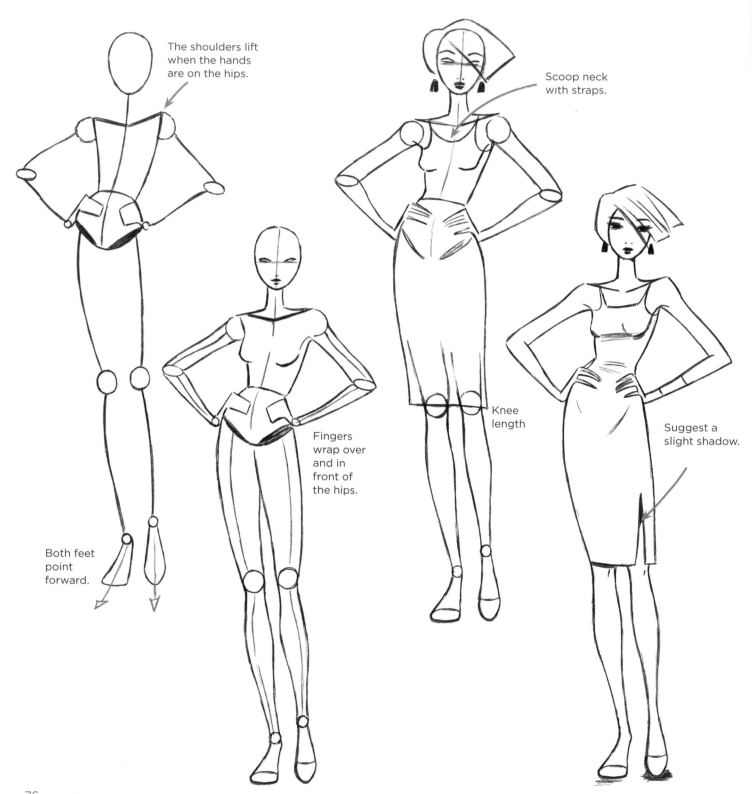

The shoulders lift when the hands are on the hips.

Scoop neck with straps.

Fingers wrap over and in front of the hips.

Knee length

Both feet point forward.

Suggest a slight shadow.

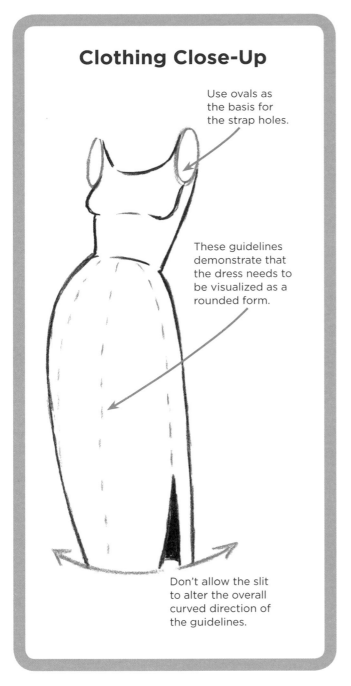

Clothing Close-Up

Use ovals as the basis for the strap holes.

These guidelines demonstrate that the dress needs to be visualized as a rounded form.

Don't allow the slit to alter the overall curved direction of the guidelines.

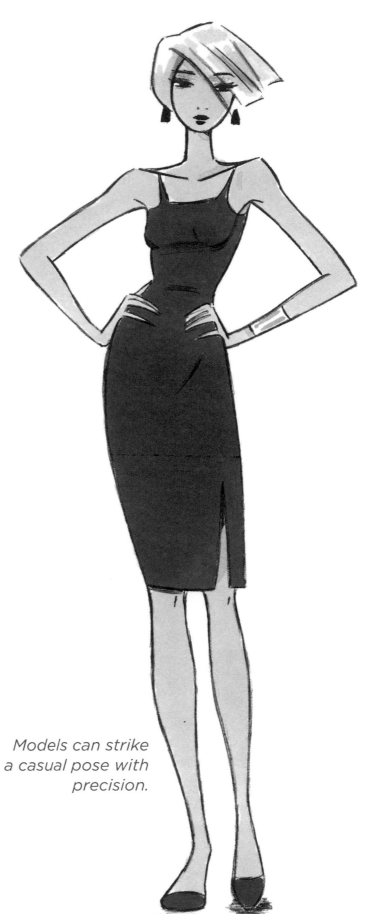

Models can strike a casual pose with precision.

SLEEVELESS DRESS WITH COWL NECK

Slinky dresses work well in the side view. Give a little forward action to the hips, and a little backward action to the shoulders and chest. This gives the dress a longer line, creating a better flow.

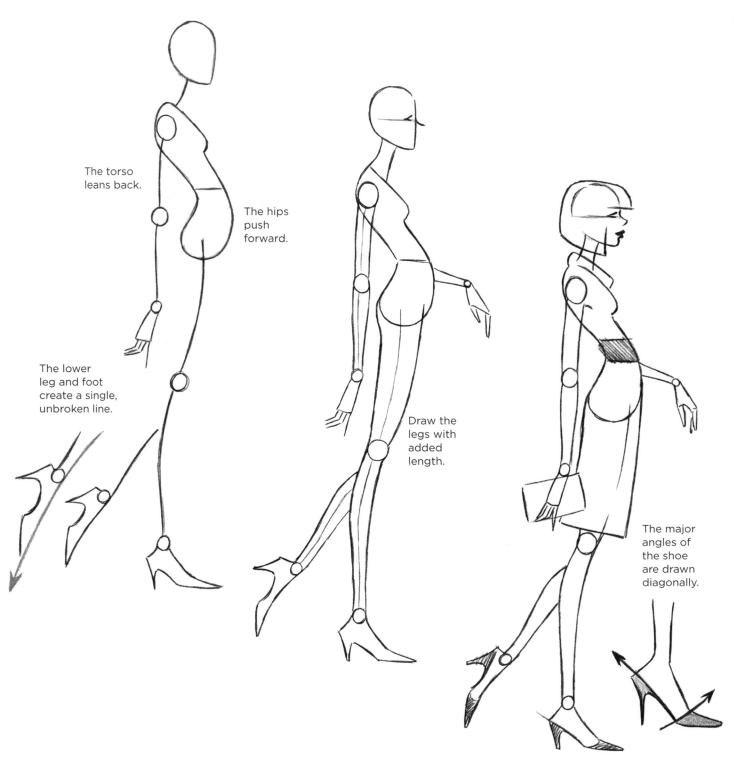

The torso leans back.

The hips push forward.

The lower leg and foot create a single, unbroken line.

Draw the legs with added length.

The major angles of the shoe are drawn diagonally.

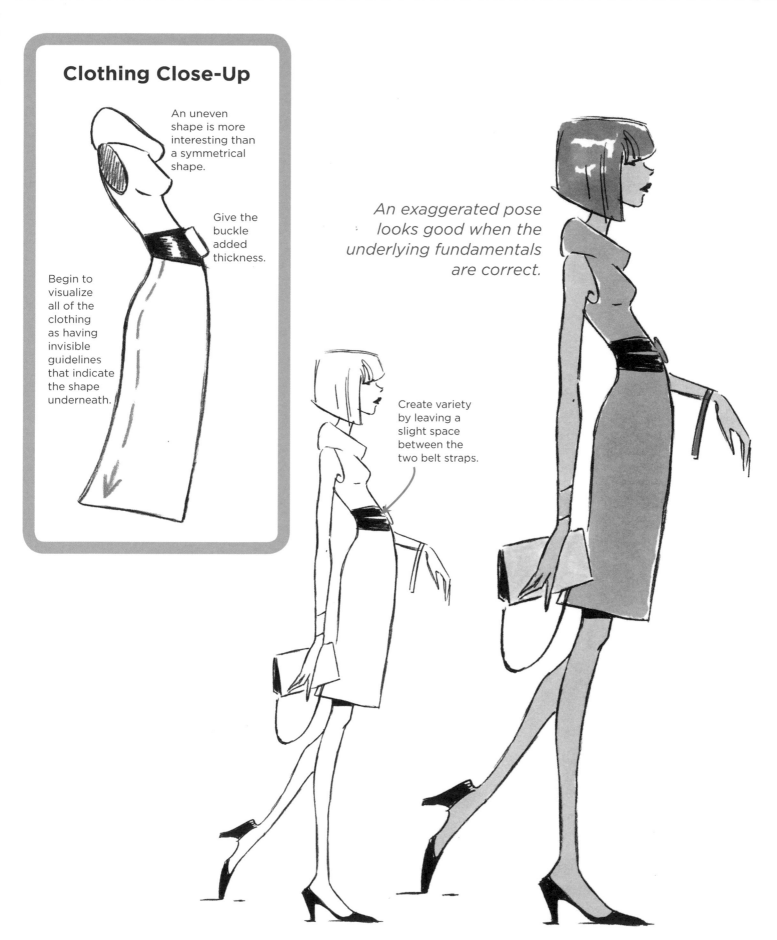

Clothing Close-Up

An uneven shape is more interesting than a symmetrical shape.

Give the buckle added thickness.

Begin to visualize all of the clothing as having invisible guidelines that indicate the shape underneath.

An exaggerated pose looks good when the underlying fundamentals are correct.

Create variety by leaving a slight space between the two belt straps.

PARTIAL-SLEEVE **PARTY DRESS**

Looking for a simple way to create a fashion statement? Try the sleeves. Or rather, try removing one of them. The partial sleeve is a cool look, and transports your dress from suburban shopping malls to the designer boutiques of any downtown city center.

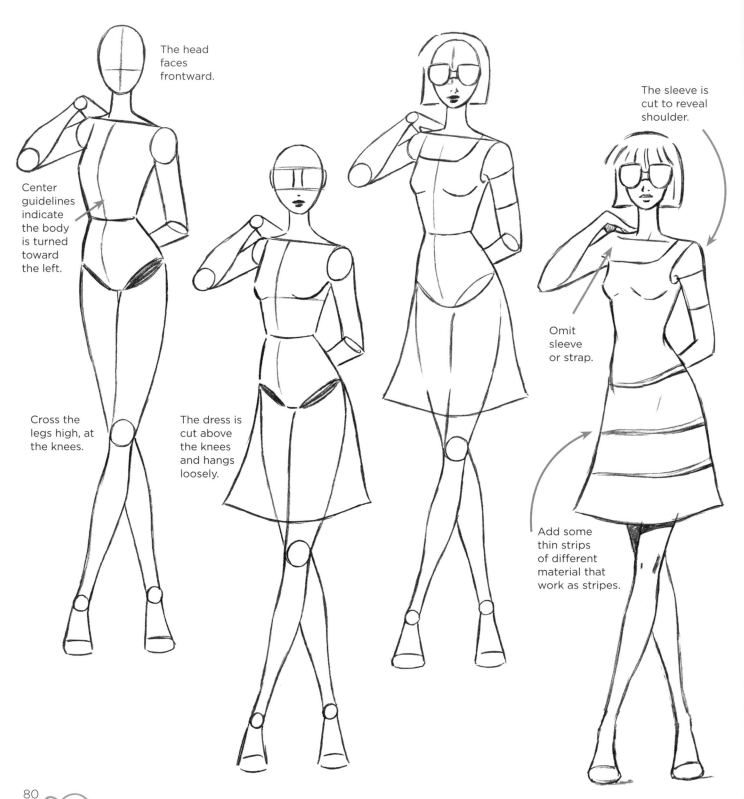

The head faces frontward.

Center guidelines indicate the body is turned toward the left.

Cross the legs high, at the knees.

The dress is cut above the knees and hangs loosely.

The sleeve is cut to reveal shoulder.

Omit sleeve or strap.

Add some thin strips of different material that work as stripes.

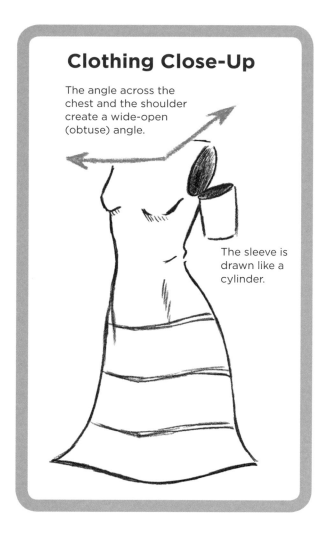

Clothing Close-Up

The angle across the chest and the shoulder create a wide-open (obtuse) angle.

The sleeve is drawn like a cylinder.

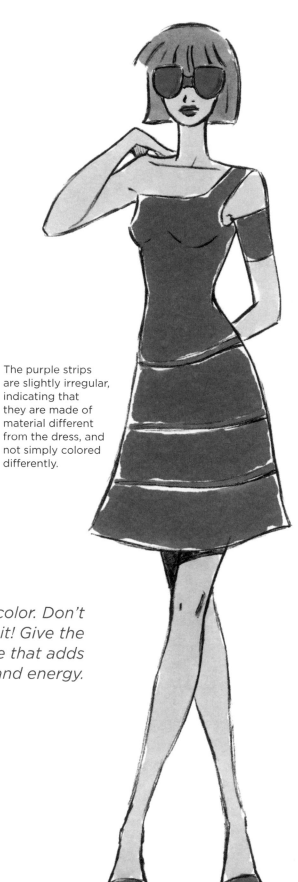

The purple strips are slightly irregular, indicating that they are made of material different from the dress, and not simply colored differently.

Red is a bold color. Don't apologize for it! Give the model a pose that adds its own style and energy.

TOGA STYLE

This is a fashionable, uptown look that is the epitome of chic. So how should we pose her? By doing less, not more. Let the stunning outfit do the work. A little restraint can be a tasteful choice for a pose. I've drawn her in a casual walk and with an implacable expression.

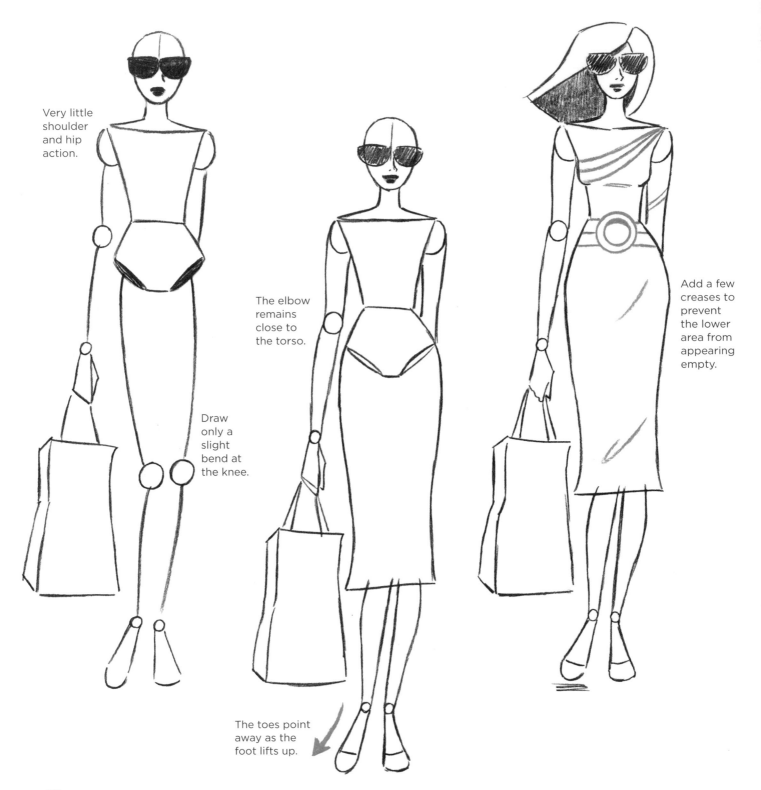

Very little shoulder and hip action.

The elbow remains close to the torso.

Draw only a slight bend at the knee.

Add a few creases to prevent the lower area from appearing empty.

The toes point away as the foot lifts up.

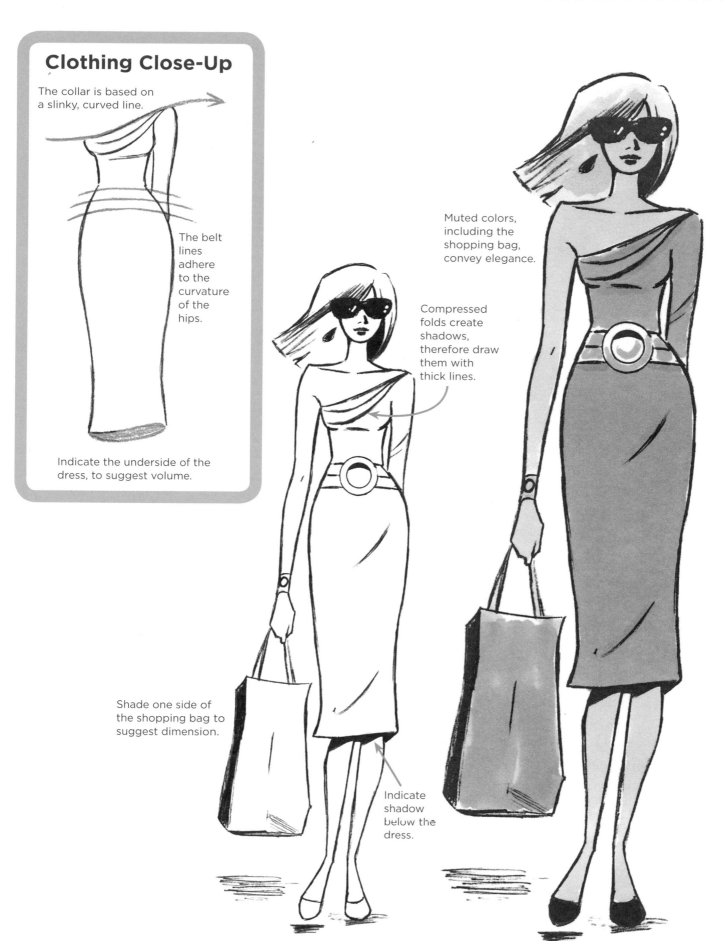

Clothing Close-Up

The collar is based on a slinky, curved line.

The belt lines adhere to the curvature of the hips.

Indicate the underside of the dress, to suggest volume.

Muted colors, including the shopping bag, convey elegance.

Compressed folds create shadows, therefore draw them with thick lines.

Shade one side of the shopping bag to suggest dimension.

Indicate shadow below the dress.

FIT AND FLARE DRESS

This figure-flattering dress can be worn with or without a belt. The lines of the dress are long and flared. The folds at the hem of the full skirt allow the dress to swing with the body's movement. This creates a fun and breezy look.

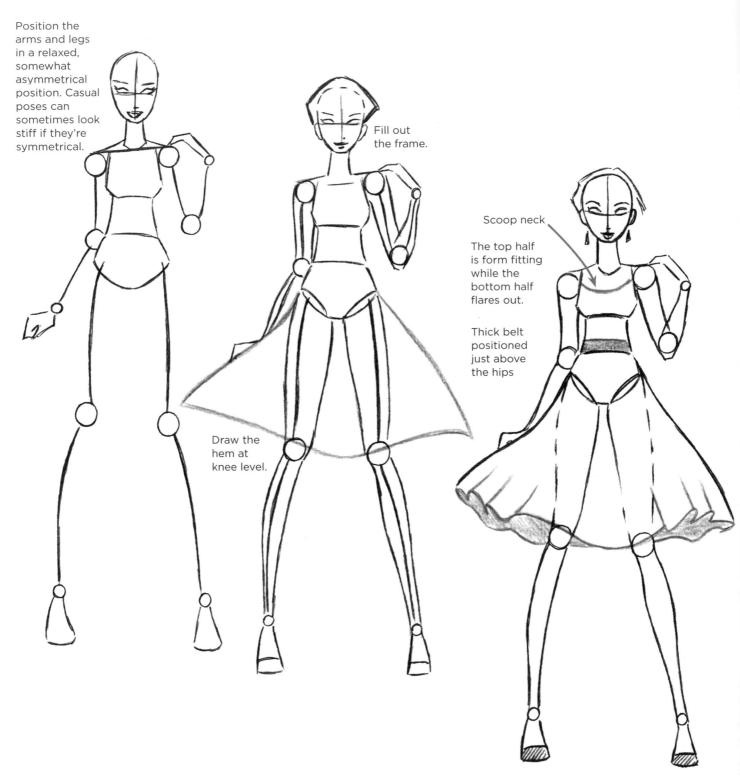

Position the arms and legs in a relaxed, somewhat asymmetrical position. Casual poses can sometimes look stiff if they're symmetrical.

Fill out the frame.

Draw the hem at knee level.

Scoop neck

The top half is form fitting while the bottom half flares out.

Thick belt positioned just above the hips

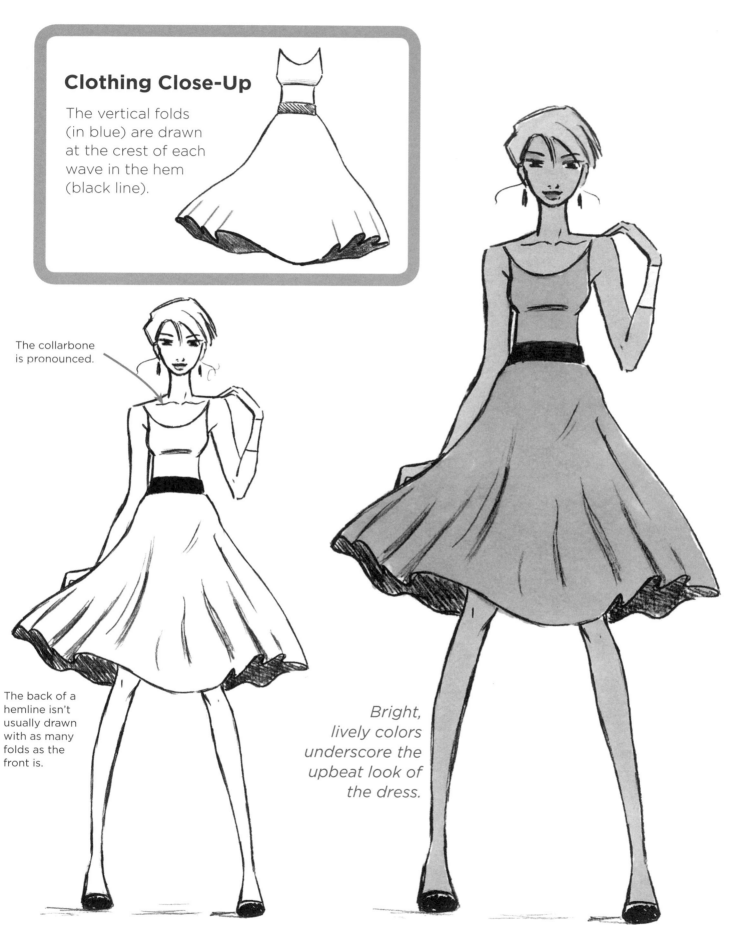

Clothing Close-Up

The vertical folds (in blue) are drawn at the crest of each wave in the hem (black line).

The collarbone is pronounced.

The back of a hemline isn't usually drawn with as many folds as the front is.

Bright, lively colors underscore the upbeat look of the dress.

DRAMATIC DRESS WITH **BELL SLEEVES**

The walk is drawn by exaggerating the counterpoise between the hips and shoulders. To do this, first draw the body in sections that can shift independently of each other as she walks. The length of the legs is super exaggerated. The slinky walk mirrors the slinky look of the dress.

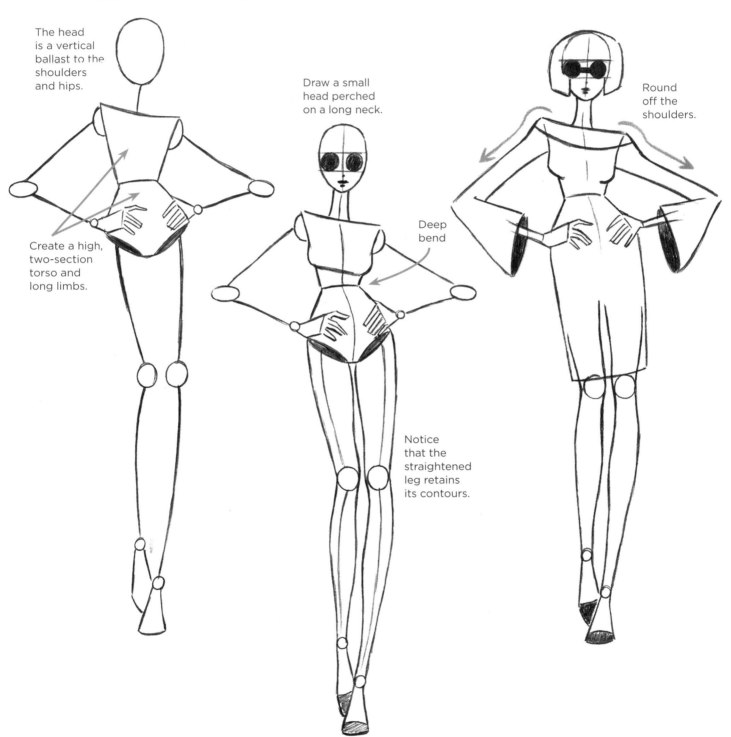

The head is a vertical ballast to the shoulders and hips.

Create a high, two-section torso and long limbs.

Draw a small head perched on a long neck.

Deep bend

Notice that the straightened leg retains its contours.

Round off the shoulders.

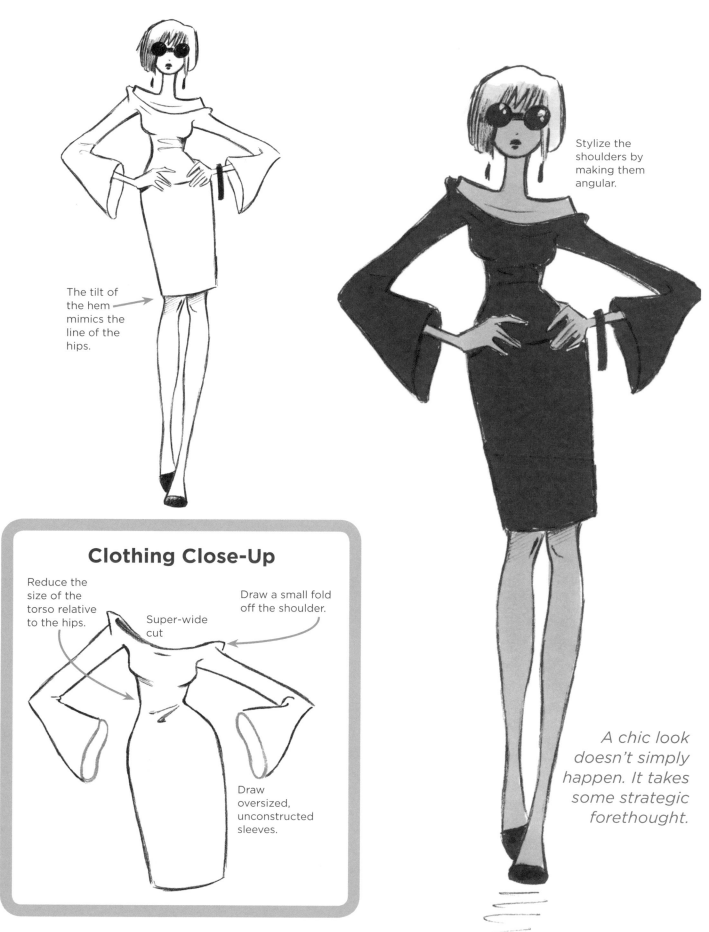

The tilt of the hem mimics the line of the hips.

Stylize the shoulders by making them angular.

Clothing Close-Up

Reduce the size of the torso relative to the hips.

Super-wide cut

Draw a small fold off the shoulder.

Draw oversized, unconstructed sleeves.

A chic look doesn't simply happen. It takes some strategic forethought.

LONG SLEEVES AND FIN BOTTOM

With a nod to art nouveau, this fin-hemline dress combines vintage and modern elements to create a spectacular look for present-day fashion. The model is the image of cool.

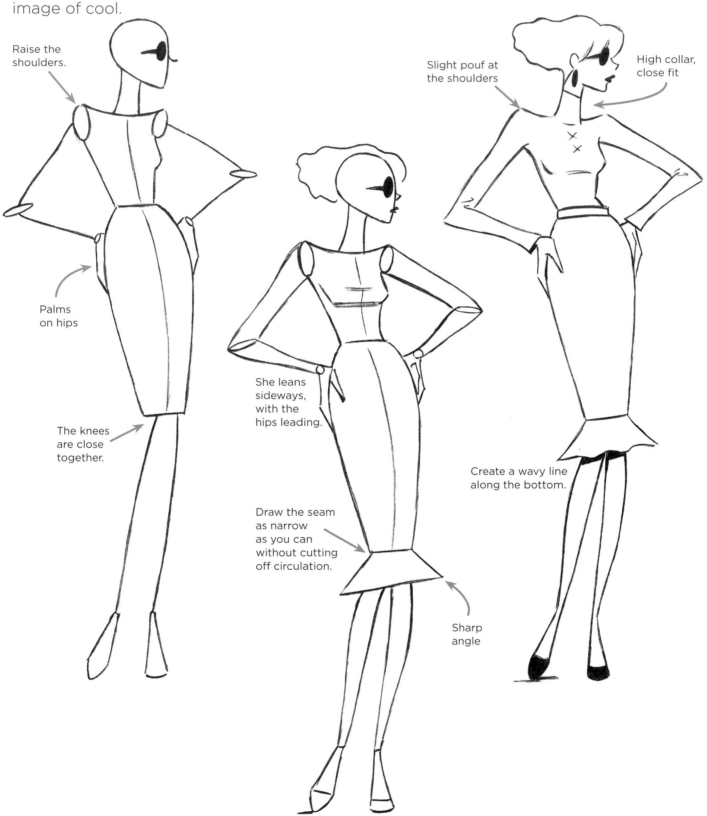

Raise the shoulders.

Palms on hips

The knees are close together.

Slight pouf at the shoulders

High collar, close fit

She leans sideways, with the hips leading.

Draw the seam as narrow as you can without cutting off circulation.

Create a wavy line along the bottom.

Sharp angle

Clothing Close-Up

You can extend the contour lines from the top all the way to the bottom of the garment. These guidelines, which you can erase later, are helpful for placing seams, creases and folds, patterns, buttons, or to simply to aid in visualizing the body as round and solid.

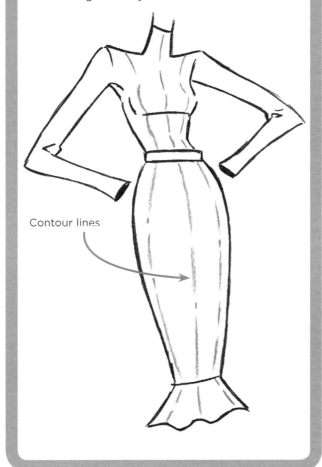

Contour lines

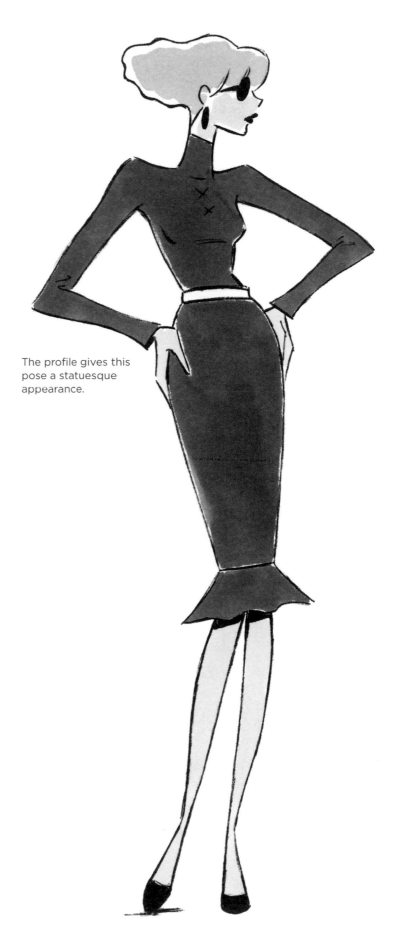

The profile gives this pose a statuesque appearance.

WORK-WEAR **DRESS**

She manages three teams, two departments, and an incorrigible Labradoodle at home. She might find a suit constricting to wear as she flies from department to department. Therefore, a comfortable, yet fashionable, dress would be a better match.

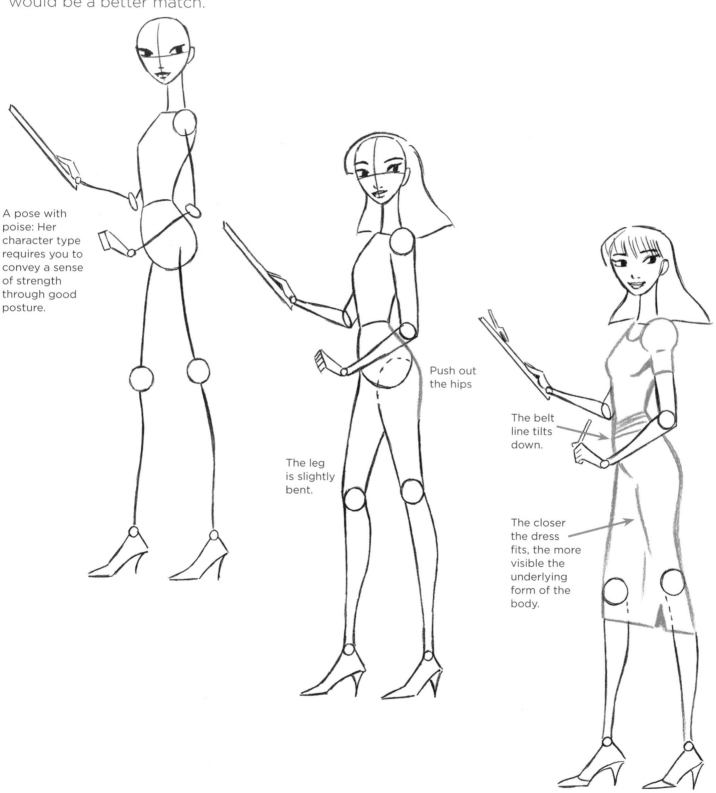

A pose with poise: Her character type requires you to convey a sense of strength through good posture.

Push out the hips

The leg is slightly bent.

The belt line tilts down.

The closer the dress fits, the more visible the underlying form of the body.

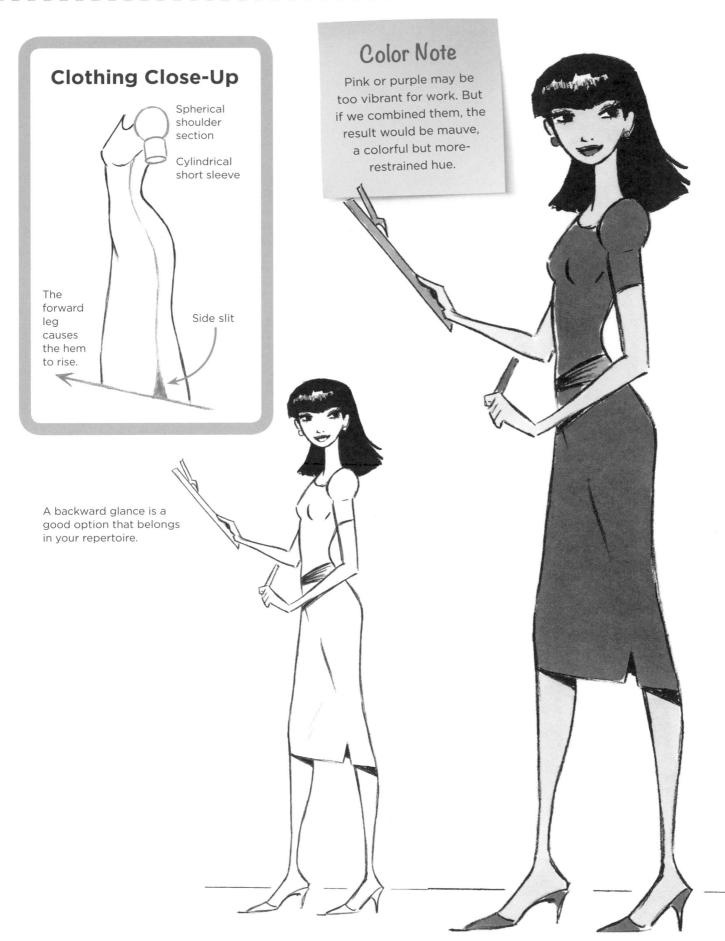

Clothing Close-Up

Spherical shoulder section

Cylindrical short sleeve

The forward leg causes the hem to rise.

Side slit

Color Note

Pink or purple may be too vibrant for work. But if we combined them, the result would be mauve, a colorful but more-restrained hue.

A backward glance is a good option that belongs in your repertoire.

SWEATER DRESS

This sweater dress and matching boots are a revival of the mod look from the 1960s. Medium-bold blue announces, but doesn't scream, her presence. Arms posed behind the back, in combo with a lifted chest, reads as an energetic pose.

The head is a simple oval shape.

Pull shoulder back.

This shoulder comes forward.

The legs are always slightly rounded, even in the initial stick construction.

The hem hits at mid-thigh.

The heel pokes out; don't let it disappear behind the front foot.

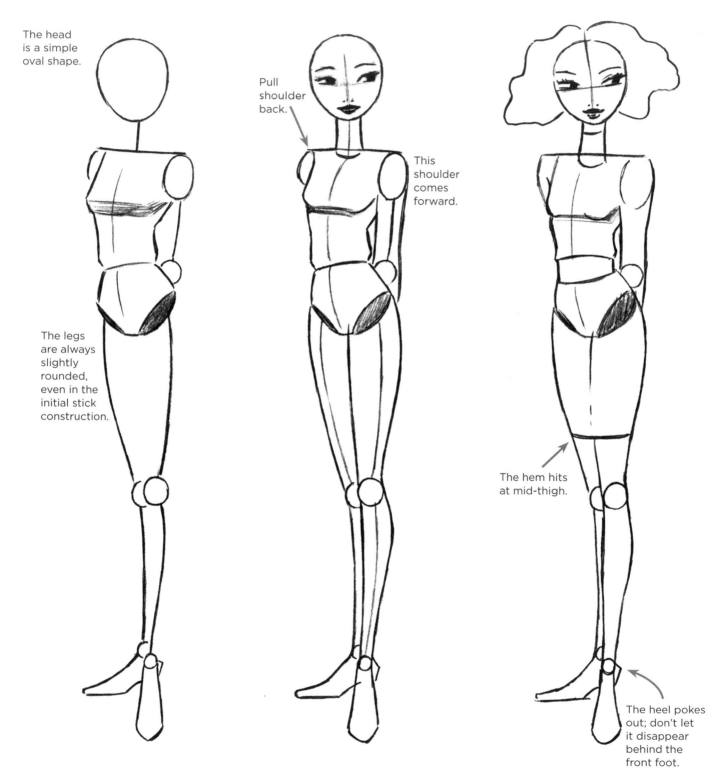

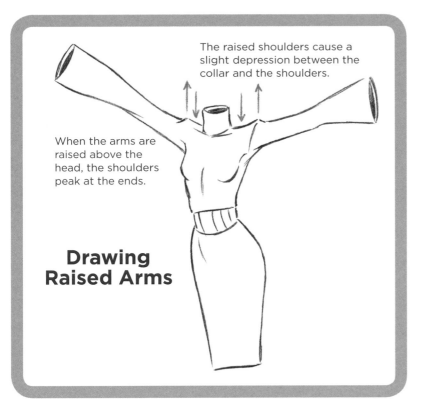

The raised shoulders cause a slight depression between the collar and the shoulders.

When the arms are raised above the head, the shoulders peak at the ends.

Drawing Raised Arms

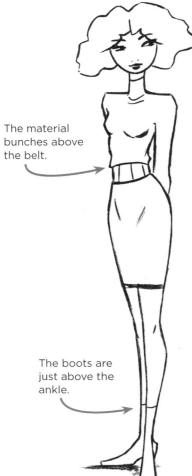

The material bunches above the belt.

The boots are just above the ankle.

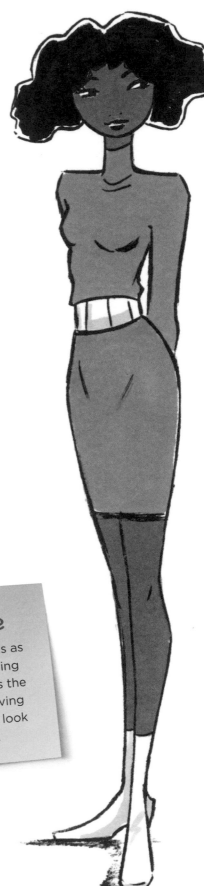

Pose Note

A glance behind is as effective as turning the head, but has the advantage of giving the viewer a full look at the face.

UNCONSTRUCTED AND
OFF-THE-SHOULDER

When a breeze hits a well-constructed outfit, it tugs on it, causing stress folds and creases. When a breeze encounters an **unconstructed** outfit, the dress interacts with it gracefully. Fortunately, artists don't have to wait for a weather effect. We can simply summon it with our pencils.

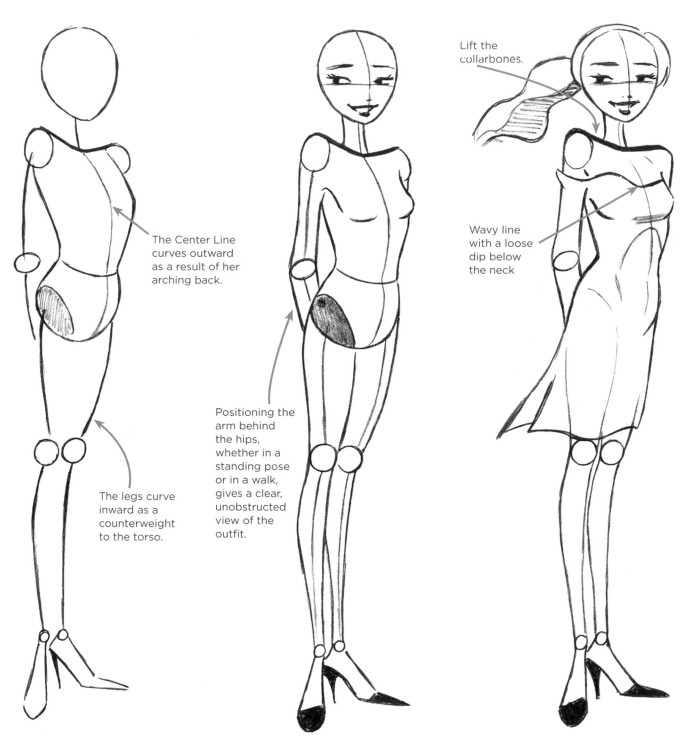

The Center Line curves outward as a result of her arching back.

The legs curve inward as a counterweight to the torso.

Positioning the arm behind the hips, whether in a standing pose or in a walk, gives a clear, unobstructed view of the outfit.

Lift the collarbones.

Wavy line with a loose dip below the neck

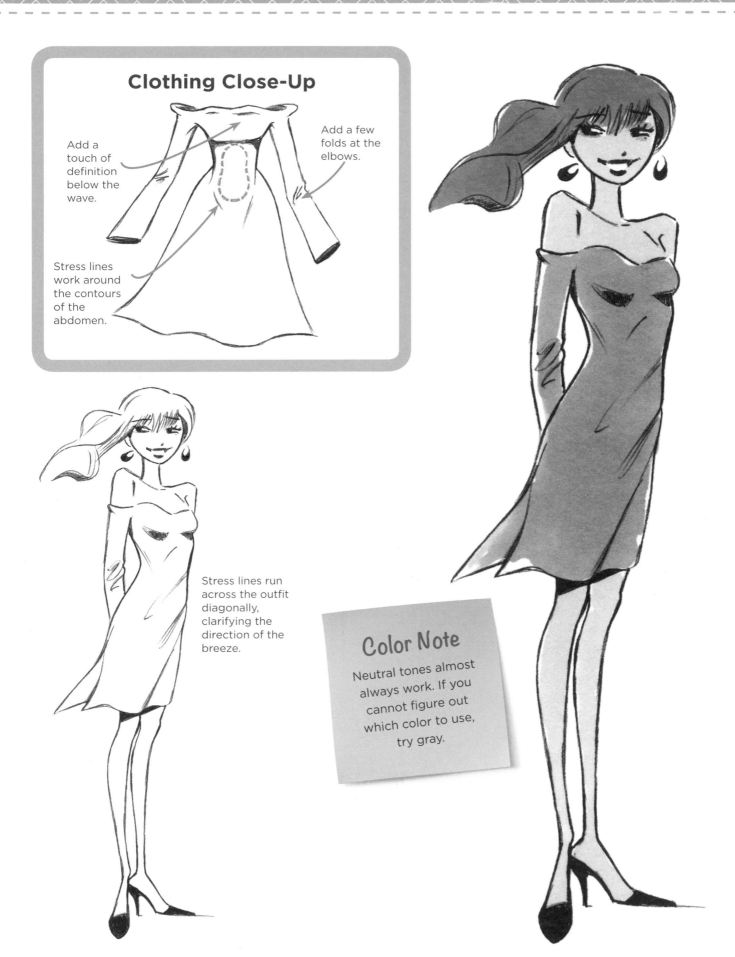

Clothing Close-Up

Add a touch of definition below the wave.

Add a few folds at the elbows.

Stress lines work around the contours of the abdomen.

Stress lines run across the outfit diagonally, clarifying the direction of the breeze.

Color Note

Neutral tones almost always work. If you cannot figure out which color to use, try gray.

LITTLE BLACK **DRESS**

The little black dress is a wardrobe staple that offers countless options. Paired with a basic shoe and a few accessories, it becomes a tried-and-true outfit that creates a splash without looking splashy. The little black dress comes in many styles, but we'll keep ours simple by focusing on the outline of the body.

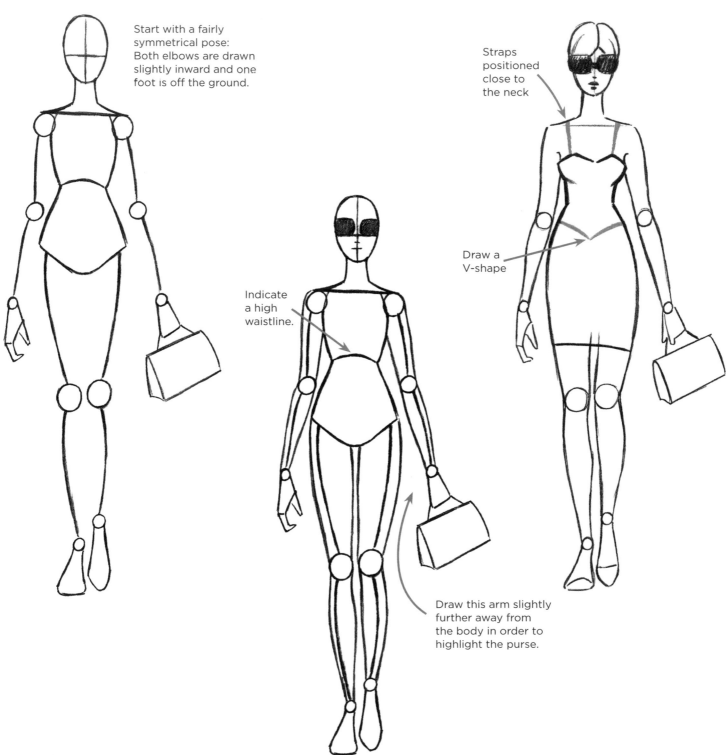

Start with a fairly symmetrical pose: Both elbows are drawn slightly inward and one foot is off the ground.

Straps positioned close to the neck

Draw a V-shape

Indicate a high waistline.

Draw this arm slightly further away from the body in order to highlight the purse.

The small vertical lines indicate pleats.

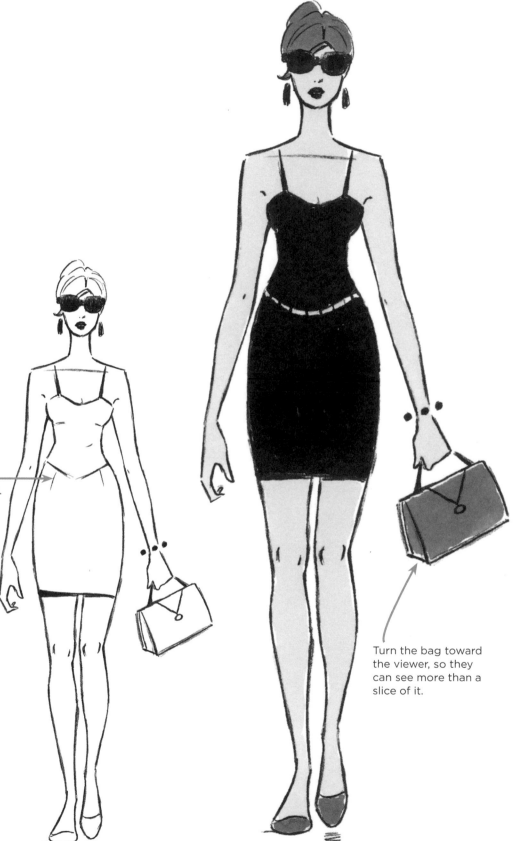

Turn the bag toward the viewer, so they can see more than a slice of it.

BACK VIEW

A long, open-backed evening gown cries out to be drawn from the back view. This angle is an eye-catcher. The key to it lies in articulating a long and flexible looking spine. Due to gravity, the length of the dress straightens out the material, therefore the dress shows fewer folds.

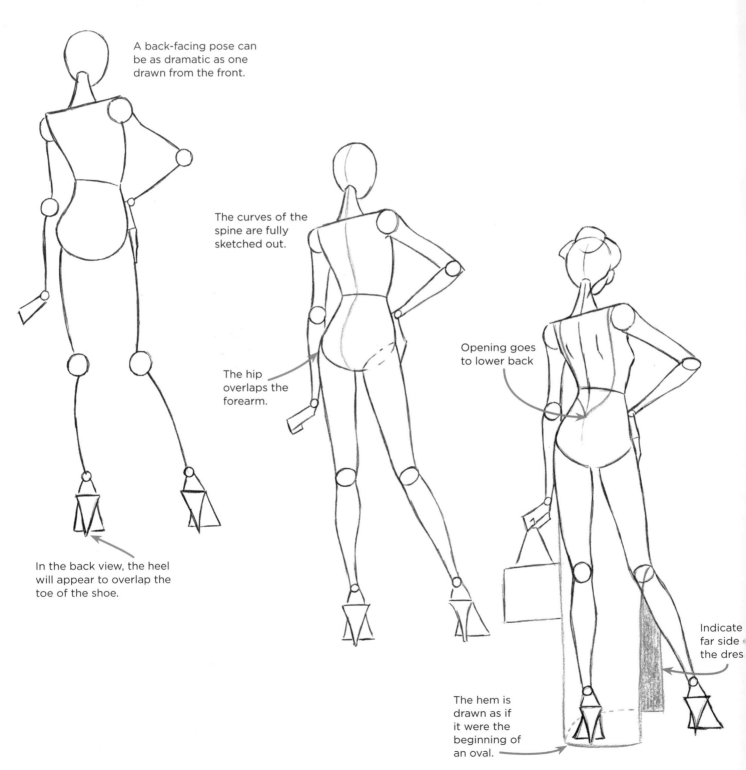

A back-facing pose can be as dramatic as one drawn from the front.

The curves of the spine are fully sketched out.

The hip overlaps the forearm.

Opening goes to lower back

In the back view, the heel will appear to overlap the toe of the shoe.

The hem is drawn as if it were the beginning of an oval.

Indicate far side the dres

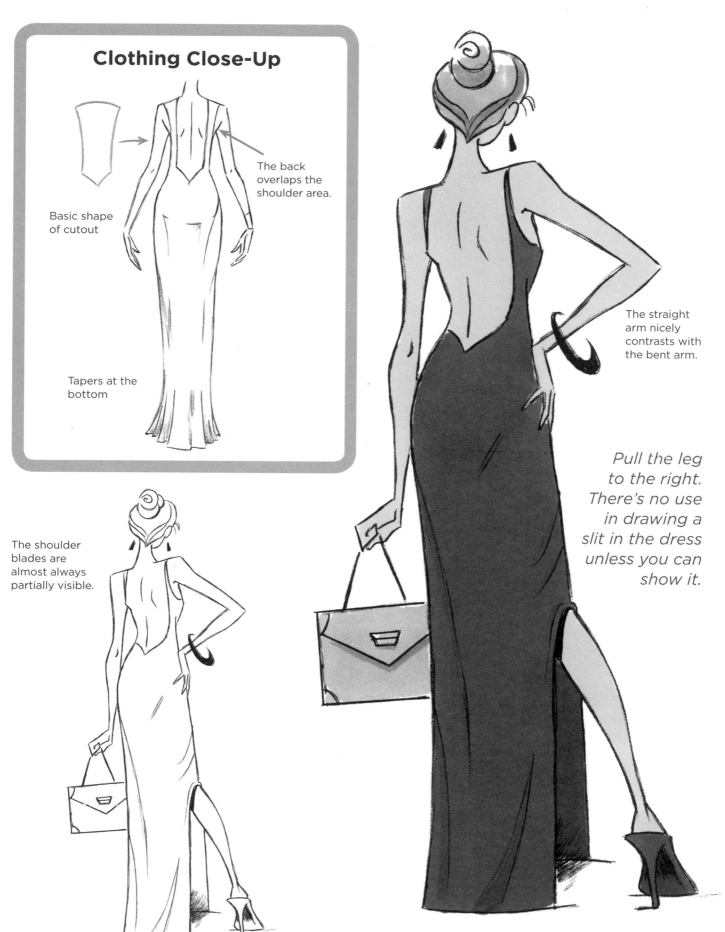

Clothing Close-Up

Basic shape of cutout

The back overlaps the shoulder area.

Tapers at the bottom

The shoulder blades are almost always partially visible.

The straight arm nicely contrasts with the bent arm.

Pull the leg to the right. There's no use in drawing a slit in the dress unless you can show it.

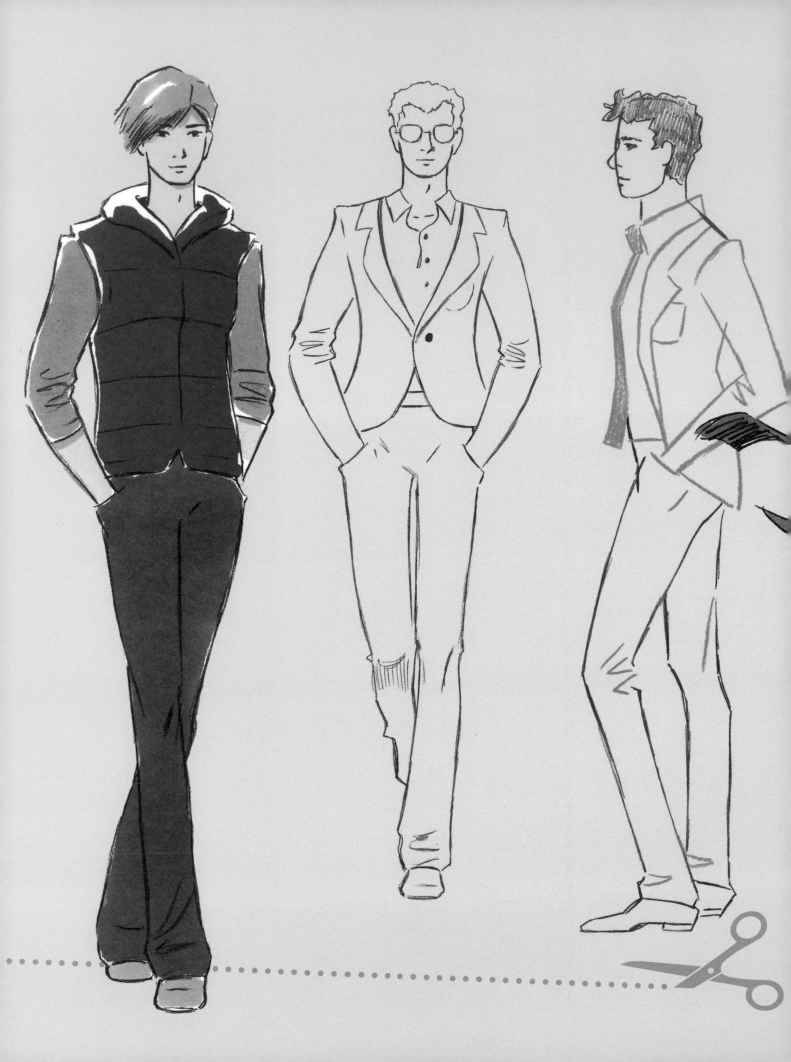

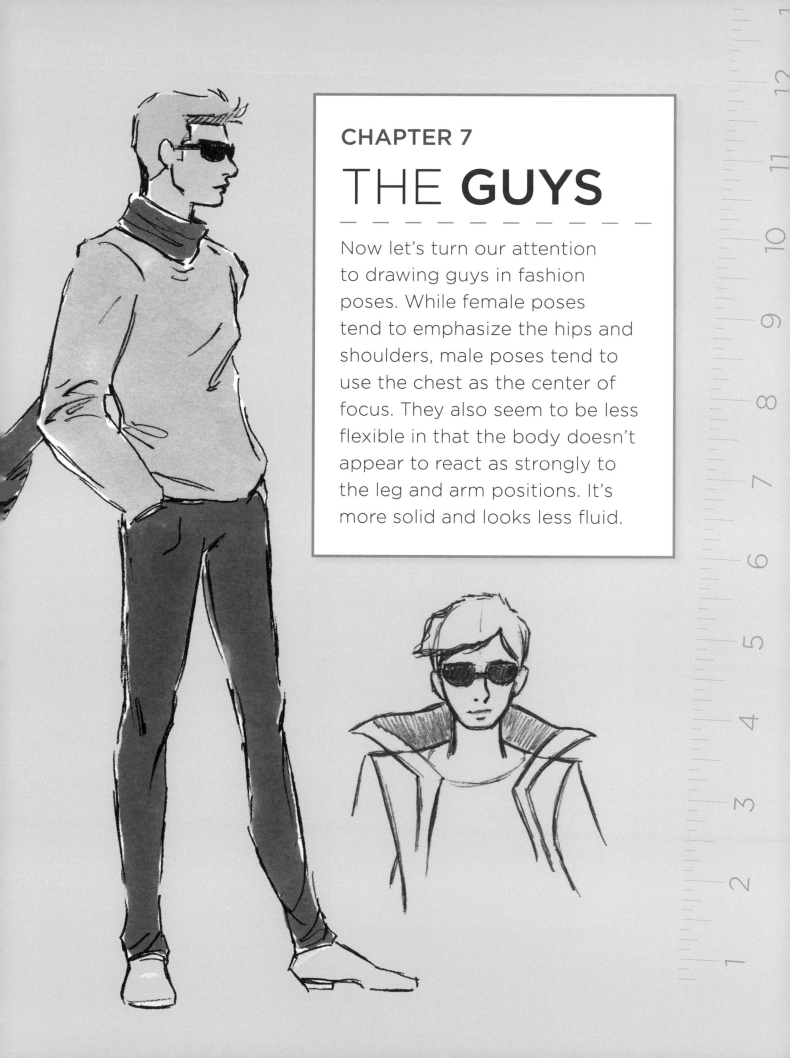

CHAPTER 7
THE **GUYS**

Now let's turn our attention to drawing guys in fashion poses. While female poses tend to emphasize the hips and shoulders, male poses tend to use the chest as the center of focus. They also seem to be less flexible in that the body doesn't appear to react as strongly to the leg and arm positions. It's more solid and looks less fluid.

THE **SUIT**—FRONT VIEW

Here's the current look for a suit. The jacket is shorter than in previous styles, and the lapels are cut wider. The pants are comfortably loose, but not oversized. The colors can be edgier, even for conventional suits. For example, this is a cobalt blue, not your dad's navy.

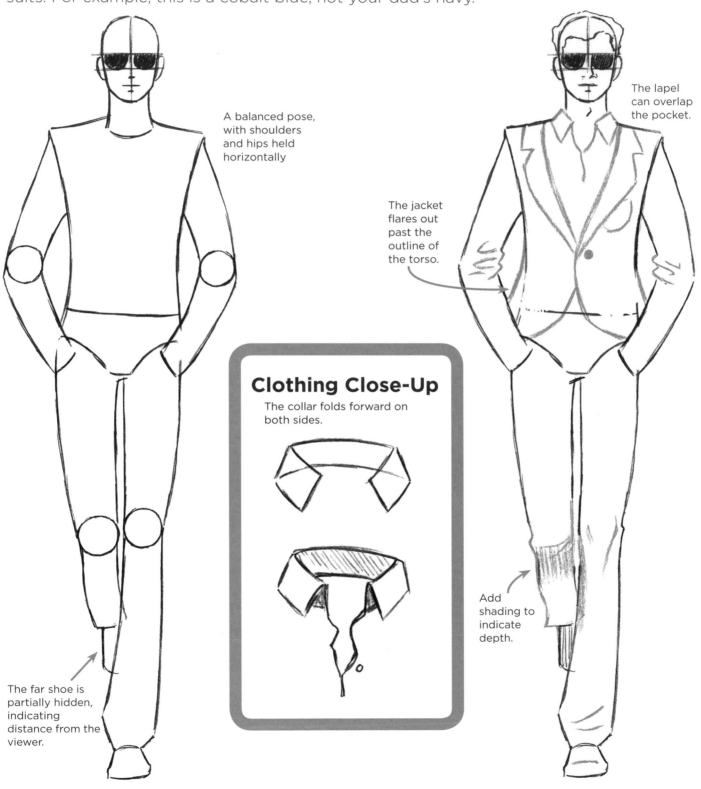

A balanced pose, with shoulders and hips held horizontally

The lapel can overlap the pocket.

The jacket flares out past the outline of the torso.

Clothing Close-Up

The collar folds forward on both sides.

Add shading to indicate depth.

The far shoe is partially hidden, indicating distance from the viewer.

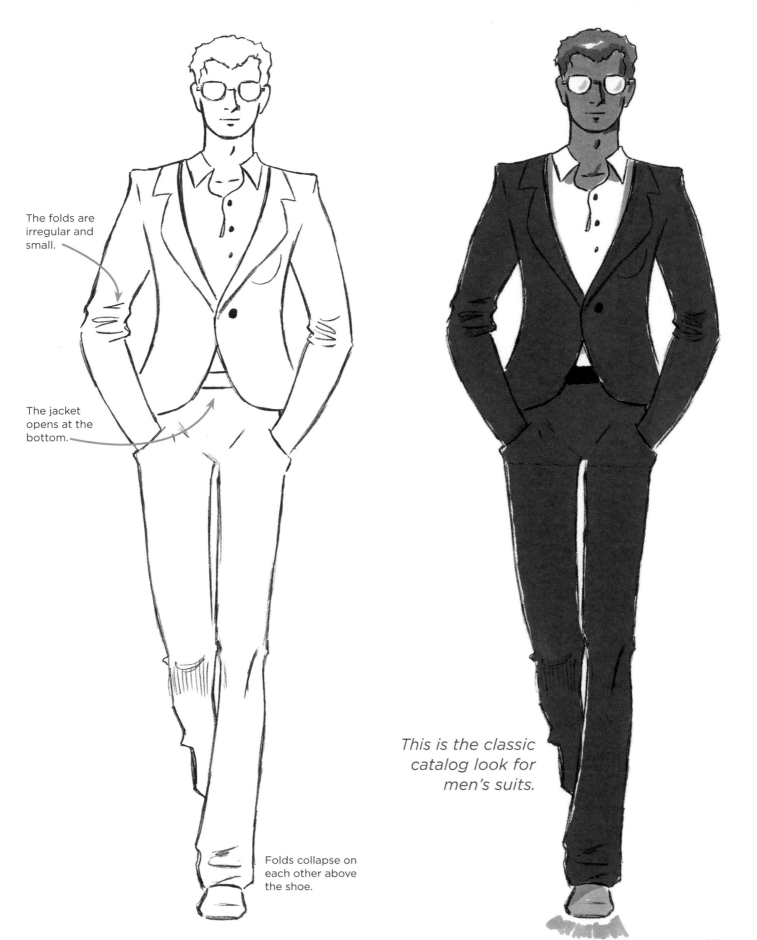

The folds are irregular and small.

The jacket opens at the bottom.

Folds collapse on each other above the shoe.

This is the classic catalog look for men's suits.

SPORTS **JACKET**—PROFILE

A sports jacket needs to fit in a way that allows the model to look casual and at ease. A well-constructed jacket gives the wearer a confident look. The cut of the shoulder is always prominent.

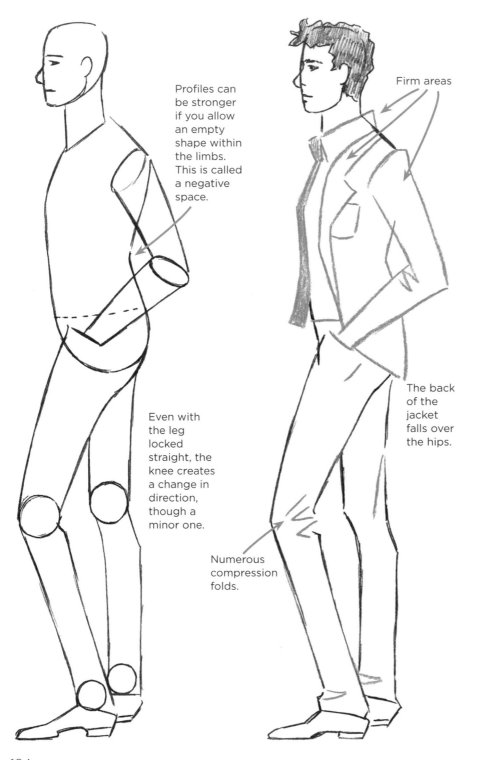

Profiles can be stronger if you allow an empty shape within the limbs. This is called a negative space.

Even with the leg locked straight, the knee creates a change in direction, though a minor one.

Firm areas

The back of the jacket falls over the hips.

Numerous compression folds.

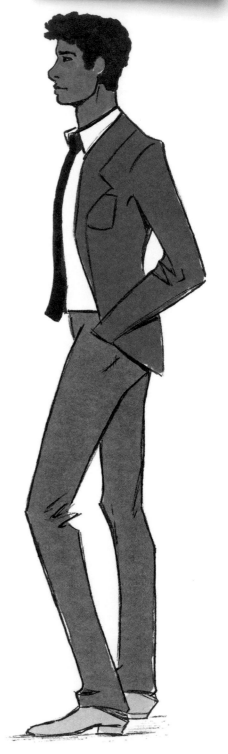

PUFFY **VEST**

When I was a kid, the only thing I knew about a vest was that campers were required to wear them in a canoe. When I got older, I was pleased to discover that vests aren't always inflatable and orange, but come in many fashionable styles and colors.

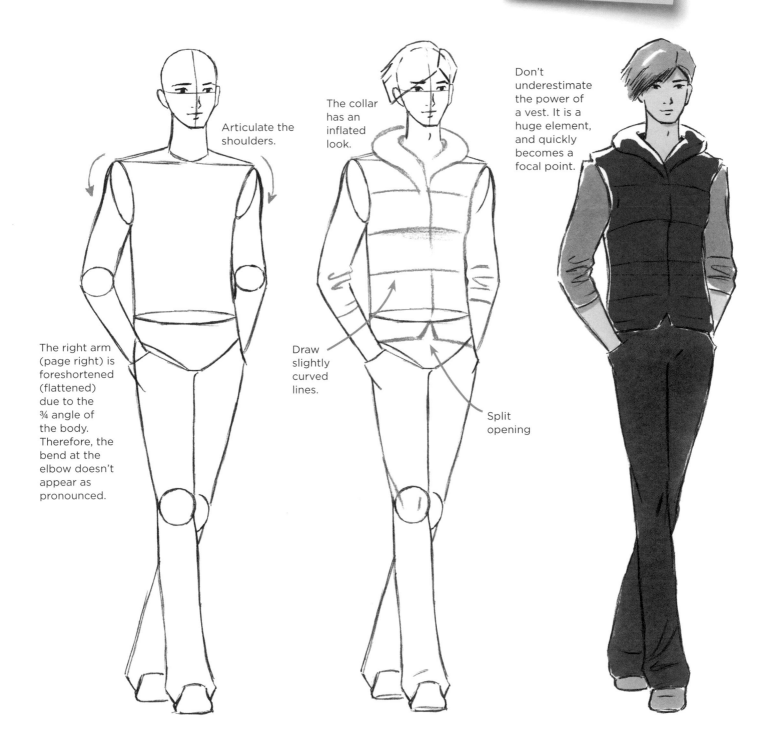

Articulate the shoulders.

The collar has an inflated look.

Don't underestimate the power of a vest. It is a huge element, and quickly becomes a focal point.

The right arm (page right) is foreshortened (flattened) due to the ¾ angle of the body. Therefore, the bend at the elbow doesn't appear as pronounced.

Draw slightly curved lines.

Split opening

CASUAL AND **SMART**

Since when is a sweatshirt a fashion statement? When it's combined with $450 sunglasses, a scarf, and designer jeans. But it's not just what you wear, it's how you wear it and the colors you select. It's also important to allow the material to guide your approach. For example, I've used a somewhat looser line to draw this pose, in keeping with the casual look of the outfit.

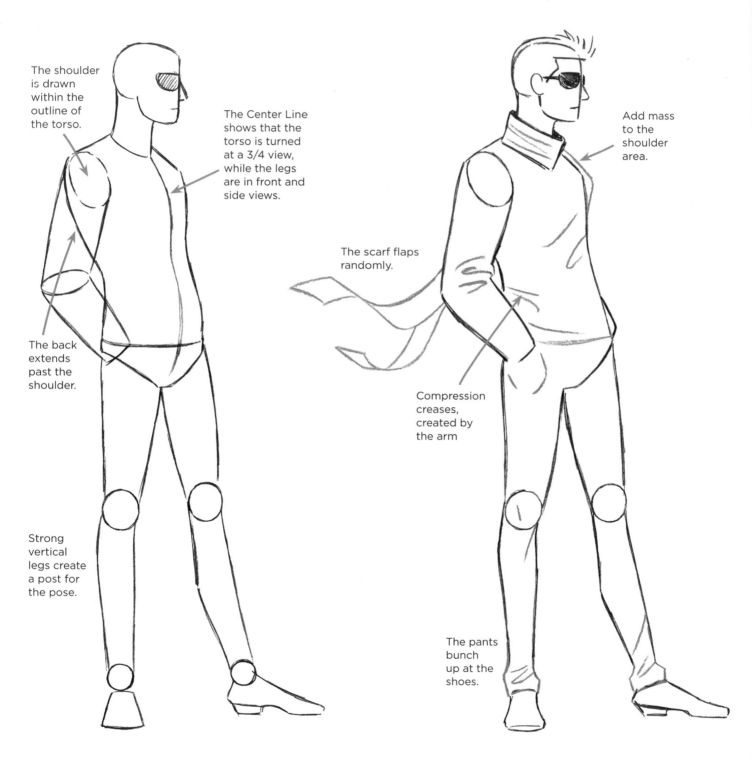

The shoulder is drawn within the outline of the torso.

The Center Line shows that the torso is turned at a 3/4 view, while the legs are in front and side views.

The back extends past the shoulder.

Strong vertical legs create a post for the pose.

The scarf flaps randomly.

Add mass to the shoulder area.

Compression creases, created by the arm

The pants bunch up at the shoes.

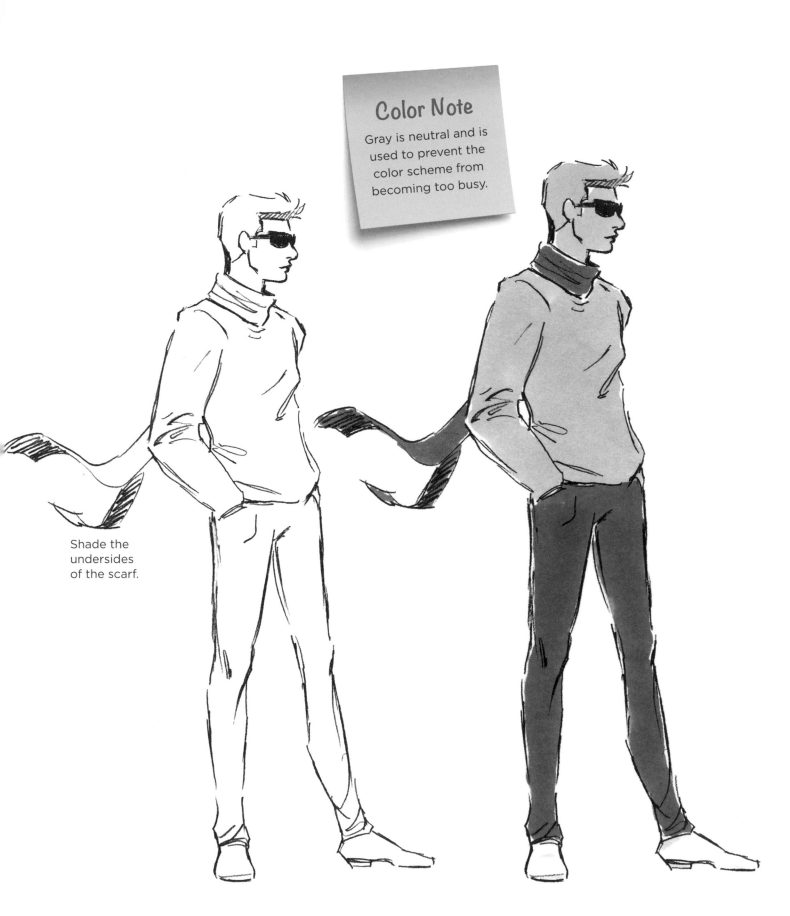

Shade the
undersides
of the scarf.

Color Note

Gray is neutral and is
used to prevent the
color scheme from
becoming too busy.

LEATHER JACKET

This leather jacket is two-toned, which includes the suede exterior and the cream-colored lining around the collar. The collar is worn up and shows a ridged interior. To finish the look, we'll draw a brushed up hairdo, a crew neck pullover, and simple slacks.

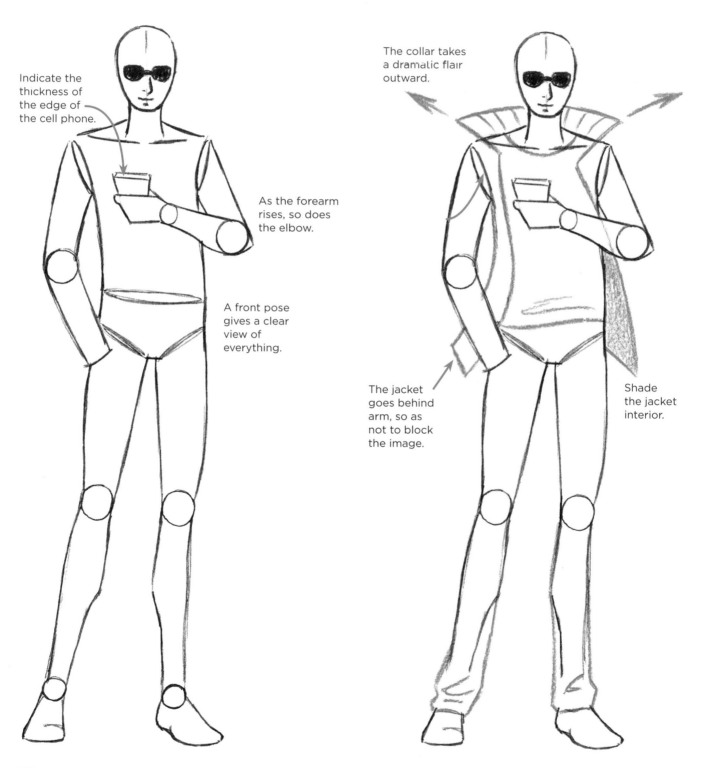

Indicate the thickness of the edge of the cell phone.

As the forearm rises, so does the elbow.

A front pose gives a clear view of everything.

The collar takes a dramatic flair outward.

The jacket goes behind arm, so as not to block the image.

Shade the jacket interior.

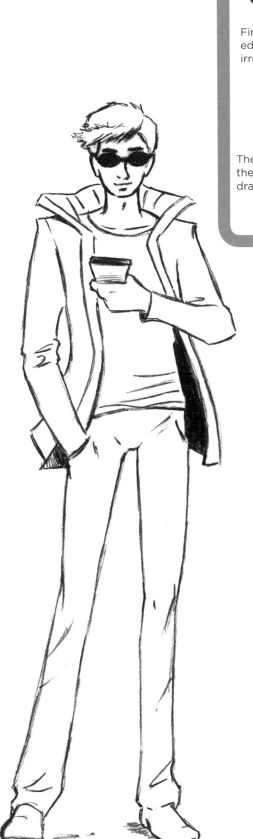

Clothing Close-Up

Finish the top edge with an irregular line.

The opening of the crew neck is drawn as an oval.

Closest points for both sides of jacket

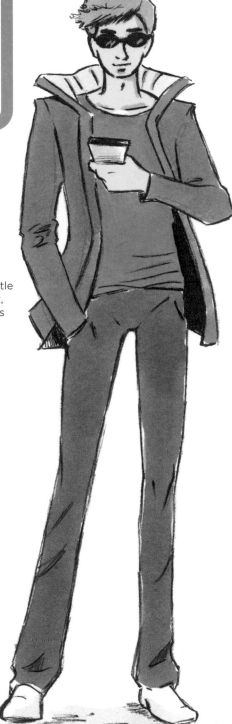

The jacket shows a little movement, which adds life to the pose.

WORKOUT CHIC

Athletic outfits are heavily designed in order to give each brand a unique look. Durability and color coordination are also important too. The material moves easily with the body.

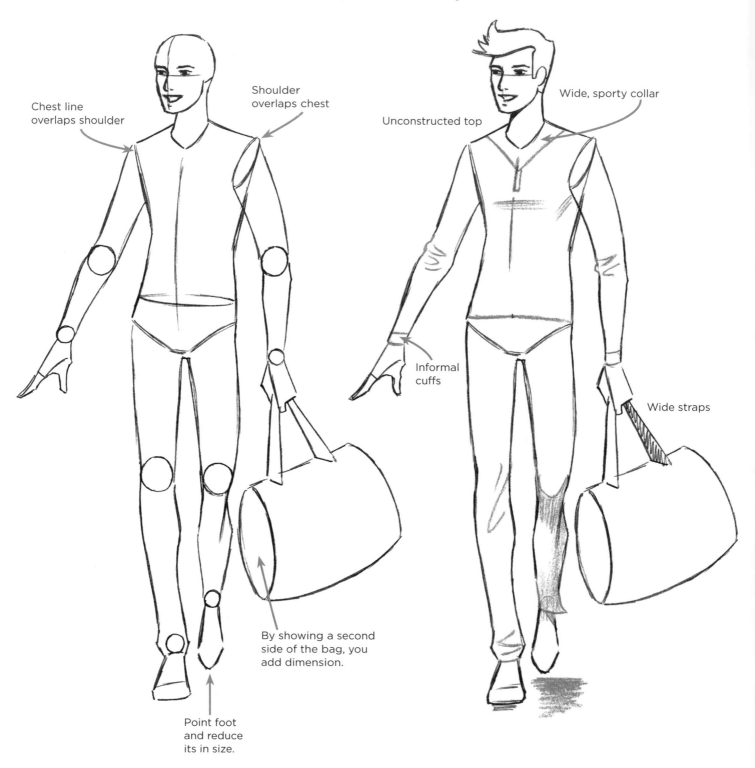

Chest line overlaps shoulder

Shoulder overlaps chest

Unconstructed top

Wide, sporty collar

Informal cuffs

Wide straps

By showing a second side of the bag, you add dimension.

Point foot and reduce its in size.

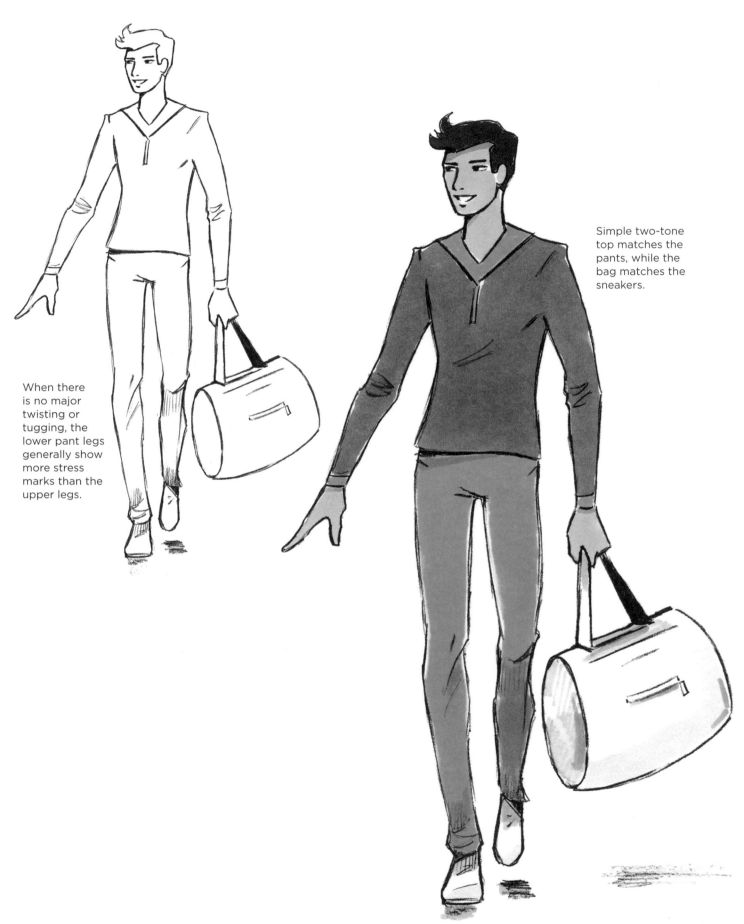

Simple two-tone top matches the pants, while the bag matches the sneakers.

When there is no major twisting or tugging, the lower pant legs generally show more stress marks than the upper legs.

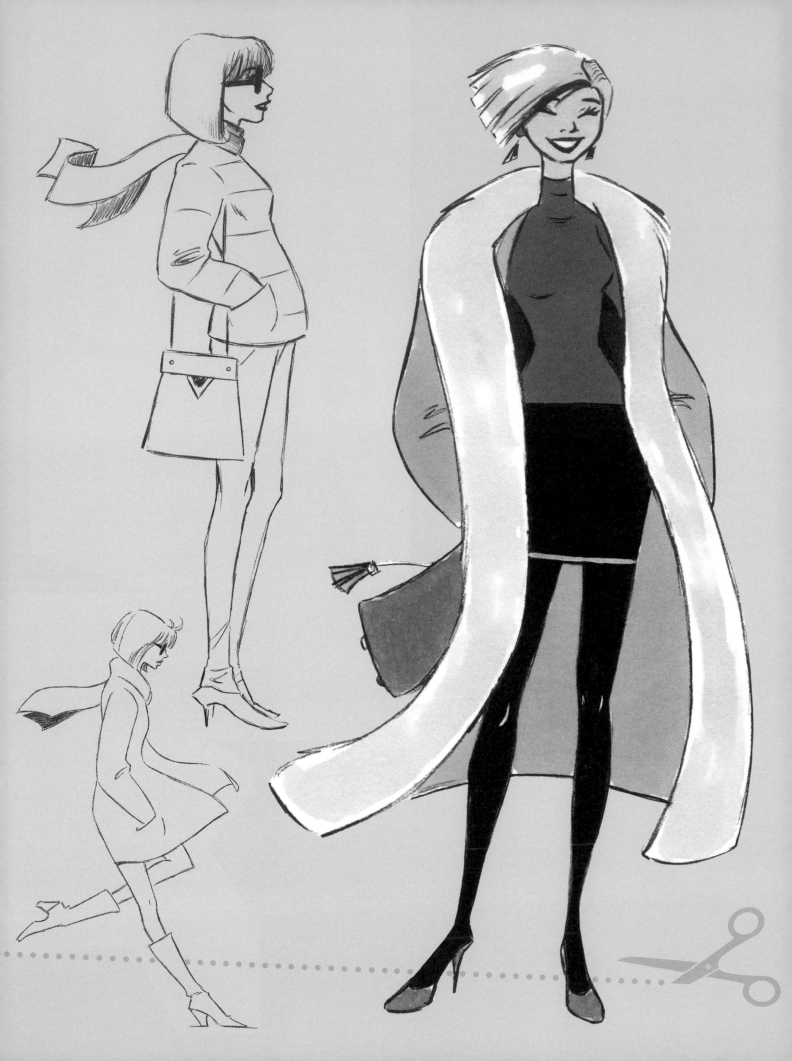

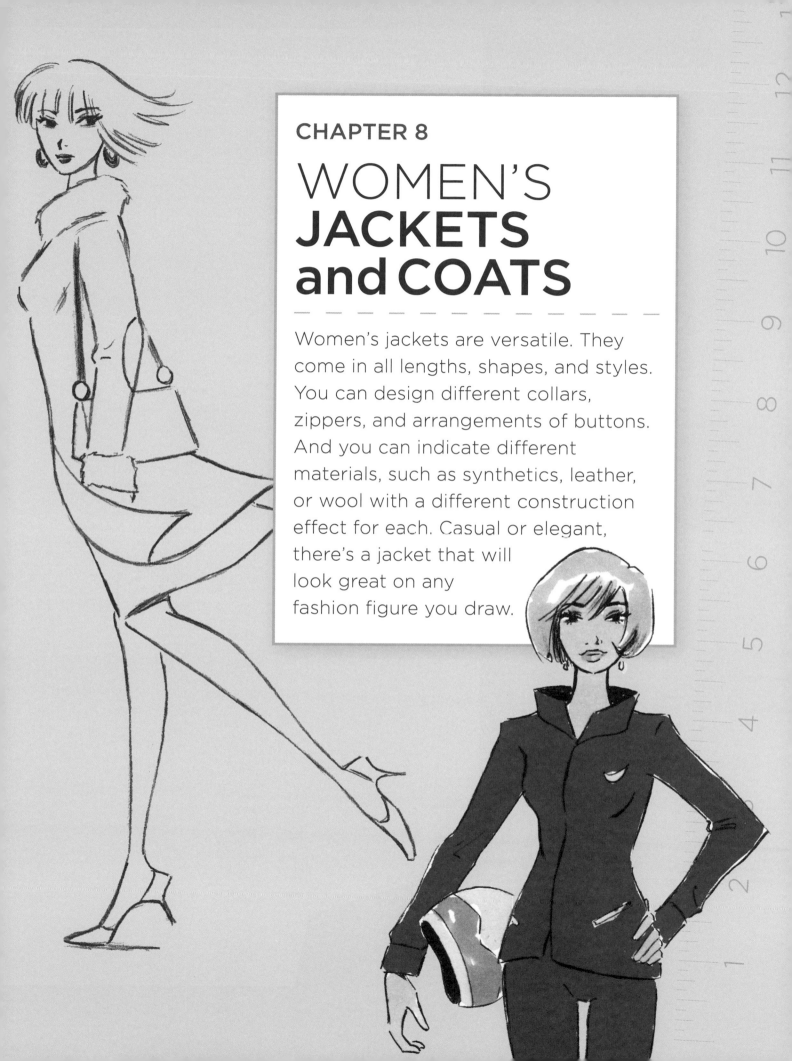

CHAPTER 8
WOMEN'S JACKETS and COATS

Women's jackets are versatile. They come in all lengths, shapes, and styles. You can design different collars, zippers, and arrangements of buttons. And you can indicate different materials, such as synthetics, leather, or wool with a different construction effect for each. Casual or elegant, there's a jacket that will look great on any fashion figure you draw.

PUFFER **JACKET**

This is casual outerwear for fall or winter. The difference between this and a true ski jacket is that a ski jacket is boxy while the puffer jacket is tailored around the contours. The inflated look of the sections of the jacket creates a pleasing contrast to the slacks.

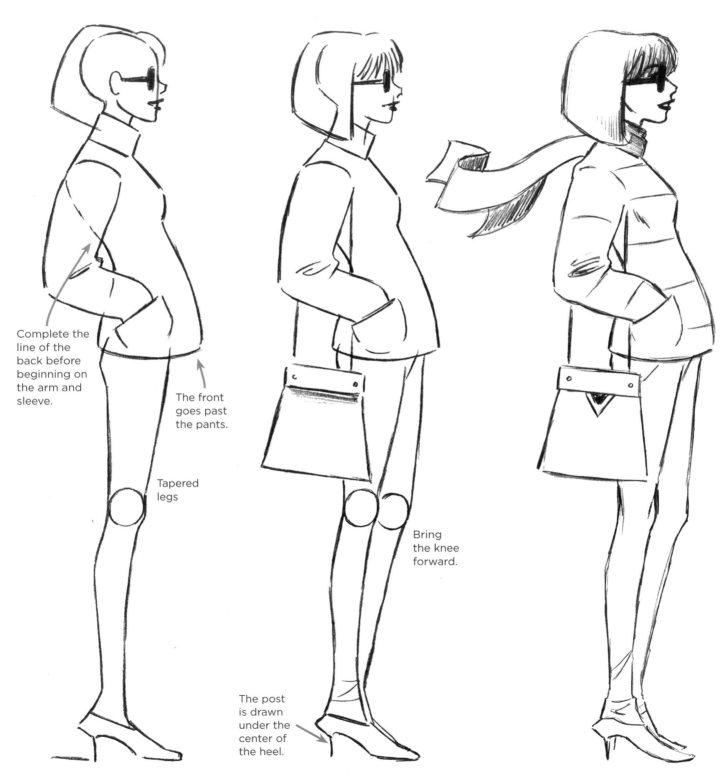

Complete the line of the back before beginning on the arm and sleeve.

The front goes past the pants.

Tapered legs

Bring the knee forward.

The post is drawn under the center of the heel.

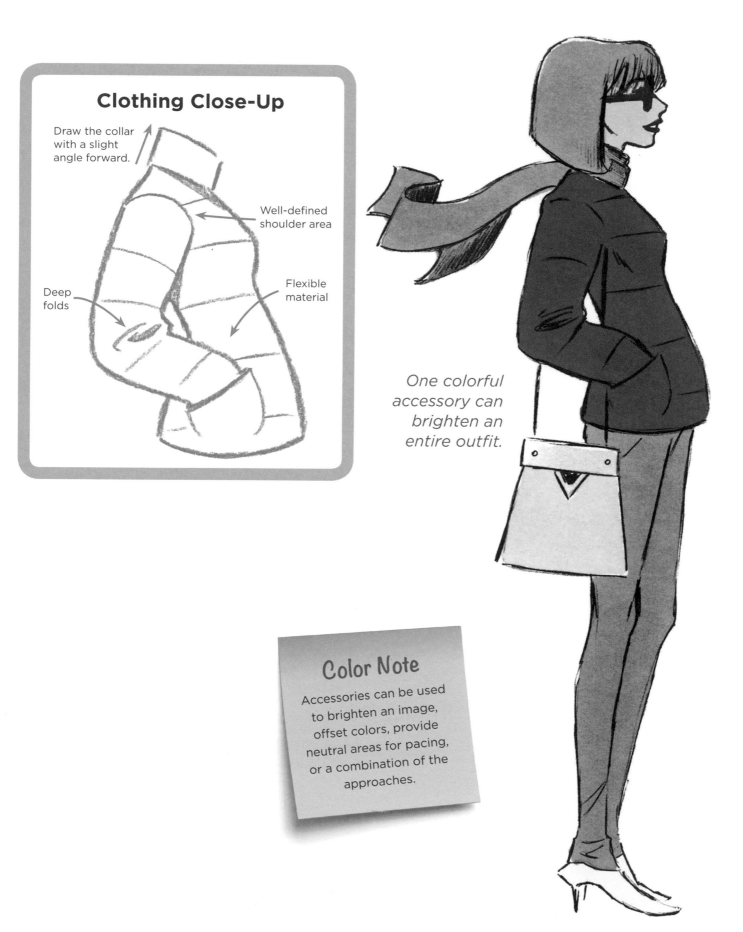

Clothing Close-Up

Draw the collar with a slight angle forward.

Well-defined shoulder area

Deep folds

Flexible material

One colorful accessory can brighten an entire outfit.

Color Note

Accessories can be used to brighten an image, offset colors, provide neutral areas for pacing, or a combination of the approaches.

THE BASIC **BLAZER**

A blazer is a carefully constructed garment. Its framework hugs the torso in certain places and leaves it loose in others. Once you know how to draw a basic blazer, you can practice drawing it over different styles of tops.

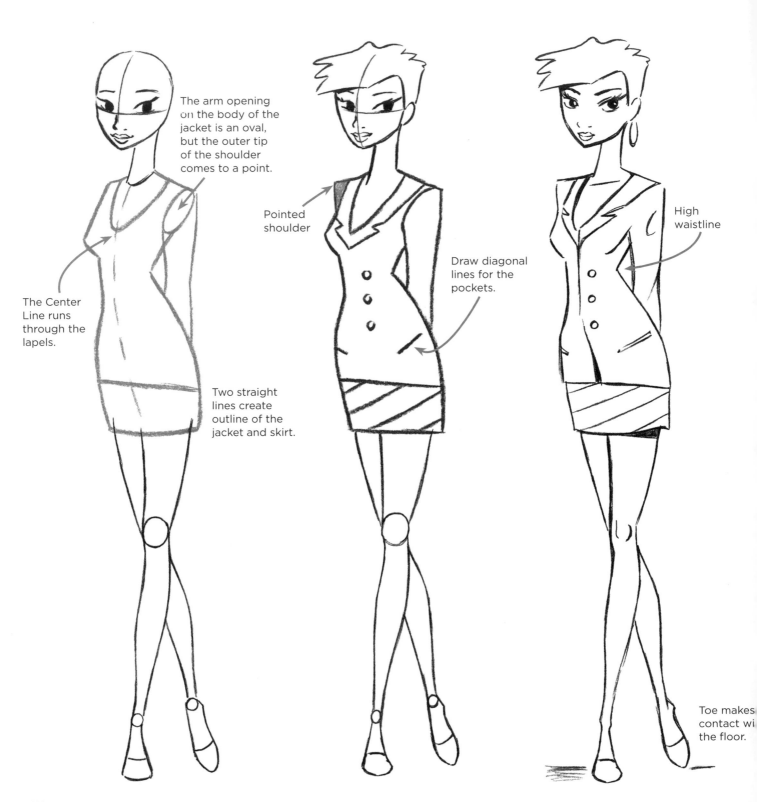

The arm opening on the body of the jacket is an oval, but the outer tip of the shoulder comes to a point.

Pointed shoulder

The Center Line runs through the lapels.

Two straight lines create outline of the jacket and skirt.

Draw diagonal lines for the pockets.

High waistline

Toe makes contact wi the floor.

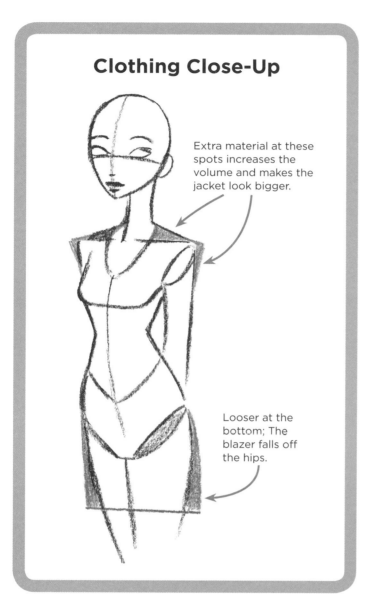

Clothing Close-Up

Extra material at these spots increases the volume and makes the jacket look bigger.

Looser at the bottom; The blazer falls off the hips.

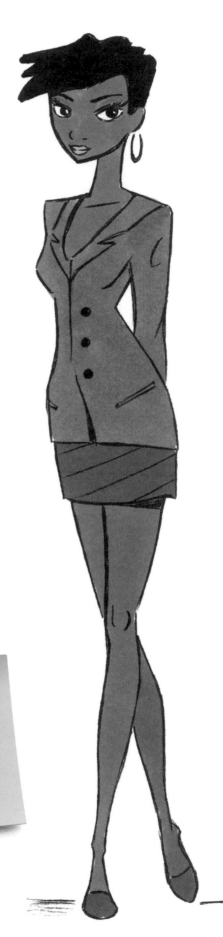

Color Note

The purple skirt adds zest, while a skirt with a traditional color would work for a more traditionally corporate environment.

PERFORMANCE **OUTFIT**

Sometimes, an ad will show a model in a cool occupation, such as a racecar driver. But the ad will be for a high-end watch or sunglasses, not a racing uniform. So it's good to know a few things about drawing and designing dynamic sports attire. It's also a subject that's fun to work with. You don't have to recreate a regulation uniform. You can design your own.

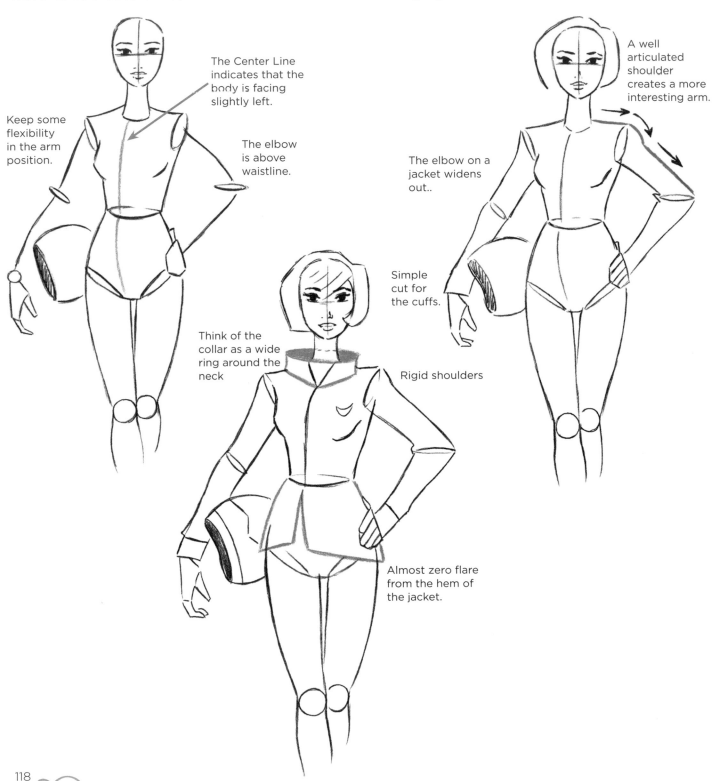

The Center Line indicates that the body is facing slightly left.

Keep some flexibility in the arm position.

The elbow is above waistline.

A well articulated shoulder creates a more interesting arm.

The elbow on a jacket widens out..

Simple cut for the cuffs.

Think of the collar as a wide ring around the neck

Rigid shoulders

Almost zero flare from the hem of the jacket.

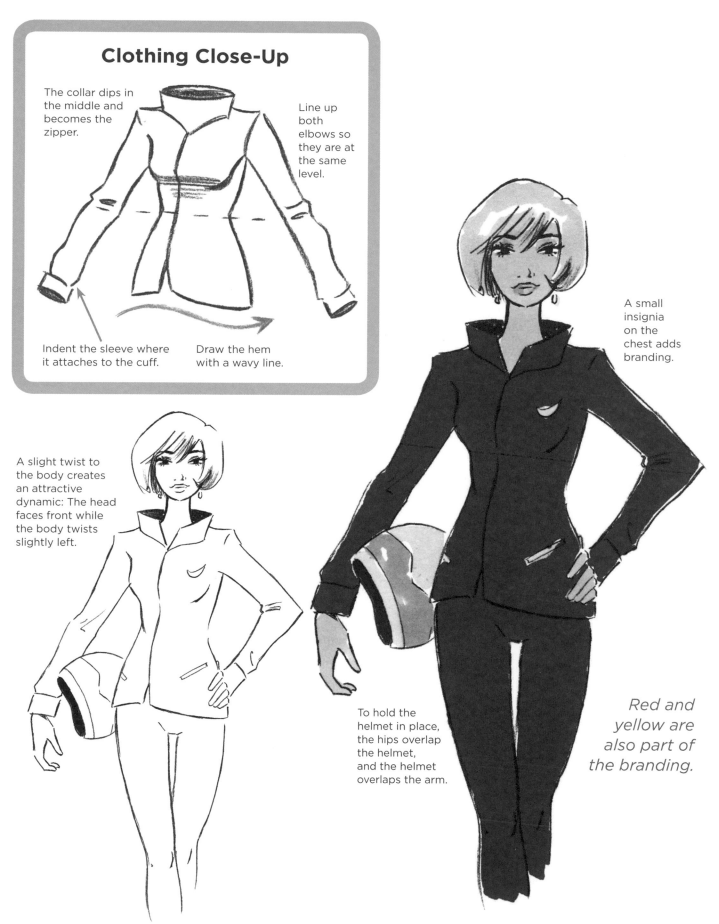

Clothing Close-Up

The collar dips in the middle and becomes the zipper.

Line up both elbows so they are at the same level.

Indent the sleeve where it attaches to the cuff.

Draw the hem with a wavy line.

A small insignia on the chest adds branding.

A slight twist to the body creates an attractive dynamic: The head faces front while the body twists slightly left.

To hold the helmet in place, the hips overlap the helmet, and the helmet overlaps the arm.

Red and yellow are also part of the branding.

LONG **COAT**

A shift in the stance is all it takes to give a long coat flowing lines. Here, the model favors one leg—the straighter one. As a result, her body sways to that side, causing the coat to move at the bottom.

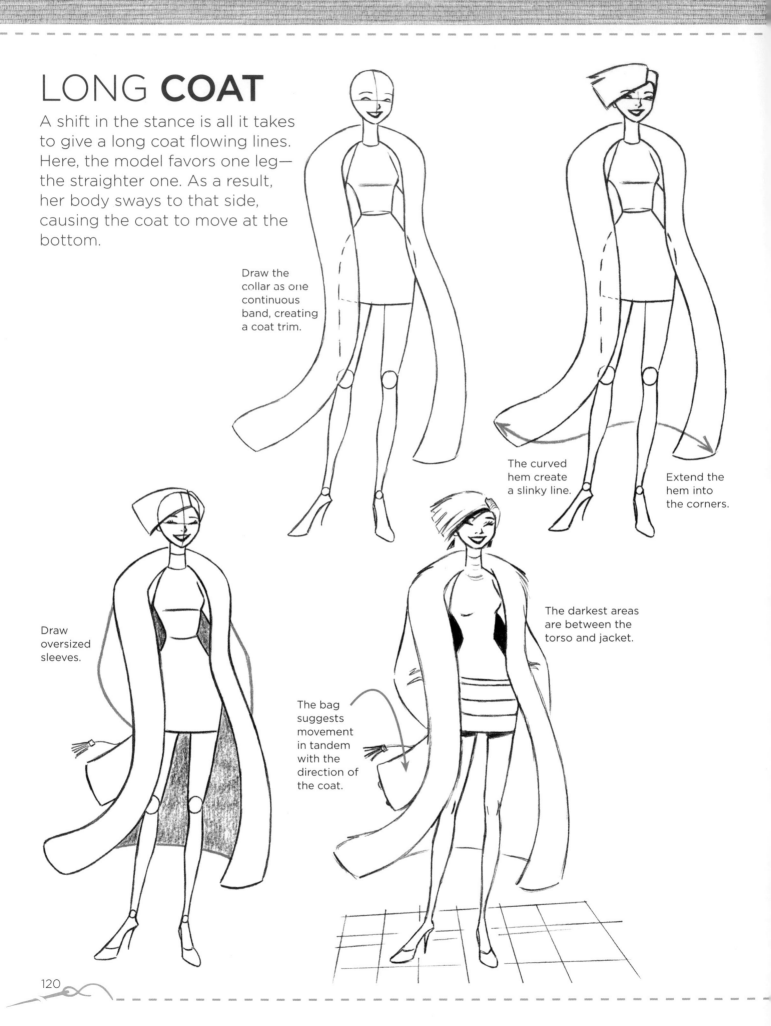

Draw the collar as one continuous band, creating a coat trim.

The curved hem create a slinky line.

Extend the hem into the corners.

Draw oversized sleeves.

The bag suggests movement in tandem with the direction of the coat.

The darkest areas are between the torso and jacket.

Clothing Close-Up

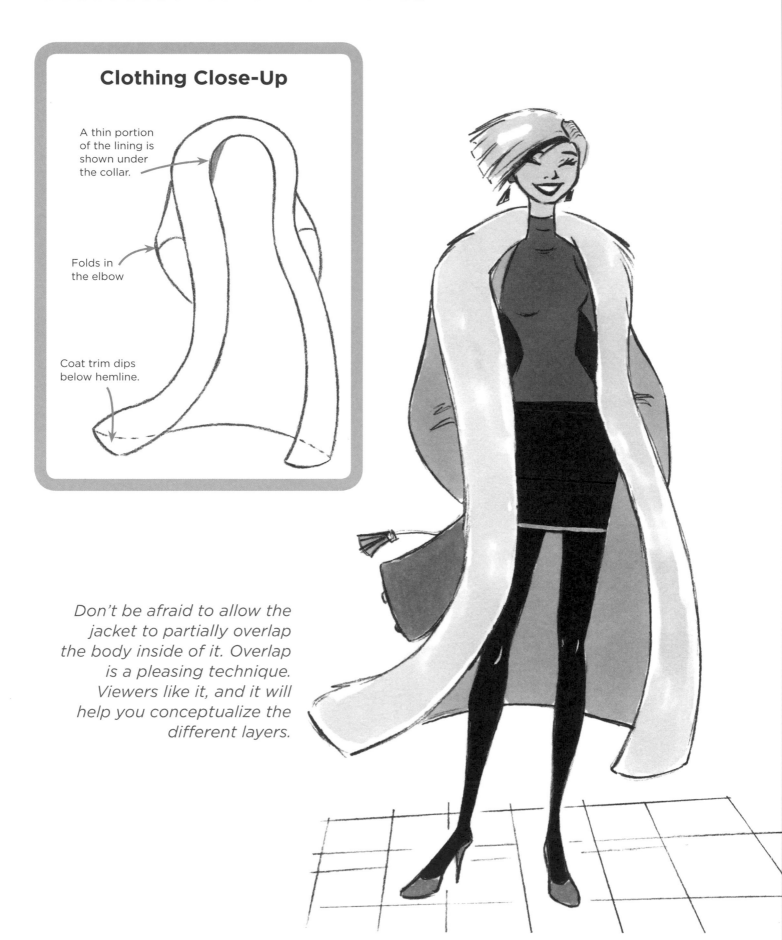

A thin portion of the lining is shown under the collar.

Folds in the elbow

Coat trim dips below hemline.

Don't be afraid to allow the jacket to partially overlap the body inside of it. Overlap is a pleasing technique. Viewers like it, and it will help you conceptualize the different layers.

MID-LENGTH **COAT**

This is a perennially popular style. It has just enough structure to look chic, but is also very comfortable. The flexibility allows us to open it up at the bottom and create flowing lines that are pleasing to draw and pleasing to view. It's a good choice for almost any occasion.

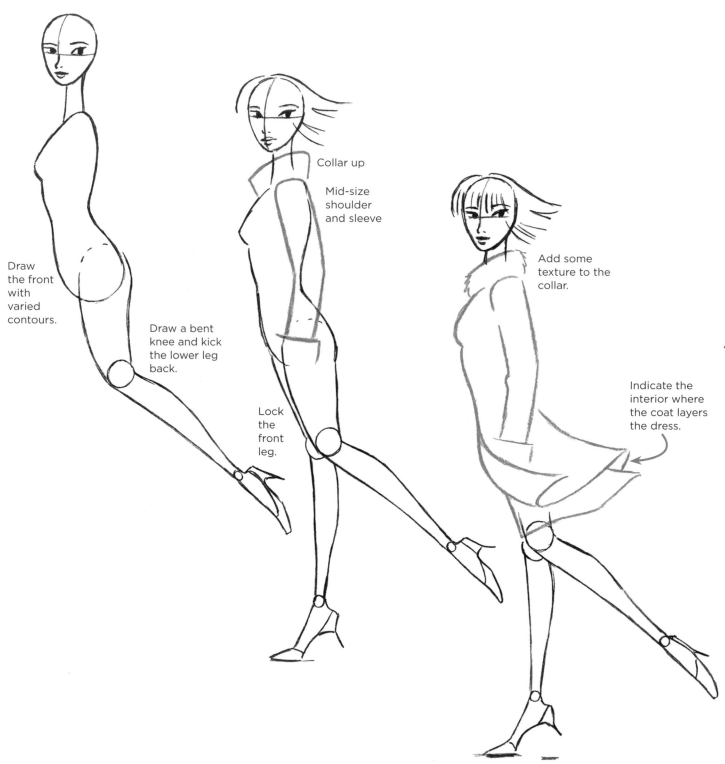

Draw the front with varied contours.

Draw a bent knee and kick the lower leg back.

Collar up

Mid-size shoulder and sleeve

Lock the front leg.

Add some texture to the collar.

Indicate the interior where the coat layers the dress.

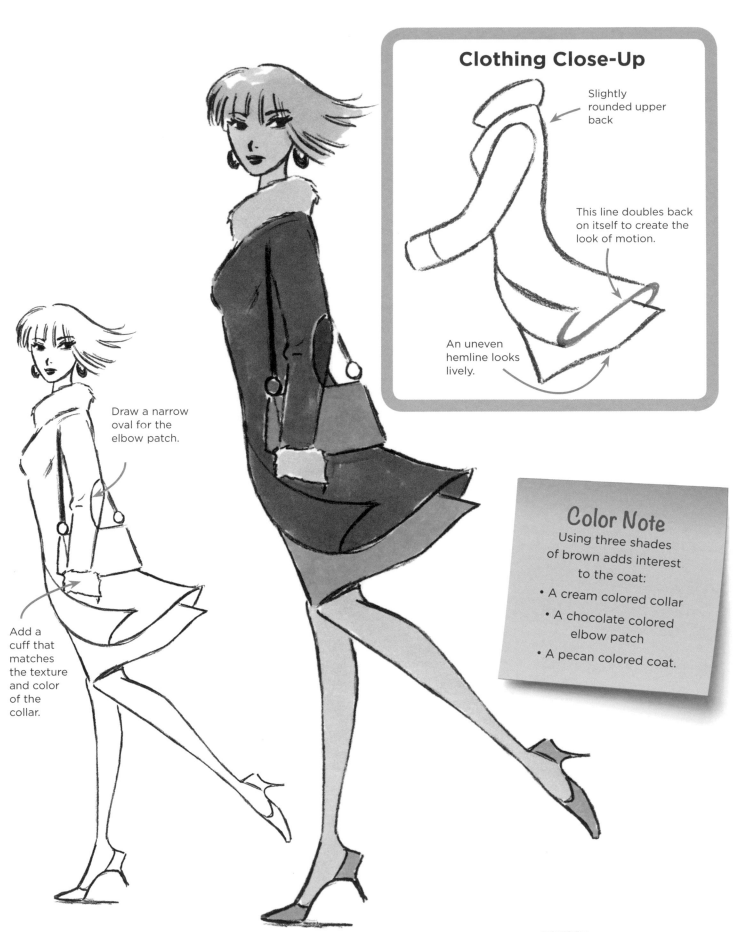

Clothing Close-Up

Slightly rounded upper back

This line doubles back on itself to create the look of motion.

An uneven hemline looks lively.

Draw a narrow oval for the elbow patch.

Add a cuff that matches the texture and color of the collar.

Color Note
Using three shades of brown adds interest to the coat:

• A cream colored collar

• A chocolate colored elbow patch

• A pecan colored coat.

SWEATER **JACKET**

This jacket can be worn with a dress, skirt, or slacks. And it turns each into an instant outfit. It's not fancy, but tasteful and a good choice for depicting scenes of cool summer nights or brunch with friends. The contrast between the fluffy collar and the closely tailored jacket is an interesting look.

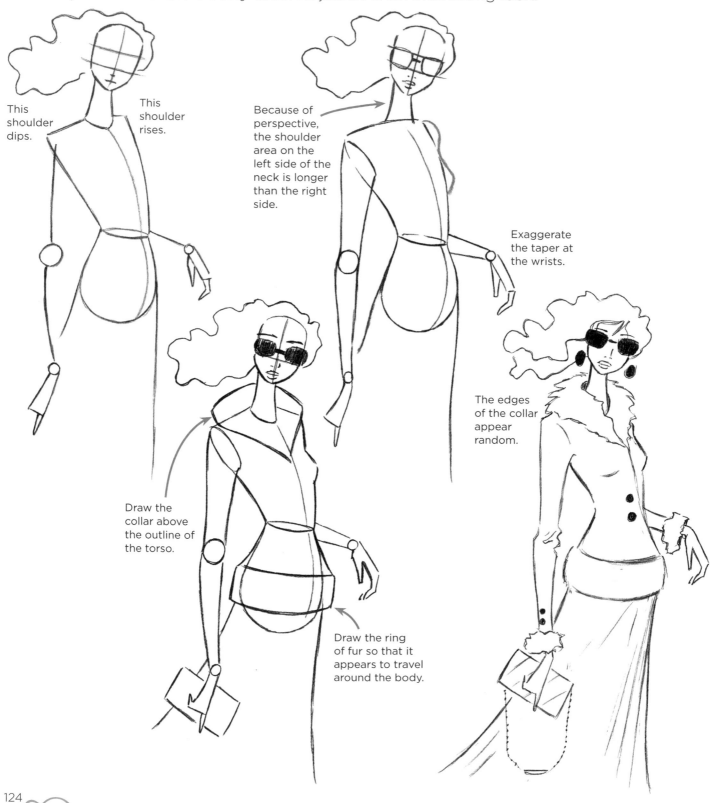

This shoulder dips.

This shoulder rises.

Because of perspective, the shoulder area on the left side of the neck is longer than the right side.

Exaggerate the taper at the wrists.

Draw the collar above the outline of the torso.

Draw the ring of fur so that it appears to travel around the body.

The edges of the collar appear random.

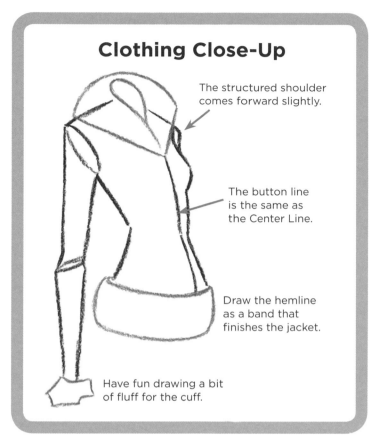

Clothing Close-Up

The structured shoulder comes forward slightly.

The button line is the same as the Center Line.

Draw the hemline as a band that finishes the jacket.

Have fun drawing a bit of fluff for the cuff.

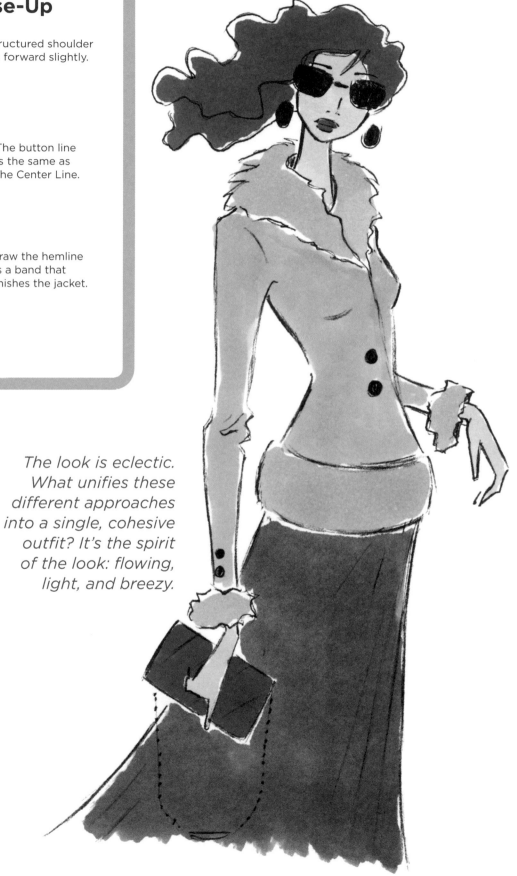

The look is eclectic. What unifies these different approaches into a single, cohesive outfit? It's the spirit of the look: flowing, light, and breezy.

UNSTRUCTURED **JACKET**

By removing the lines that define the basic framework of a coat, you begin to show its softness. This allows you to draw the fabric as if it were blowing out in a breeze. Draw the coat open, in order to create an even less restricted look.

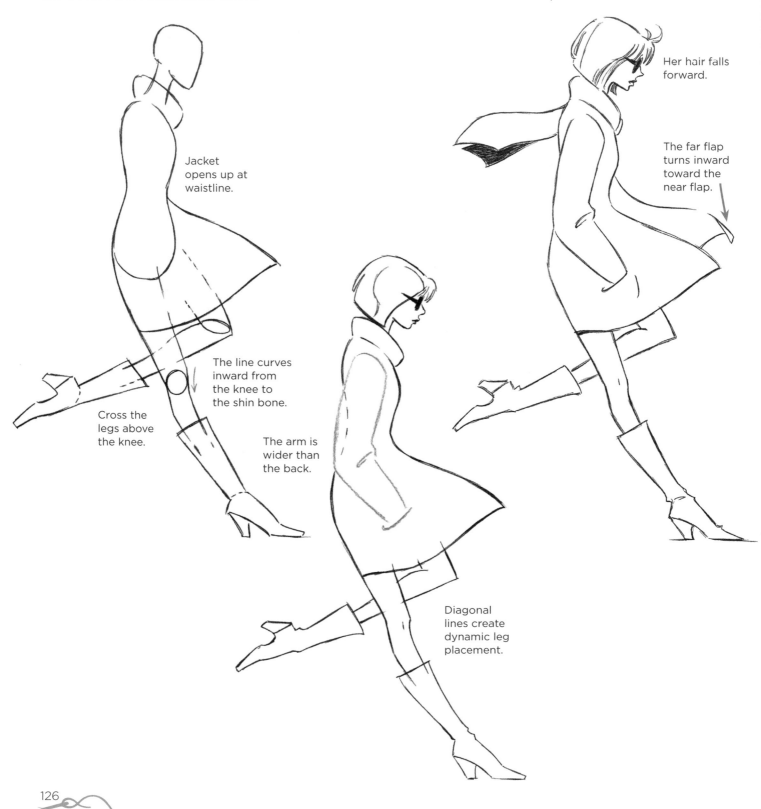

Jacket opens up at waistline.

Her hair falls forward.

The far flap turns inward toward the near flap.

The line curves inward from the knee to the shin bone.

Cross the legs above the knee.

The arm is wider than the back.

Diagonal lines create dynamic leg placement.

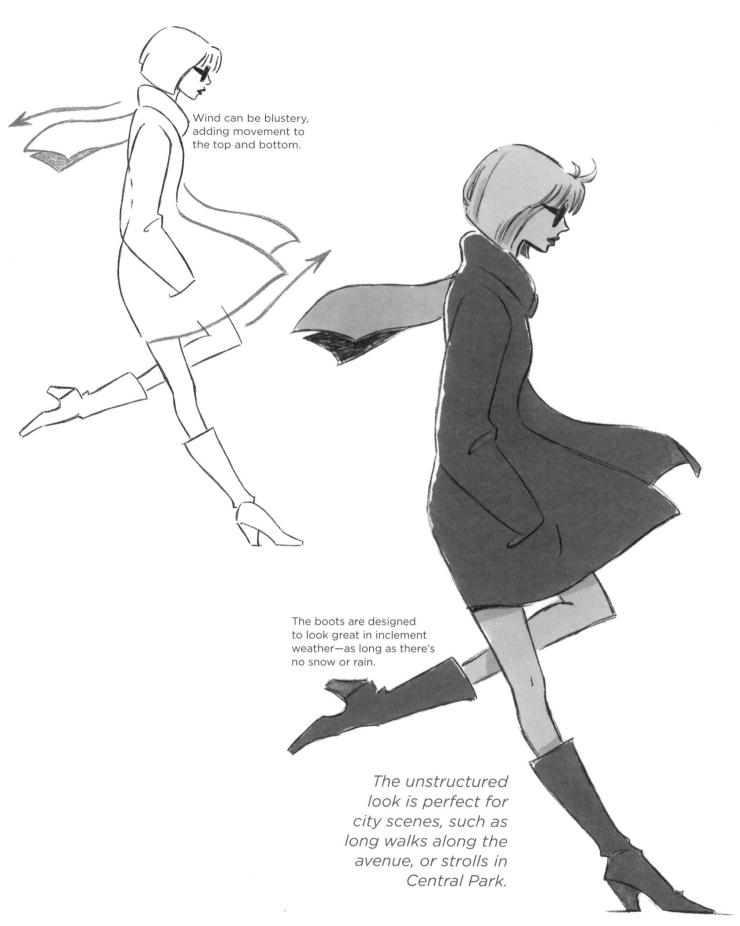

Wind can be blustery, adding movement to the top and bottom.

The boots are designed to look great in inclement weather—as long as there's no snow or rain.

The unstructured look is perfect for city scenes, such as long walks along the avenue, or strolls in Central Park.

A-LINE COAT

This simple but pleasing coat has an asymmetrical shape. It's a faux-Parisian schoolgirl look. The coat is boxy, which is part of its charm. However, you'll also notice one subtlety: the lines of the body are slightly curved inward. It's oversized in a friendly way.

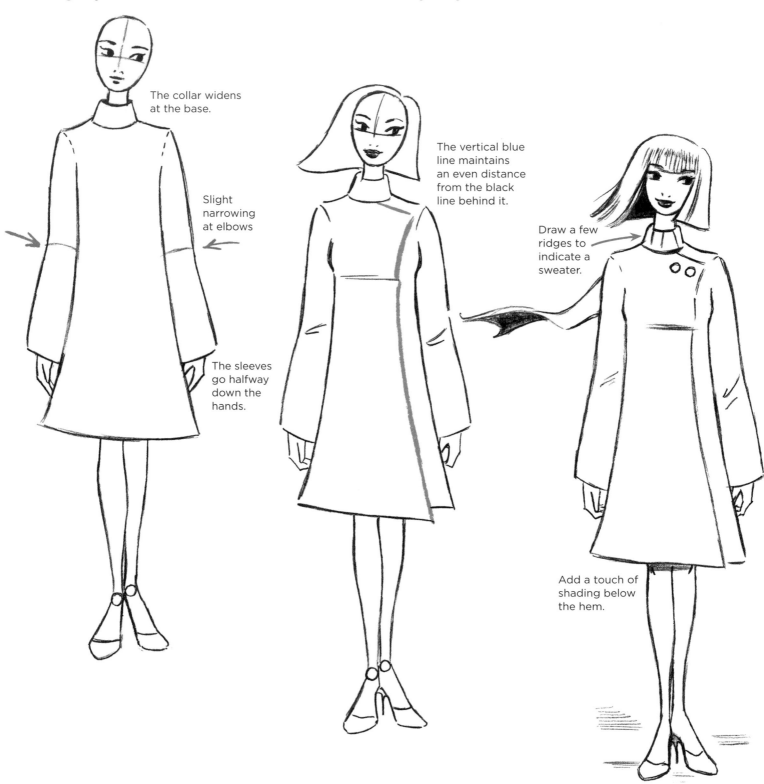

The collar widens at the base.

Slight narrowing at elbows

The sleeves go halfway down the hands.

The vertical blue line maintains an even distance from the black line behind it.

Draw a few ridges to indicate a sweater.

Add a touch of shading below the hem.

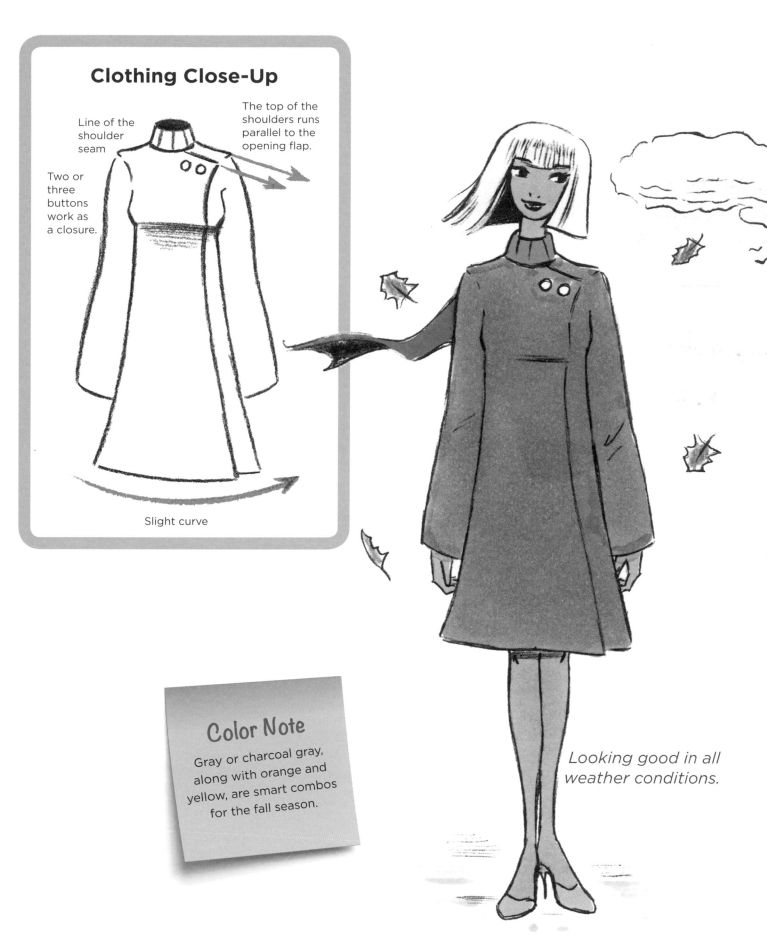

Clothing Close-Up

Line of the shoulder seam

The top of the shoulders runs parallel to the opening flap.

Two or three buttons work as a closure.

Slight curve

Color Note

Gray or charcoal gray, along with orange and yellow, are smart combos for the fall season.

Looking good in all weather conditions.

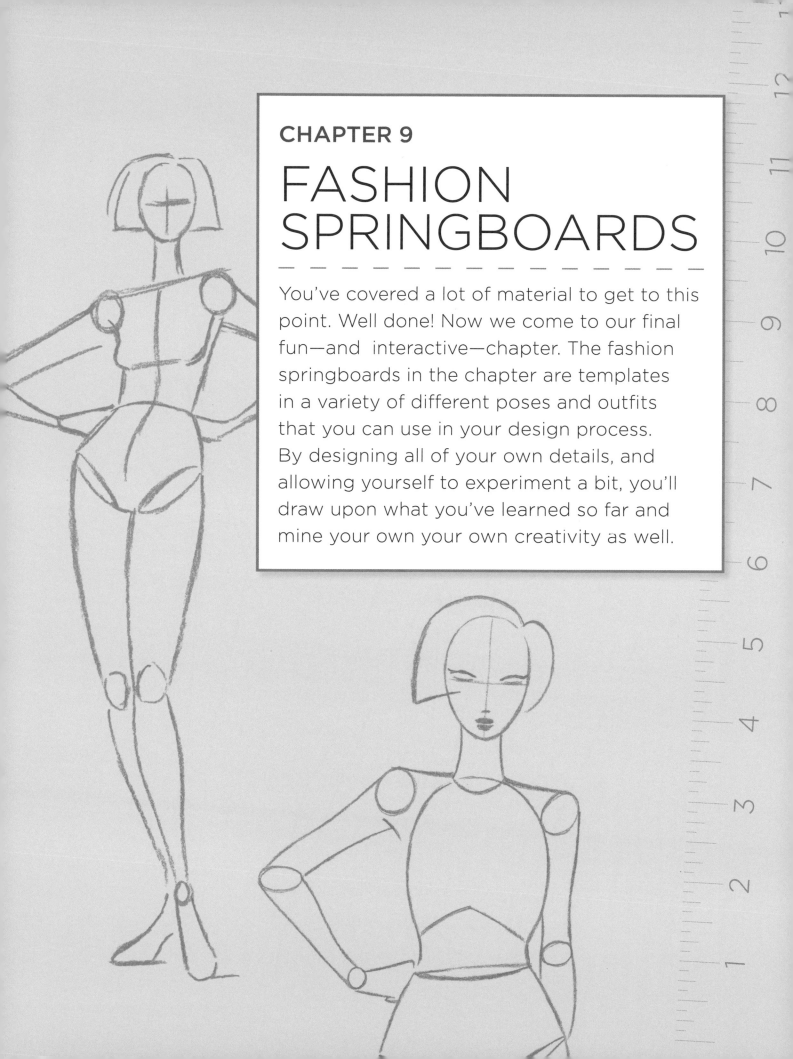

CHAPTER 9
FASHION SPRINGBOARDS

You've covered a lot of material to get to this point. Well done! Now we come to our final fun—and interactive—chapter. The fashion springboards in the chapter are templates in a variety of different poses and outfits that you can use in your design process. By designing all of your own details, and allowing yourself to experiment a bit, you'll draw upon what you've learned so far and mine your own your own creativity as well.

FASHION SILHOUETTES

As a springboard for creating stylish looks, fashion silhouettes can make a big impact. These solid-color figures are used to sell not only fashion, but also the *idea* of fashion. For example, clothing catalogs and fashion articles often use fashion silhouettes to show the latest trends. The contrast pops, while focusing the eye on the outfit.

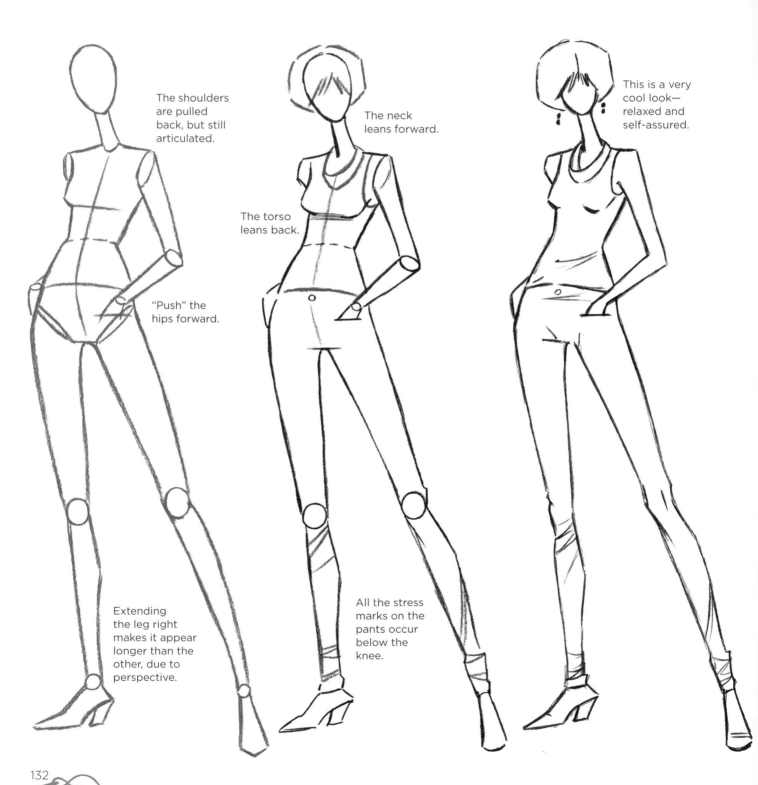

The shoulders are pulled back, but still articulated.

"Push" the hips forward.

Extending the leg right makes it appear longer than the other, due to perspective.

The neck leans forward.

The torso leans back.

All the stress marks on the pants occur below the knee.

This is a very cool look—relaxed and self-assured.

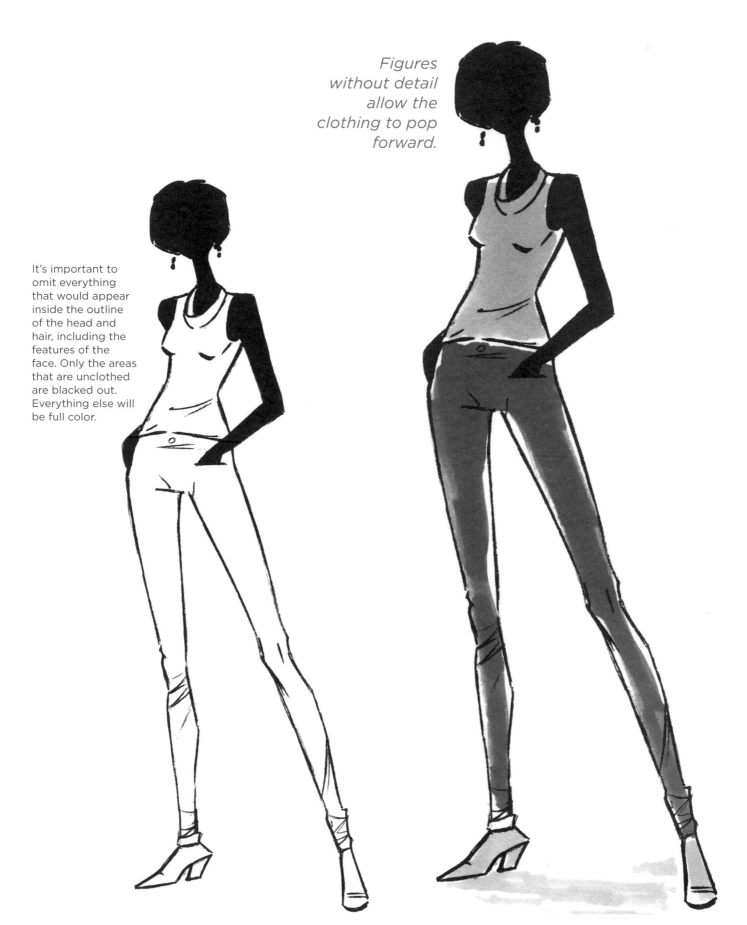

Figures without detail allow the clothing to pop forward.

It's important to omit everything that would appear inside the outline of the head and hair, including the features of the face. Only the areas that are unclothed are blacked out. Everything else will be full color.

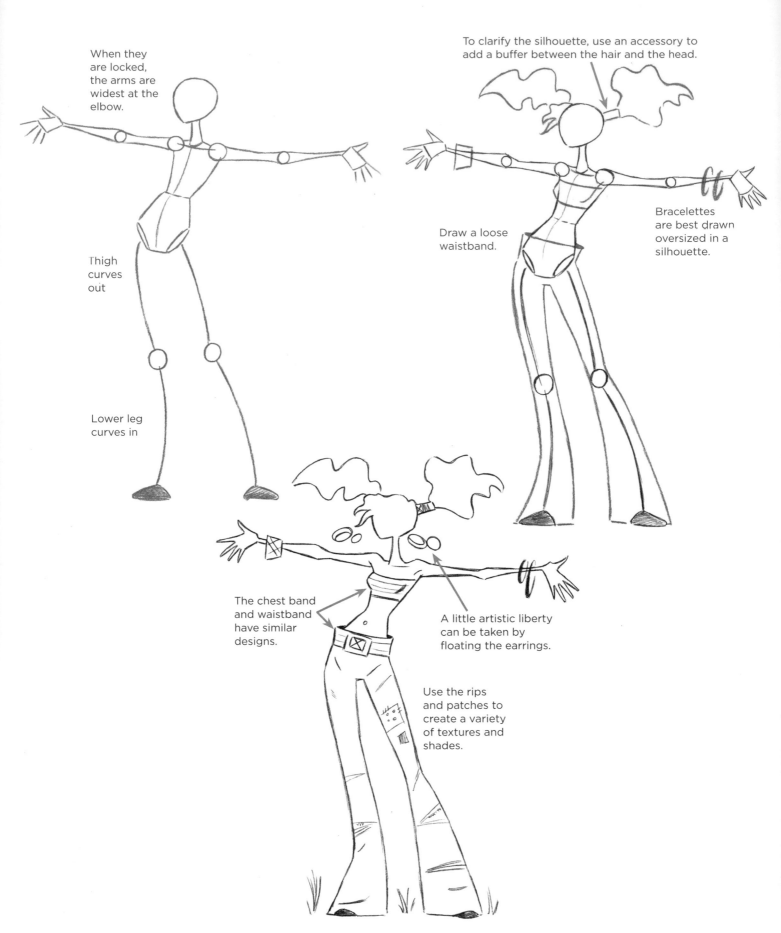

When they are locked, the arms are widest at the elbow.

Thigh curves out

Lower leg curves in

To clarify the silhouette, use an accessory to add a buffer between the hair and the head.

Draw a loose waistband.

Bracelettes are best drawn oversized in a silhouette.

The chest band and waistband have similar designs.

A little artistic liberty can be taken by floating the earrings.

Use the rips and patches to create a variety of textures and shades.

Why not try this figure yourself with a few changes, such as creating shorts instead of jeans or drawing a V-collar blouse, like the one in the previous example?

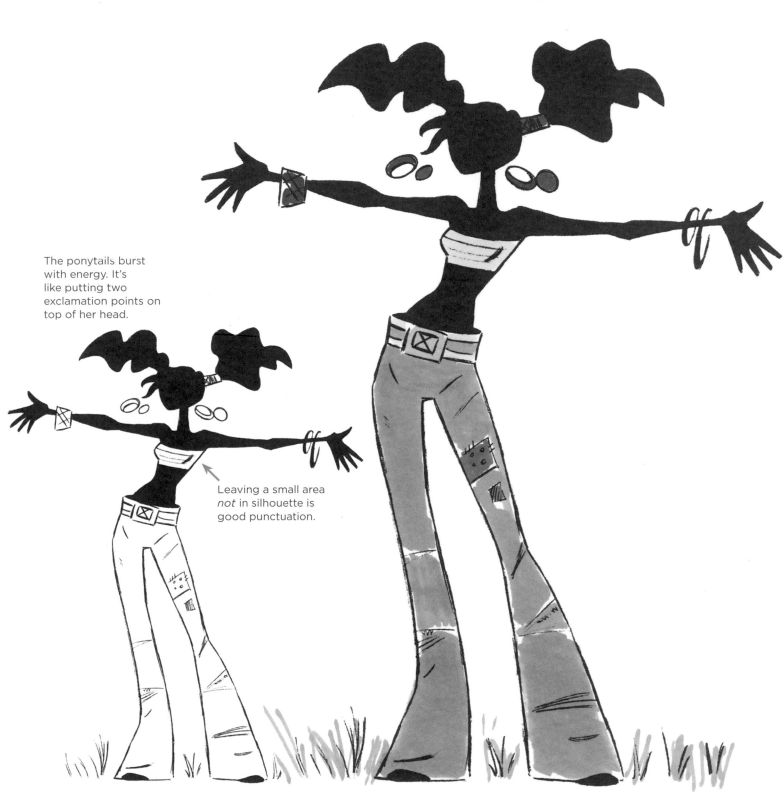

The ponytails burst with energy. It's like putting two exclamation points on top of her head.

Leaving a small area *not* in silhouette is good punctuation.

A COLLECTION OF FASHION **SPRINGBOARDS**

The templates that follow allow you to draw right in the book. Just trace over the blue lines, and complete the rest however you like. You can add your own colors, accessories, and finishing flourishes. There's no right way to work with these springboards. Just express what it is you have in your mind's eye.

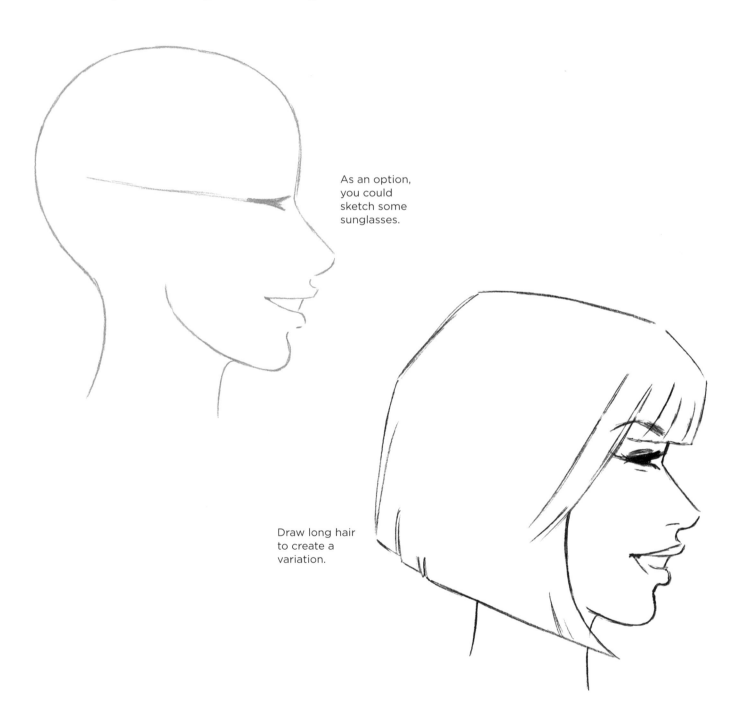

As an option, you could sketch some sunglasses.

Draw long hair to create a variation.

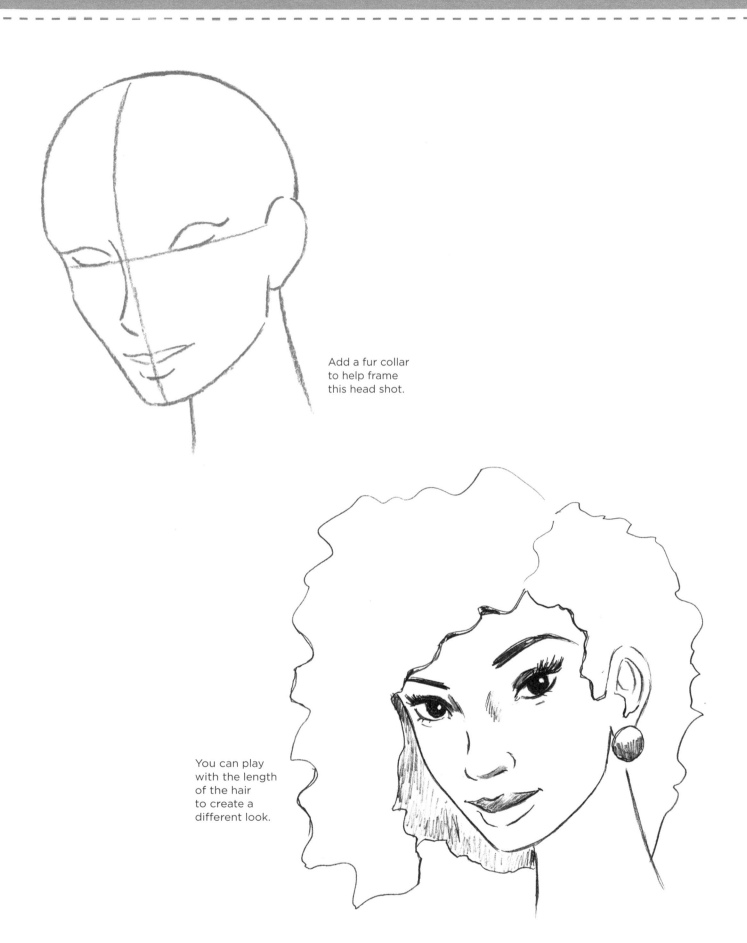

Add a fur collar
to help frame
this head shot.

You can play
with the length
of the hair
to create a
different look.

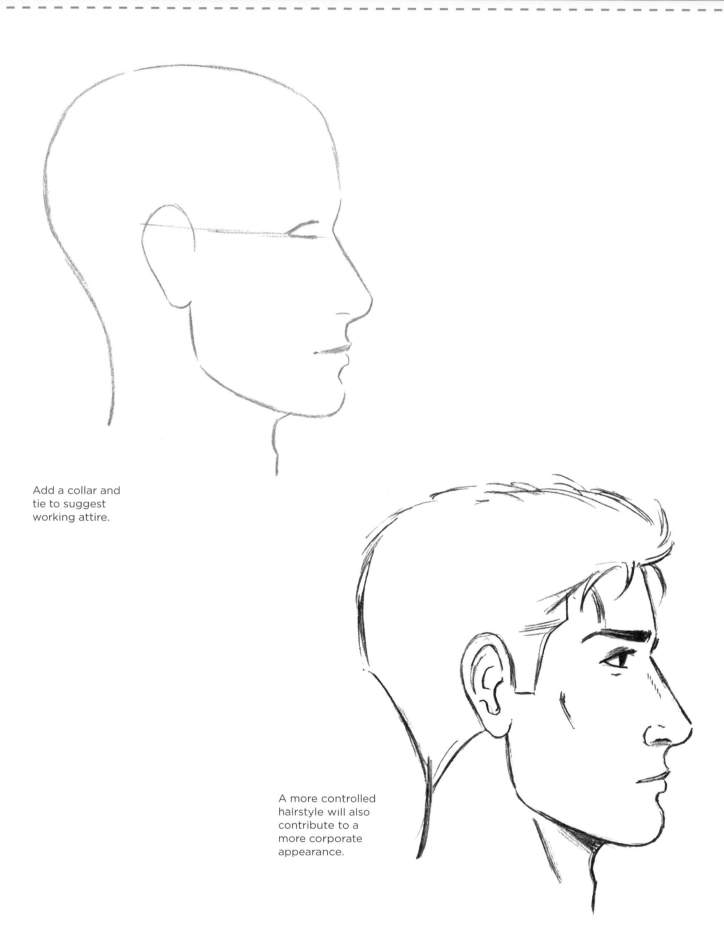

Add a collar and tie to suggest working attire.

A more controlled hairstyle will also contribute to a more corporate appearance.

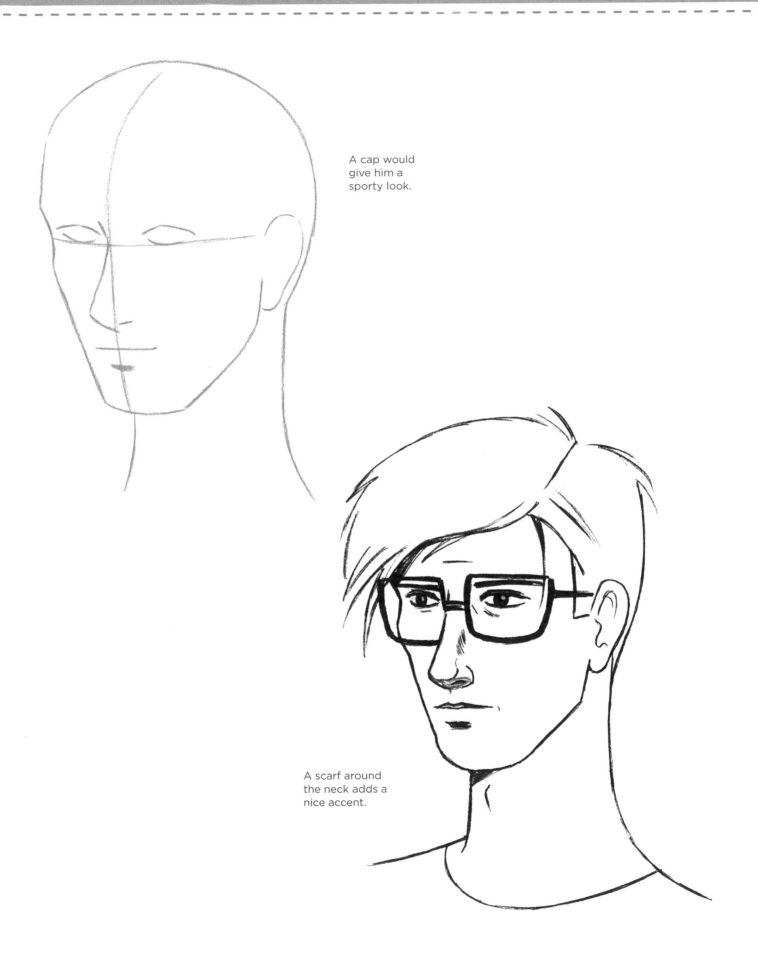

A cap would give him a sporty look.

A scarf around the neck adds a nice accent.

Complete the heads and features, then draw patterns, buttons, collars, or folds, and finish up with jewelry, purses, or sports bags.

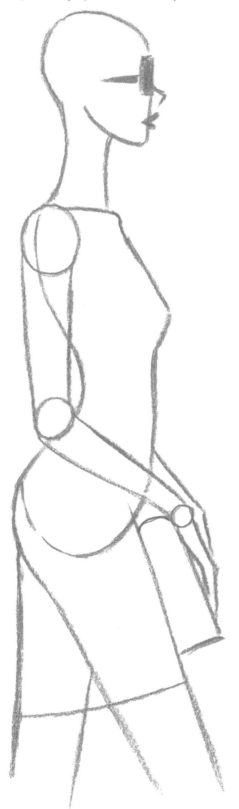

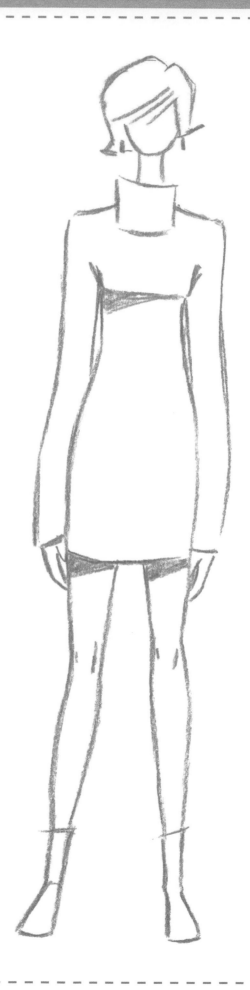

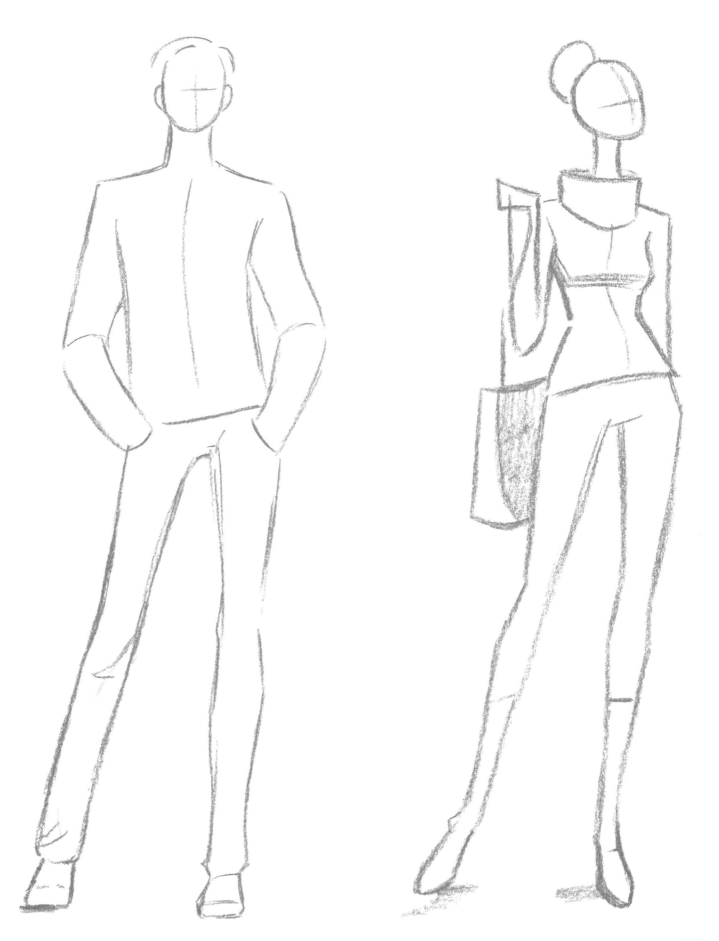

Here are your basic starting points. Where you end up is completely up to you, your imagination, and your fashion sense.

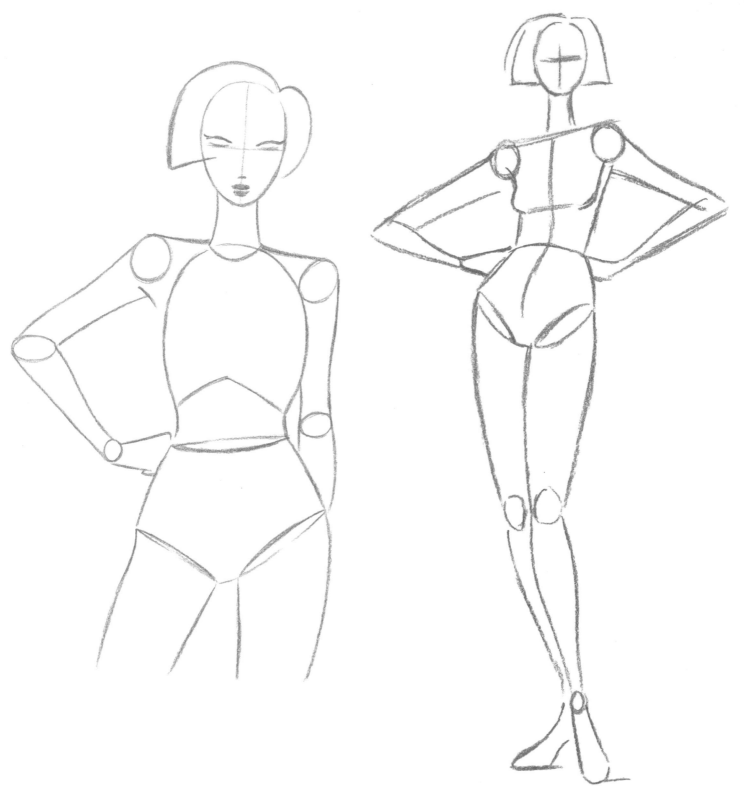